ICON AND IDEA

ICON

AND

IDEA

The Function of Art in the Development of Human Consciousness

HERBERT READ

SCHOCKEN BOOKS · NEW YORK

The Charles Eliot Norton Lectures
at Harvard University

First SCHOCKEN PAPERBACK edition 1965

PREFACE

SOME apology must first be made for presenting a somewhat revolutionary theory in what may strike the reader as a perfunctory manner. A brevity of treatment and a directness of style were imposed by the manner in which the book was conceived—as a series of seven lectures. When, in 1953, I was invited to give the Charles Eliot Norton Lectures at Harvard University, I chose this theme because it was uppermost in my mind, and because I was anxious to test its viability before an intelligent audience. The generous welcome it received on that occasion encourages me to offer it, inadequate though it be, to a wider public.

I do not claim to be the originator of the theory now presented. As I make clear in the first chapter, the germ of it is latent in the neglected works of Conrad Fiedler, and it is also an obvious (though not an authorized) deduction from Cassirer's philosophy of symbolic forms. Cassirer claimed that every authentic function of the human spirit embodies an original, formative power. Art, myth, religion, cognition—"all live in particular image-worlds, which do not merely reflect the empirically given, but which rather produce it in accordance with an independent principle." Cassirer believed that each of these functions of the human spirit creates its own symbolic forms, and that these forms enjoy equal rank as products of the human spirit. "None of these forms can simply be reduced to, or derived from, the others; each of them designates a particular approach, in which and through which it constitutes its own aspect of 'reality'."

I do not question this "equality" among symbolic forms, as current instruments of discourse. But in this book I am attempting to establish for the symbols of art a claim to priority which is historical. I believe that to some extent Cassirer does this too, though never systematically nor with any realization of the consequences of such an act. For if the image always precedes the idea in the development of human consciousness, as I maintain it does, then not only must we rewrite the history of culture but we must also reëxamine the postulates of all our philosophies. In particular, we must ask ourselves once again what is the right basis of education.

To make such immense claims in seven brief lectures is an

impertinence, but no one could be more conscious than myself of my inadequacy for the major task of consolidating a theory so lightly entertained. It would require a detailed knowledge of the comparative history of civilizations, particularly the formative phases of such civilizations; and in secure possession of all the relevant facts, a logical ability to order them in a systematic fashion. I have neither this knowledge nor this ability, nor time left in my life to acquire either. But I have an ardent conviction of the truth of my hypothesis, and I think it is sufficiently firmly based on experience to be cast to the critical lions.

I gave a first outline of the theory in a lecture (the Conway Memorial Lecture) delivered in London in April 1951. The separate publication of that lecture led to correspondence and discussion which has done much to correct the first outline, and in particular I was grateful to Dr. Julian Huxley for a warning against the imprecise use of the word "evolution." "Development" may be merely a more ambiguous word, and one dare not speak of *progress* in the image-world of art. Images, once created, are everlasting—or last as long as they have sensuous acuity. But much depends on our ability to create them and on their enduringness—certainly all we imply by the word progress in the world of ideas. We manipulate ideas by logic or scientific method, but we come upon them in the contemplation of images. But I begin to anticipate my argument. . . .

I have many obligations to record—and, first of all, my obligation to the President and Fellows of Harvard College, and to the Norton Professorship Committee, for the honor they conferred on me. During my stay in Cambridge, I enjoyed the hospitality of Lowell House, for which my sincere thanks are given to Dr. and Mrs. Elliott Perkins. My immediate mentor was Professor Frederick Deknatel, chairman of the Department of Fine Art, and to him, and to Mr. John Coolidge, the Director of the Fogg Museum of Art, my obligations were continuous during my stay of eight months. I would also like to thank Miss Ward and Miss Lucas, and the remainder of the staff of the library of the Fogg Museum, for their unfailing courtesy and help in the preparation of the lectures.

H. R.

August 1954

PREFACE TO THE NEW EDITION (1965)

THE theory I first presented in this book ten years ago maintains that the image, which when projected into a plastic form I call the icon, preceded the idea in the development of human consciousness, and therefore in the development of the aptitudes and skills dependent on consciousness.

In the interval I have had ample opportunity to test this theory against the criticism it received and to seek further support for it in the works of other writers. One such confirmation that I should have remembered when I wrote my book is to be found in Freud's *The Ego and the Id*. I quote the relevant paragraph from the English translation by Joan Riviere (London, 1927), pp. 22-3:

> We must not be led away, in the interests of simplification perhaps, into forgetting the importance of optical memory-residues—those of *things* (as opposed to *words*)—or to deny that it is possible for thought-processes to become conscious through a reversion to visual residues, and that in many people this seems to be a favourite method. The study of dreams and of preconscious phantasies on the lines of J. Varendonck's observations gives us an idea of the special character of this visual thinking. We learn that what becomes conscious is as a rule only the concrete subject-matter of the thought, and that the relations between the various elements of this subject-matter, which is what specially characterizes thought, cannot be given visual expression. *Thinking in pictures is, therefore, only a very incomplete form of becoming conscious.* In some ways too, it approximates more closely to unconscious processes than does thinking in words, and it is unquestionably older than the latter both ontogenetically and phylogenetically.

"Thinking in pictures" is, of course, only the first stage of icon-making, or a creative artistic activity, but the step from thinking in pictures to making icons is one that was taken in the prehistoric period, and though from any point of view the first words would be poetic icons, they still remained "an incomplete form of becoming conscious."

Such a generalization is supported by the evidence of other psychologists, notably C.G. Jung, and I have made several references to his researches in the main body of my text. I would now like

to quote a psychologist who is also a theologian, Dr. E.L. Mascall (University Lecturer in the Philosophy of Religion, Oxford). The passage comes from *Words and Images: A Study in Theological Discourse* (London, 1937), p. 112:

My present point is simply to insist that images, like language, have an epistemological character and function which is not exhausted by description in terms of coding and decoding; the image, or the image complex, like the word or the word-complex, is an *objectum quo,* by the entertainment and contemplation of which the mind is able to enter into intimate cognitive union with the reality of which it is a manifestation.

Finally, and most impressively, I can bring to my support the words of one of the greatest of modern philosophers, Max Scheler. I quote Peter Heath's translation of *Wesen und Formen der Sympathie* (*The Nature of Sympathy,* London, 1954, pp. 252-3):

Anything in our experience which can be put into words is always something which, having been singled out by common language, must also be accessible to others; and such experience presents a quite different appearance in internal perception from anything that is "ineffable." It is given *prior* to the ineffable. For this reason poets, and all makers of language, having the "god-given power to tell of what they suffer," fulfil a far higher function than that of giving noble and beautiful expression to their experiences and thereby making them recognizable to the reader, by reference to his own past experience in this kind. For by creating new forms of expression the poets soar above the prevailing network of ideas in which our experience is confined, as it were, by ordinary language; they enable the rest of us to *see*, for the first time, in our own experience, something which may answer to these new and richer forms of expression, and by so doing they actually *extend* the scope of our *possible* self-awareness. They effect a real enlargement of the kingdom of the mind and make new discoveries as it were, within that kingdom. It is they who open up new branches and channels in our apprehension of the stream and thereby show us for the first time *what* we are experiencing. That is indeed *the mission of all true art;* not to reproduce what is already given (which would be superfluous), nor to create something in the pure play of subjective fancy (which can only be transitory and must necessarily be a matter of complete indifference to other people), but to press forward into the whole of the external world *and* the soul, to see and communicate those objective realities within it which rule and convention have hitherto concealed. The history of art may be seen,

therefore, as *a series of expeditions against the intuitable world, within and without, to subdue it for our comprehension; and that for a kind of comprehension which no science could ever provide.*

I could not hope for a clearer and more succinct statement of the theory I put forward in *Icon and Idea*, but I think this identical point of view may be explained by the fact that both Scheler and I have been inspired by the same pioneer—Conrad Fiedler. Scheler refers specifically to Fiedler's *Ursprung der Kunsttätigkeit* in a footnote to a previous statement in this same chapter of *The Nature of Sympathy*—"even my own artistic ideas only mature *in* the process of depiction and only attain a definite shape *in so far* as they are bound up with this process."

I would also venture to seek an ally in the author of a work of great importance which has appeared since I wrote *Icon and Idea*—Professor Siegfried Giedion's *The Eternal Present*, Vol. I: *The Beginnings of Art* (1962) and Vol. II: *The Beginnings of Architecture* (1964). I cannot quote a passage so apt as the one from Scheler, but Giedion insists throughout his work that "Art is a fundamental experience. It grows out of man's innate passion to develop a means of expression for his inner life." He expounds with an overwhelming power of illustration the whole transition in man's prehistory from symbol to concept. On one point he provides a correction—he insists that abstract symbols came into being with the beginning of art, whereas I imply that they were a development of the Neolithic period. This correction does not affect my argument: whether abstract or pictorial, the symbols were visual icons that anticipated the development of the concept.

Finally, I would like to draw attention to a new book in which I myself have developed the theory in further detail: *The Origins of Form in Art*, New York (Horizon Press) and London (Thames & Hudson), 1965.

A few minor corrections to the original text have been made in this edition.

HERBERT READ

Stonegrave
York, England
June, 1965

CONTENTS

ILLUSTRATIONS

The sources of the photographs reproduced are indicated in the following list. Where there is no indication, the photograph is either an official one, supplied by the museum or gallery in question, or is from an unknown source. The photograph of the drawing at Windsor Castle (Plate 63) is reproduced by gracious permission of Her Majesty the Queen.

1 Finger drawings on clay. Pech-Merle cave near Cabrerets (Lot), France *Photo: Laborie.*

2 Heads of oxen from the cave at Lascaux near Montignac-sur-Vézère (Dordogne). *Photo: Service Commercial Monuments Historiques.*

3 Frieze of animals from the cave at Lascaux. *Photo: Laborie.*

4 Fight of archers. From a cave near Morella la Vella, province of Castellón, Spain. After a drawing by F. Benitez.

5 Part of the frieze of animals and hunters, painted in black and red, at Cueva Vieja, Alpera (Albacete), Spain. After J. Cabré Aguilo, *El arte rupestre en Espana* (Madrid, 1915).

6a Ox and horses from the cave at Lascaux. *Photo: Service Commercial Monuments Historiques.*

6b Male koodoo from the Nswatugi cave, Whitewaters, Southern Rhodesia. McGregor Museum, Kimberley.

7 Nine-square checkered design from the cave at Lascaux. Polychrome, 24 × 24 cm. The hoof of an ox breaks into the upper outline. *Photo: Archives photographiques, Paris.*

8 Crouched bison from the cave at Altamira, near Santander (Spain). Polychrome, painted on a natural relief, beyond which the horns and tail project. Length: 185 cm. *Photo: Laborie.*

9a Horse engraved and painted in bistre from the cave at Lascaux. *Photo: Archives photographiques.*

9b Animal (*li-yu*) of cast bronze. Chinese (Chou dynasty: about eleventh to ninth century B.C.). Freer Gallery of Art, Washington, D.C.

10a Krater, late Mycenian, found at Enkomi (Cyprus). British Museum.

10b Krater, Athens; seventh century B.C. British Museum.

ILLUSTRATIONS

23 Hunting scene from the cave at Lascaux (Montignac-sur-Vézère). Upper Paleolithic period. *Photo: Laborie.*

24 The Sphinx of Naxos. From Delphi. Greek; about 550–540 B.C. Delphi Museum. *Photo: "Sphinx."*

25a Mother and child. Terra-cotta figurine from Cyprus. Louvre Museum, Paris.

25b Terra-cotta idol from Cyprus. Louvre Museum, Paris. *Photos: Archives photographiques.*

26 Mourning over a dead child. Painting from a lekythos, found at Eretria. Second half of fifth century B.C. British Museum.

27 Boating by moonlight. Attributed to Ma Yüan (*c.* 1190–1224). Chinese; Sung Dynasty (A.D. 960–1279). Eumorfopoulos Collection, British Museum.

28 Church of S. Maria Maggiore, Rome. A pagan basilica restored and re-decorated by Pope Sixtus III (432–440). *Photo: Anderson.*

29 The Ascension, by Niccolo di Pietro Gerini (matriculated 1368, died 1415). Pisa, S. Francesco. *Photo: Brogi.*

30 Dome of the church at Chèves (Charente), France. *Photo: Archives photographiques*

31 The church of Hagia Sophia, Constantinople (Istanbul).

32 Lincoln Cathedral: interior of the nave, looking east. *Photo: Mansell, London.*

33 Virgin and Child with the Apostles. Mosaic in the main apse of the cathedral, Torcello; about 1100. *Photo: Anderson.*

34 Krater, dipylon ware. Greek; eighth century B.C. Metropolitan Museum of Art, New York.

35 The Broomhall krater. Attic; seventh century B.C. The Earl of Elgin. *Photo: Marie Beazley.*

36 Head of a woman. From an amphora, late seventh century B.C. From Kübler, *Altattische Malerei.*

37 A valediction scene by the painter Lydos. Attic; middle of the sixth century B.C. Vlasto Collection, Athens. *Photo: Prof. Bernard Ashmole.*

38 Amphorae, decorated with chariot races. Attic; sixth century B.C. Metropolitan Museum, New York.

39 Pyxis, middle Corinthian period (600–575 B.C.). British Museum.

40 Painting by Exekias on an amphora, showing Achilles and Ajax playing a board game. Sixth century B.C. Vatican, Rome. *Photo: Anderson.*

41 Pinax (plate) signed by Epiktetos; about 500 B.C. British Museum.

ILLUSTRATIONS

42 Stylized female figures, carved marble. Cycladic; second millennium B.C. Louvre Museum, Paris. *Photo: Archives photographiques.*

43 Idol of carved marble. Cycladic; Bronze Age, end of third millennium B.C. Ashmolean Museum, Oxford.

44a Minotaur in cast bronze. Greek; sixth century B.C. Louvre Museum, Paris.

44b Warrior in cast bronze. Greek; sixth century B.C. Louvre Museum, Paris. *Photos: Archives photographiques.*

45 Standing maiden from Attica; about 580–560 B.C. Staatliche Museum, Berlin.

46 The Rampin horseman: the head from the Louvre Museum, Paris, completed by fragment of the torso from the National Museum, Athens; about 600–575 B.C. *Photo: Mr. G. Mackworth Young.*

47 Figure of Cleobis, found at Delphi; about 600–575 B.C. Delphi Museum.

48 Figure from the Parthenon frieze. 442–438 B.C. British Museum. *Photo: F. L. Kenett.*

49 Fragment found on the Acropolis, Athens. From Payne and Young, *Archaic Marble Sculpture from the Acropolis*, Pl. 25 (4).

50 Bronze statuette found at Delphi. Possibly Cretan; about 640–630 B.C. The Museum, Delphi. *Photo: Georges de Miré* (from Pierre de la Coste-Messelière, *Delphes* (Paris, 1943).

51 Apollo from Boeotia; about 540–510 B.C. National Museum, Athens. *Photo: Hege.*

52 The Annunciation. Carving in alabaster. English (Nottingham); fifteenth century. Victoria and Albert Museum, London.

53 Tapestry. French; end of the fifteenth century. *Photo: Victoria and Albert Museum.*

54 Masaccio: Detail from the 'Tribute Money'. Santa Maria del Carmine, Florence. *Photo: Anderson.*

55 Masaccio: St. Jerome and St. John. National Gallery, London.

56 Giotto: Life of Christ—Joachim with the shepherds (detail). Arena Chapel, Padua. *Photo: Alinari.*

57 Sassetta: St. Francis and the Wolf of Gubbio. National Gallery, London. *Photo: Keyes.*

58 Giovanni di Paolo: Christ Suffering and Christ Triumphant. Accademia, Siena. *Photo: Alinari.*

ICON AND IDEA

I

THE VITAL IMAGE

Who brought this furious wild-ox into being:
"Now create his likeness; for the impetuosity of his heart provide an equal,
Let them strive together and let Uruk have rest."

THE EPIC OF GILGAMISH (*trans.* G. R. LEVY)

"ARTISTIC activity begins when man finds himself face to face with the visible world as with something immensely enigmatical. . . . In the creation of a work of art, man engages in a struggle with nature not for his physical but for his mental existence."[1]

These words were written in 1876 by Conrad Fiedler, whose importance as a philosopher of art is now beginning to be recognized outside Germany. Fiedler was an amateur of the arts and a friend of the most original artists of his time, such as Hans von Marées and Adolf Hildebrand. His fragmentary writings express, in my opinion, a profound understanding of the nature of art.

At any rate, it is from Fiedler that I have taken the basic theory of this book—the theory that art has been, and still is, the essential instrument in the development of human consciousness. The significance of art, Fiedler held, lies in the fact that it is the particular form of activity by which man not only tries to bring the visible world into his consciousness, but even is forced to the attempt by his very nature. Such an activity, Fiedler adds, is not fortuitous, but necessary; its products are not secondary or superfluous, but absolutely essential if the human mind does not want to cripple itself.[2]

Something like the same theory had been present in German philosophy long before Fiedler's time: we find an intimation of it in Schelling and in Schiller, in Goethe, and above all in the poet Hölderlin. In Hölderlin we find the notion that the function of the

poet is the transmutation of the world into word. Poetry is a taking possession of reality, a first establishment of the frontiers of reality in our understanding. In our own time Martin Heidegger has taken up this notion of Hölderlin's: "Poetry," he says, "is the establishment of being by means of the word . . . poetry is the inaugural meaning given to being . . . not just any speech, but that particular kind which for the first time brings into the open [into consciousness, that is to say] the essence of all things—all that we can then discuss and deal with in everyday language."[3]

Such is the hypothesis which, in this book, I propose to develop in relation to the plastic arts, hoping to demonstrate historically that the arts have been the means by which man was able step by step to comprehend the nature of things. Art has never been an attempt to grasp reality as a whole—that is beyond our human capacity; it was never even an attempt to represent the totality of appearances; but rather it has been the piecemeal recognition and patient fixation of what is significant in human experience. The artistic activity might therefore be described as a crystallization, from the amorphous realm of feeling, of forms that are significant or symbolic. On the basis of this activity a "symbolic discourse" becomes possible, and religion, philosophy, and science follow as consequent modes of thought.

It is an immensely presumptuous claim. It gives to art the first place and primary function in the evolution of all those higher faculties that constitute human culture. My attempt to substantiate such a claim will range far and wide through the history of art, and from time to time it will be necessary to take philosophical bearings. If I am successful in establishing this claim, then we shall not only have reinterpreted the past, but also have reached deep down into the necessary foundations of our own culture.

I shall only incidentally, and as it serves my immediate purpose from time to time, attempt a psychological justification of this hypothesis. I believe such a justification lies ready at hand, in Gestalt psychology, for example, and more particularly in the "genetic epistemology" of an experimental psychologist like Jean Piaget.[4] Some of my ideas, as I have said in the Preface, have already been expressed with far greater authority by Ernst Cassirer;[5] and R. G. Collingwood, one of the few contemporary philosophers to pay

serious attention to the problems of art, has given me some essential guidance. Finally, I must acknowledge the inspiration I continue to receive from the only metaphysics that is based on biological science —the metaphysics of Henri Bergson. I rely, in particular, on his definition of such necessary terms as consciousness and intuition.

With that kind of equipment I propose to describe the more decisive stages in man's aesthetic apprehension of reality. These stages correspond to chronological though not necessarily sequent epochs in the history of art—beginning in prehistory and ending in our own time, and indicate successive conquests by human consciousness of different modalities of existence—the animal, the human, the intellectual, the numinous, or the transcendental spheres of being or experience. I do not claim that these modalities exhaust the whole of reality present to our consciousness; as consciousness develops it expands in thousands of directions, like a tree. Even in the sphere of the plastic arts, my survey will leave out of account many formal varieties and historical styles. But if we can indicate a correspondence between the main epochs of art and an expanding awareness of the nature of reality, then it should be comparatively easy to extend the method to minor and subtler phases of the history of art.

I should like the reader to note that I have just spoken of the *expansion* of consciousness. It was tempting to use the word *evolution*, but though I do believe that a process of evolution is discernible in human consciousness between prehistoric times and our own, it is very difficult to correlate it with the aesthetic faculty. Art, as we are often told, does not evolve—one can say that there has been no progress that is specifically aesthetic between the art of the Stone Ages and the art of today. Such statements always involve a certain ambiguity represented by the word "art." If by art we mean the skill or ability required to carry out the artist's intention, then indeed there is no considerable difference between the cave drawings and the drawings of a Raphael or a Picasso. Art in this sense must be regarded as a part of the sensuous development of *homo faber*, an endowment which can be put to various uses and which can also be abused and disused. But, nevertheless, in another sense art does evolve: aesthetic awareness has progressively increased in scope and depth. One must imagine a constant force, a blind instinct, groping

towards the light, discovering an opening in the veil of nothingness and becoming aware of significant shapes. The specifically aesthetic act is to take possession of a revealed segment of the real, to establish its dimensions, and to define its form. Reality is what we thus articulate, and what we articulate is communicable only in virtue of its aesthetic form.

Let us now try to project ourselves into that epoch of our human development which we call prehistoric because it has left no written records, and which might, indeed, extend backwards beyond the invention of language. Before the word was the image, and the first recorded attempts of man to define the real are pictorial attempts, images scratched or pecked or painted on the surfaces of rocks or caves. Our knowledge of the existence of this primal art is comparatively recent, and so staggering was the impact of such knowledge on the scientific mind that for some years the authenticity of the evidence was doubted. Even now the significance of this art, for anthropology, for aesthetics, and, I would say, for philosophy, has not been sufficiently appreciated.

Normally we adjust our minds to a time span of some seventy years; it is doubtful if many people can grasp an historical period of more than thirty centuries, which would include the poetry of Homer, and the dawn of philosophy in the East. We are now required to adjust our minds to a time span of four hundred centuries, and the effort, in terms of human faculties and institutions, is extremely hazardous. We can grope backwards, as Gertrude Rachel Levy has done,[6] from known religious practices and social customs, and reconstruct, with careful observance of the fragmentary evidence, the first dawn of a specifically human consciousness: a consciousness not yet logical, not aware of causality, but aware of synchronicity—able, that is to say, to make a mental connection between events that are separate in location. *To make a connection*, however irrational or illogical in our sense of reason and logic that connection might be—that was the first step in civilization, the basis of the first magical economy. But a connection could only be made—that is to say, rendered visible, perceptibly realized and represented—by a sign,

which is an image that can be separated from immediate perception and stored in the memory. The sign came into existence to establish synchronicity, in the dumb desire to make one event correspond to another.

The main preoccupations of prehistoric man, as of the human race always, were economic. To secure sufficient food to support life—such must have been the first concern of those nomadic hordes that constituted paleolithic man. Drastic climatic changes, driving these hordes in search of habitable regions, must have gradually increased that concern until it reached an intensity of which we now have no conception. But out of that intensity was born magic—the first attempt to evade direct causality and influence events from a distance, secretly. The gathering of fruits, the killing of edible animals—that is what we mean by direct causality. But the ensurance of success in hunting, and later the ensurance of soil fertility by rainfall—these were efforts which demanded the concordance of a wishful thought and the act itself. The wishful thought was expressed as a rite, and ritual, as Jane Harrison and others long ago recognized, is inseparable from the first manifestations of art.

I have, in an earlier book,[7] spoken against the too simple view that art was originally a by-product of ritual; it would be just as logical to regard ritual as a by-product of art. No human faculty arises in isolation: art develops, in primitive man and in the child, out of scribbles and the casual recognition of significant signs; but it would not develop—and this is the point—unless there was some purpose in its development—some unconscious wish drawing it onwards. Ritual developed out of economic needs, and out of a belief in the effective correlation of discrete events. But ritual could not have developed without a system of signals—gestures elaborated into dances, images materialized as plastic symbols. Civilization is coördination: a mutuality of faculties. The only priority in human development is the vital one—the will to live. All our faculties serve this imperious need, and art, as well as magic (and later religion) was part of a complex response to this single impulse.

Prehistoric art must be understood in this sense—as a response to vital needs. That the symbols which were evolved for this economic or utilitarian purpose should acquire in the process of their evolution

a vitalistic quality which we now recognize as one of the aesthetic components of art is perhaps still a mystery to be explained—or is it simply a law of life that vital needs create vital means, that vitality is communicated by intensity of feeling, by the instinctive correspondence created between the intense feeling and the adequate symbol? These questions will be more easily answered when we have looked a little more closely at prehistoric art.

It is always tempting to apply a recapitulation theory to prehistoric art, and then to suggest that the human race, in the evolution of its aesthetic activities, traced the same hesitant steps as the child of today. To substantiate that possibility we should need some stratographical evidence—Mousterian sites which gave exclusive evidence of a scribbling stage; Aurignacian sites, exclusive evidence of a schematic stage; Solutrian sites, exclusive evidence of a dawning vitalism; Magdalenian sites, exclusive evidence of full naturalism. So far as I know, such evidence, precise and limiting in its chronological sequence, does not exist.

In any case, the mental processes involved in such a comparison are too inaccessible, and it would be a psychological fallacy to read into the prehistoric mind our own modes of feeling and expression. It is true that the modern child, *as a rule*, goes through an evolutionary sequence of the kind I have described in acquiring the ability to make pictorial images. He first scribbles aimlessly and then, out of the graphic chaos, begins to select and isolate significant signs—signs for the objects nearest to his vital needs, his mother first and foremost. But apart from other circumstances which alter the case, there is the immense difference that the modern child's pictorial modes of expression have, from birth onwards, to struggle against the imposed conventions of speech. The historical baby is swaddled in semantics —expected, almost from the moment of birth, to effect a correspondence of sign and sound, and of sound and meaning. The result is a dissociation of perception and expression—on the one hand, a life of sensation and feeling; on the other hand, an acquired system of thought and symbolization. In other words, the child tends to draw what it knows, not what it sees; and what it knows is inexact, incomplete, a mystery to be represented by a symbol rather than by a

visual representation. This symbol in child art has been called a *schema*, and generally it bears a recognizable relation to the object— for example, a circle for the head, a rectangle for the body, and four strokes for the limbs of a human figure. These schematic symbols are not necessarily artless; indeed, in children's art, and incidentally in comparable tribal art, they often have a strong aesthetic appeal. But they are not naturalistic, they are not reproductions of perceptual images. Only in exceptional cases does the modern child evade this tendency to schematization and imitate the visual appearance of objects. We then call him a prodigy.[8]

To compare the prehistoric artist with the modern child, therefore, would not be very sensible. Nevertheless, there are some striking resemblances. We often find, for example, parallel lines traced by fingers on the clayey surfaces of caves, very much like the scrawls a modern child will make on a wall; the confused mass of scribbling on the ceiling of the cave at Pech-Merle (Plate 1) is very like the scribbling of a child; and just as we find recognizable forms emerging from a linear chaos in the drawings of children, so we find animal forms emerging from a prehistoric linear chaos. But if we assume that the individual prehistoric man, in the manner of the modern child, went through such early phases of hapless scribbling, then he must have made a sudden leap to a realistic mode of representation of exact eidetic fidelity. The intermediate schematic stages, so familiar to us in our own children's drawings, are completely missing. It is true that there is at Lascaux one schematic drawing of a human figure (Plate 23), but it only lends point to what I am going to say, for this schematic figure of a man is associated with a perfectly naturalistic drawing of a beast, and there is no doubt that both drawings were made at the same time.[9]

This may be an historical chance; earlier phases of prehistoric art, representing in a schematic manner not only human beings but also animals, may have perished and left no traces. But it looks, from this solitary example, as if, where animals were concerned, prehistoric man was endowed with a peculiarly intense eidetic imagery that made a naturalistic mode of drawing compulsive.

In general, these animals, in the caves of Southern France and Northern Spain, are drawn as isolated figures, though they may be

superimposed on one another, and many separate drawings may be crowded together on the same ceiling or wall (Plates 3 and 6a). Sometimes the outlines are engraved into the rock surface, or modeled round natural protuberances, but in other cases there is an outline drawn in a dark pigment which is then colored with a three-dimensional or modeled effect (Plate 8). But one should discount to some extent the impression of stylized subtlety of modeling, for that has often been introduced fictitiously into copies of the cave drawings made before adequate methods of photography were available. Prehistoric art is essentially a linear art, an art of outline,[10] and to that extent it is not the impressionistic art it has sometimes been called. To give a linear outline to an image is already to make use of an artistic convention; it is a stage beyond perception, an artifice in aid of the retention of the image in the mind: in fact, a memory image. Limbs and muscles, bosses and hollows, are clearly articulated, and dynamically interrelated. Vertical and horizontal axes essential to the representation of the object provide a primitive structurization of space, but composition does not exist; at any rate, there seems to be no sustained intention to dispose discrete masses coherently in space. There is no perspective projection in the scientific meaning of the term, though animals are sometimes painted one behind the other, and there may be a twisting of the outlines of, for example, a pair of horns, to represent a sideways extension of the object (Plate 2). But these are devices common to artistically "uneducated" children today. There are certain representations of incidents, as at Lascaux, in a sequential frieze, which may be regarded, perhaps, as a very primitive form of pictorial composition (Plate 3).[11]

The general character of this animal style of the Paleolithic period is best described by the word *vitalistic,* for the effect of the drawing, if not the intention, is to enhance the vital potency of the animals. They are usually depicted at rest, standing or lying down, with a certain monumental intensity (Plates 6, 8 and 9a).

The Levantine or East Spanish style of drawing, which had its origins in the Paleolithic period, is completely different, and no doubt arose in different climatic conditions. Instead of monumentality we have movement, and instead of the isolated beast, the herd or the hunt (Plates 4 and 5). In addition to animals we have human

figures, almost invariably armed, and these men are active, either pursuing the animals, fighting one another, or dancing. A considerable difference exists between the style in which the human figures and the animals are depicted. Although the animals associated with the hunters are often simplified, by comparison with the three-dimensional polychromatic beasts of the Franco-Cantabrian style, *they are still vitalistic*, and do not depart from a naturalistic mode of representing the animal. The men's figures, however, are highly stylized, always two-dimensional and generally monochromatic. If in movement, the legs and arms are elongated, stretched to tension, with a general effect of insectlike flickering. This is most striking in Bushman rock paintings of South Africa, which are stylistically related to Eastern Spanish rock paintings. In such crowded compositions the tiny stylized human figures dart round the larger beasts like so many mosquitoes.

"Stylized" is not satisfactory as a descriptive word for this type of prehistoric art; it is not a satisfactory word in itself, for there are many styles in art,[12] and "stylization" is used to indicate merely one of them, a particular kind of mannerism. Since the main concern of the artist was obviously to indicate movement, the Franco-Cantabrian style might perhaps be called "kinetic". Better still, I think, would be the word "haptic", which was invented by the Austrian art historian, Alois Riegl, to describe types of art in which the forms are dictated by inward sensations rather than by outward observation. The running limbs are lengthened because in the act of running they *feel* long. In fact, the two main prehistoric styles are determined on the one hand by the outwardly realized *image*, on the other hand by the inwardly felt *sensation*, and "imagist" and "sensational" would do very well as descriptive labels.

Not only were these two styles of drawing contemporaneous, but they were even practised by the same artists. It would seem, therefore, that a dissociation existed between the perceptual images due to sight and the haptic images due to bodily (somatic) sensation. Since this dissociation can be shown to exist in civilized man in spite of all attempts to create an illusion of integrated perception, it is safe to assume that it existed among prehistoric men, who had not the same intellectual prejudice in favor of an integrated mode of expression.

It does not seem to me that the origins of haptic expression present any theoretical difficulty: the form of any instinctive expression is subjectively determined, and whether it is a cry of rage or a shout of joy, the modulation is due to an inner sensational reflex—perhaps not always so obvious as a lump in the throat, but of the same physical nature. The elongations and other exaggerations of haptic art have the same explanation: they are reflexive modes of expression, associated with particular modes of action. For the purposes of my present argument, it may be assumed that these modes of expression are covered by the more general term vitalistic.

The reproduction externally of a *perceptual* image is a very different process, calling for a perfection of sensorimotor coördination which can only have been developed under biological stress. "There had to exist," as the Abbé Breuil has said of paleolithic art, "a hidden spring of intense visual emotion."[13] That stress or spring was provided by the dangers of big-game hunting, sharpened by the stress of hunger. In order to survive, prehistoric man, at a certain stage in his history, had to hunt and to kill, and his quarry was fierce and strong. In the course of centuries he became obsessed with these animal forms, for his success in hunting depended on the sharpness of his powers of observation. Think of this process in physiological terms: the same pattern of excitation impressed countless times on the brains of countless generations of hunting men, of men with no outlets into discursive modes of thought, of men who must nevertheless learn, record, preserve, and propagate their hunting lore. Add, if you like, whatever magical accessories these men eventually brought to their aid: the image, the living image of the animal, becomes all the more essential. But only the animal, only the objective prey. The rest of creation, the landscape, the plants, the fowls, and the fishes that could be caught without danger or effort—these called for no revealing images, for no magical identifications.[14] Thus we get this otherwise inexplicable concentration on the animal, on the living flesh that meant life to prehistoric man.

Frobenius relates an experience he had during one of his expeditions in Africa which reconstructs, as vividly and exactly as we can expect, the actual circumstances in which the later prehistoric drawings were made. In 1905 he met in the jungle a hunting tribe of

pygmies, who had been driven from the plateau to the refuge of the Congo. Several of their members, three men and a woman, guided the expedition for almost a week, and were soon on friendly terms with Frobenius and his colleagues. One afternoon, finding their larder depleted, Frobenius asked one of them to shoot an antelope, which he thought must be an easy job for such an expert hunter. He and his fellows looked at Frobenius in astonishment and then burst out with the answer that, yes, they would do it gladly, but that it was naturally out of the question for that day since no preparations had been made. After a long palaver they declared themselves ready to make these at sunrise. Then they went off as if searching for a good site and finally settled on a high place on a nearby hill.

"As I was eager to learn what their preparations consisted of," Frobenius relates,

"I left camp before dawn and crept through the bush to the open place which they had sought out the night before. The pygmies appeared in the twilight, the woman with them. The men crouched on the ground, plucked a small square free of weeds and smoothed it over with their hands. One of them drew something in the cleared space with his fore-finger, while his companions murmured some kind of formula or in-cantation. Then a waiting silence. The sun rose on the horizon. One of the men, an arrow on his bowstring, took his place beside the square. A few minutes later the rays of the sun fell on the drawing at his feet. In that same second the woman stretched out her arms to the sun, shout-ing words I did not understand, the man shot his arrow and the woman cried out again. Then the three men bounded off through the bush while the woman stood for a few minutes and then went slowly towards our camp. As she disappeared I came forward and, looking down at the smoothed square of sand, saw the drawing of an antelope four hands long. From the antelope's neck protruded the pygmy's arrow."[15]

The aesthetician does not need any more elaborate hypothesis than the one suggested by this anecdote to explain the development of vitalism in the cave paintings. Certain types of primitive art may have been associated with somewhat different rites but the impulse would have been the same—the desire to "realize" the object on which magical powers were to be exercised. That certain con-temporaneous drawings are more naturalistic than others may be

explained, not by a difference of talent in the artists, but rather by a difference of environment and purpose. I think it is true that the most vividly naturalistic drawings are those found in the depths of caves. No doubt more elaborate rituals were performed in such sanctuaries; but I would also like to suggest that the most compelling eidetic imagery would arise in the dark, away from other visual distractions; and though light must have been provided for the execution of the drawings, the artist would have been faced by the blank wall of the cave, on which he could project his eidetic images like lantern slides on a screen.[16]

Where a visual emotion was not involved, or where the subjects were mere accessories, there would not be the same need for realism. If we assume that the tectiform drawings and other linear abstractions (Plate 7) found in association with the animals were traps, or perhaps sometimes tracks, then there would be no compelling reason for depicting them realistically; indeed, if magical efficacy was the intention of the drawing, then they must not be recognizable by the depicted animal! For the same reason the hunters themselves must be invisible, as they would be in the actual stalking of the animal.[17] It is not until we get out of the deep caves, into the open rock surfaces or the walls of rock shelters where magic may have been no longer in question, that we find any human figures with stylistic vitality. But even then, as we have seen, there is no recourse to the eidetic image, or to a perceptual image of any kind. The stylized symbol of the human form, though it is so dynamic in the Franco-Cantabrian and Bushman art, was not due to any mimetic faculty. It is ideoplastic, determined, as I have already suggested, by inward feeling and not by outward observation; it is not intended as a visual realization of the human figure. It is not even a memory image; rather it is a sign, and in the extreme case we are very near to the Chinese ideogram or pictograph. We are at the beginning of the long evolution that led to the invention of writing.

It was an evolution that involved a gradual decline in vitalism, but not necessarily in aesthetic significance. The artifacts of the Mesolithic and Neolithic cultures are different from the artifacts of the earlier Aurignacian and Magdalenian cultures, not because a decline of aesthetic sensibility was taking place, but because a different

way of life was being imposed by different climatic conditions. Our axiom in art history should be: *always expect a constant aesthetic factor; look for the external forces that transform it.* If we are concerned with aesthetic sensibility, and not with irrelevant demands for pictorial realism, then we must be prepared to find as much aesthetic appeal in a Neolithic axhead or a predynastic Egyptian vase as in a cave painting from Altamira or Lascaux. Professor Hawkes, in his *Prehistoric Foundations of Europe*, has warned us against the fallacy of assuming that the historical development from naturalism to symbolism is mere degeneration. On the contrary—"to feel need for a true portrayal in art-magic is elementary compared to belief in the efficacy of a symbol: a portrait is individual, a symbol collective or abstract."[18] But Professor Hawkes himself is guilty of a curious fallacy when he goes on to suggest that "with the passing of realism in art one may equate the rising of human intelligence towards abstract thought." Here is a trace of what I would call the Hegelian heresy—the identification of human intelligence with discursive reasoning, as though one could say that Plato was "more intelligent" than Praxiteles, or that Freud was "more intelligent" than Cézanne.

Beauty, which comes so easily to our lips, is not a necessary postulate of the prehistoric epoch. If we read beauty into the most famous of all the prehistoric animal representations—the Altamira bison (Plate 8)—it may be that we are bringing to its appreciation eyes long accustomed to the stylized conventions of historical art. When the Altamira artist depicts a recumbent bison turning its head, and makes a rhythmical pattern of the horns, the outline of the skull, the bended knees and indrawn haunches, he is not departing from the natural attitudes of the beast, or not perhaps from the unnatural attitudes which the beast would assume when slain. But stylization is always such a departure from natural attitudes. "Stylized," remarks one of the characters in André Malraux's novel *The Walnut Tree of Altenburg*, "stylized, that is to say humanized, as man would have made it had he been God." There is no humanizing tendency in paleolithic art. But there is, perhaps, an automatic projection of nature's patterns—a subjectively physical response to the objectively "good" Gestalt. As we shall see in the next chapter, before a sense of beauty could arise, there had to be a conscious *abstraction* from the

process of nature. There is no evidence that such a conscious act of abstraction was made by paleolithic man. The most we can suppose is that economy and rhythm of movement—the necessary ingredients of skill—were transferred from the artefact to the image; that some of the instinctive skill acquired in chipping flint implements or weapons was applied to the drawing of animals. This might explain an element of stylization in the drawings: it would not explain what I am trying to explain: the need to realize an image in plastic form.

I will not speculate on whether the high degree of skill which we find in prehistoric drawings points to a specialized or professional group with a traditional training in painting. The only evidence— that from the primitive communities of the present day—is contradictory. I can only say that I do not find such a hypothesis strictly necessary. I would rather assume—and admittedly it is an assumption —that prehistoric man possessed a natural ability to draw, and although practice might have been necessary to make perfect, a good artist would have been of the same nature as a good hunter; that is to say, he would have been an individual whose particular sensational and cortical endowment made him exceptionally facile in that particular activity. In other words, the prehistoric artist was not made, but born.

Towards the solution of the mystery of that birth we have no clue, unless we seek one in our own children. It is all very well to speak of prehistoric man's chance recognition, in some protuberance of rock, in some fingermarks on the damp clayey walls of a cave, of a resemblance to some natural object; of the passage from chance recognition to deliberate imitation. That remains a cosy theory: it is neat and materialistic. But even allowing full credit for such a lucky mutation in primitive behavior (I call it "lucky" because what is involved is a mental comparison of perception images and memory images, and a mental state of attention in which the comparison can be effected), we need some motive to set the process in action—some form of psychic energy. What was going on in the mind of prehistoric man? What were his conscious thought processes, what were his *unconscious* dream processes? We know that the primitive man of today has a mental equipment very different from that of the civilized man. It is much more fragmented, much more discontinuous, more

"Gestalt-free." Professor Jung once told me how, in his travels in the African bush, he had noticed the quivering eyeballs of his native guides: not the steady gaze of the European, but a darting restlessness of vision due perhaps to the constant expectation of danger. Such eye movements must be coördinated with a mental alertness and a swiftly changing imagery that allow little opportunity for discursive reasoning, for contemplation and comparison. Of course, to such a mind a tree stump might easily be momentarily mistaken for a lion's head; but only *momentarily*. The impression would not be dwelt on, and I see no physiological reason why the process should become originative or inventive; no reason to suppose that the primitive man would deliberately proceed to make tree stumps look like lions' heads, or trim a boss of rock in his cave to make it look like a bison. Essential to this stage of development were a will and a capacity to articulate an image, and to retain this image in the memory.

We can have little conception of the gradual development, throughout millennia of human existence, of the faculty of imagination. But certainly a capacity to retain the perceptual image was developed, and became the foundation of an intelligence specifically human. And no doubt certain images had a priority in this development—images connected with the primary instincts of food-getting and sex. Physical imprints of perceptual imagery have been called *engrams*, and if we may assume that man inherits a physical predisposition towards images that conform to these patterns, then we arrive at Jung's conception of the *archetype*, a term in his psychology which indicated an inherited structure of the brain predisposing the human race, at certain epochs, to the invention of particular kinds of symbol, or to the creation of particular mythical figures. These structural features of the psyche can only have been evolved by collective experiences of long duration, and of great intensity and unity. The life-or-death struggle with the animal, at a certain geological epoch when the human race depended for its survival on the killing of such animals, was precisely one of those profound social experiences which, in Jung's hypothesis, are creative of an archetype. In any case, the animal entered the human consciousness as an archetype in this prehistoric period, and was manifested, in the individual artist, as a vital work of art. But this work of art, this

animal art, was art by virtue of being vital. A correspondence was established between the efficacy of the image as a symbol, or as a totem, and its vividness as a representation of the animal's essence: image corresponded to desire in its intensity, its actuality.

A progressive skill then led to the stabilization of the image; what was recognized as most vital was accepted as the collective symbol. But vitality, at this stage of human development, was enough. If abstract values did enter into the composition of one or two of the animals at Altamira or elsewhere, they were incidental to the magical function of the image, and never became independent values. We have to wait for another cycle of human development, which I shall deal with in the next chapter, to see the emergence, in all its independence, of geometrical intuition, and with it, of that ideal category of representation which we call *beauty*. What the prehistoric period establishes, in all *its* independence, is an instinctive mode of representation possessing vitality.

The vitality thus realized is selective; it is a concentration of attention on one aspect of the phenomenal world, that aspect which for the moment has predominant biological significance. Far from being a playful activity, an expenditure of surplus energy, as earlier theorists have supposed, art, at the dawn of human culture, was a key to survival—a sharpening of faculties essential to the struggle for existence.[19] Art, in my opinion, has remained a key to survival. However much it may have been smothered in false idealism and intellectual sophistication, it is still the activity by means of which our sensation is kept alert, our imagination kept vivid, our power of reasoning kept keen. The mind sinks into apathy unless its hungry roots are continuously searching the dark sustenance of the unknown, its sensitive foliage continuously stretching towards unimaginable light. The mind's growth is its expanding area of consciousness, and that area is made good, realized, and presented in enduring images, by a formative activity that is essentially aesthetic.

It should already be clear that the term "aesthetic" covers two very different psychological processes, just those processes whose first tentative differentiation takes place in paleolithic art, the one tending to an emphasis on *vitality*, the other discovering the still centre, the balance and harmony of *beauty*. The contemplation of beauty lifts the

sensibility out of the stress of life, out of the intentional purposiveness of the symbol, into a state of suspended animation, into a condition of serenity. We may imagine an ideal work of art in which vitality and beauty are both fully present and perfectly balanced; perhaps such a moment occurred when the Altamira bison was painted. It occurred again, perhaps, in some Greek statue of about 500 B.C. or some Gothic cathedral of about A.D. 1150. But it was always a precarious balance, difficult to achieve, impossible to sustain. In general, the artist has had to choose between the path of vitality and the path of beauty.

The prehistoric artist, for reasons which are obvious enough, chose the path of vitality. That path gets lost in the deserts of time, but we find it reappearing whenever a civilization exists in acute dependence on animal life—more particularly in association with the nomadic tribes of the Bronze and Iron Ages. The animal style which swept across the temperate zone of Europe and Asia in the sixth and seventh centuries B.C. provides the best examples. But that style in all its vitality reappears whenever the animal in its archetypal significance emerges from the unconscious depths, to take possession of the artist's mind, in Mesopotamia, in China, in Africa, in Greece itself (Plates 9*b*–11*b*). Vitality, not beauty, is the distinctive quality of Etruscan art (Plate 11*a*), and it is animal vitality that gives Viking and Celtic art, for all its abstract elaboration, its characteristic quality. It is not altogether fanciful to suppose that the same archetypal energy informs the symbolic horses of Delacroix and even the sporting horses of George Stubbs.

But vitalism is not merely animalism: it is rather the Life Force itself, and as such can be manifested in the human form as well as in the animal form, and even in abstract ornaments. It is the general characteristic of many types of tribal art, and wherever magical rites are associated with human or animal life, vitality rather than beauty is the dominant aesthetic quality. Vitality as an aesthetic factor has reappeared in all its uncompromising power in modern art. "Beauty," Henry Moore has declared, "is not the aim in my sculpture . . . For me a work must first have a vitality of its own . . . a work can have in it a pent-up energy, an intense life of its own, independent of the object it may represent."[20]

Vitality in this sense—vitality no longer attached to animal art—is generally a reaction to the deathly rigidity of all processes of repetition and imitation: the lifeless act of copying, mechanical ritual. The symbol passes from the artist into the hands of the priest, or into the hands of the teacher, and finally into the hands of the manufacturer. Deprived of the vital originative impulse of the creative artist, it becomes conventionalized, systematized, commercialized. The artist then begins to suspect the whole tradition of idealism which has divorced him from the animal sources of vitality, and strives to recover that quality.

In doing so he recovers his confidence. In this sense, vitalism in art is a challenge to nihilism in art, to the sense of despair induced by the sophistications of idealism or intellectualism. Modern nihilism in philosophy and art is the violent outcry of a disillusioned idealism. Transcendentalism has overreached itself; Sartre is the rebellious offspring of Hegel. But beauty is implicated because beauty was for so long imprisoned in its classical temple, kept inviolate, separated from the vital sources of life. It returns to those sources in the art of a modern sculptor like Henry Moore.

II

THE DISCOVERY OF BEAUTY

Was bleibet aber, stiften die Dichter.

To most students of the history of art, the transition from the Paleolithic to the Neolithic period has every appearance of a catastrophic decline. Instead of the accurate depiction of animals in drawings of great variety, we find geometrical designs which tend to degenerate into dull repetitive patterns; instead of a vital naturalism, a deadly monotony of abstraction.

Yet we know that by general cultural standards the later period represented a great advance in civilization. Man ceased to be a nomad hunting wild beasts and practicing crude magic; he became a sedentary agriculturalist, learned how to cultivate crops and domesticate animals, invented crafts like pottery, made astronomical calculations on which he based the first calendars. The neolithic artefacts, particularly the ceremonial stone axheads and spears, reach an incomparably higher standard of workmanship, and in the place of magic we discern the first glimmerings of a spiritual religion.[1] The New Stone Age is the cradle of the first great civilizations of the Ancient World.

I think we can show that in art, too, the Neolithic Age witnessed a wider development of aesthetic sensibility, a further conquest of plastic awareness, a unification and classification of sensuous experience. The area of reality, of the formal comprehension of the external world, was immensely extended in those dark ages of the Orient.

When, in the first chapter, I was considering the art of the paleolithic caves, I paused for a moment to point out that one of the

drawings, that of a bison at Altamira, might be read as a stylistic composition, rather than as a direct eidetic image of the animal. An element of fancy, of mental playfulness, might have inspired the artist in selecting this particular attitude for representation. I suggested this only as a possibility, for animals, in some of their attitudes, do compose into a rhythmical pattern—a leaping deer, a coiled snake, a bird in flight—and the attitude of this Spanish bison, far from being stylized, is perhaps significantly naturalistic. An unusual attitude is selected because it is particularly vivid. What we might admit, not only at Altamira, but noticeably at the Font de Gaume cave, and at Lascaux, is the operation of a selective instinct for significant pattern, for pattern significant of the habits of the animal, for pattern, one might almost say, signifying the animal's essential character. The form of an animal is, of course, closely related to the function that has enabled it to survive—the flight of the bird, the swiftness of the deer, the concentration of power in the head of the bull—and in representing the animal the prehistoric artist automatically emphasized what was most significant in the animal's form.[2]

Such a quality in paleolithic art perhaps constitutes a style, and in this sense we can speak quite legitimately of the Aurignacian or the Magdalenian style. The styles vary with the sites and the periods; they reflect the cultural habits of distinct phases of human economy. But in my opinion, in their aesthetic evolution, the paleolithic artists did not reach beyond the unique Gestalt, the specific awareness and apprehension of a single and separate image. The elements of composition were unknown to them, and I myself cannot find, in the collocation of images on any particular rock surface, anything but the use of a two-dimensional plane in a purely arbitrary manner. The space at Altamira, for example, was filled with images separately conceived, placed where a suitable place offered itself, and often the latest drawing would obliterate the images already on the rock surface. Admittedly, as at Lascaux, there is sometimes a representation of incidents that involve more than one animal; there are friezes of animals in procession, herds in their collective unity, and the depiction of hunting events in all their actuality. But "actuality" does not imply inclusivity. There is selection, but what is selected is the significant detail, the immediate silhouette, the pattern of action.

The composition, we might say, is dictated neurologically: a will-to-form does not enter into the process.

When we move into the Neolithic period, across dark ages that reveal no traces of a continuous development, we find an art that is entirely different in kind, an art in which completely new formal elements are present. These elements reflect a new way of life. I have no intention now, or at any subsequent stage in my argument, to ignore the fact that new developments in aesthetic consciousness are set in motion by new economic conditions.

But activation is one factor in a complex process: it charges the situation with dynamism. To carry the process through to a stage of satisfaction requires another factor, the formative one, the act of creation. The achievements of art, as Worringer has said, always represent the fulfillment of what is desired. And what is desired, even in these early stages of human development, cannot be expressed wholly in economic terms. There are over-all feelings, of isolation, of anxiety, of confidence, of joy, that will at times break through the economic framework of a civilization.

In the interval between the Old and the New Stone Ages we have passed from a nomadic mode of life, with man dependent on his skill in hunting and killing animals, to a more settled mode of life, with man dependent on agriculture and stock raising—without doubt the greatest revolution in human history. But this revolution was not catastrophic; it took place over vast stretches of time, and at different paces in different climatic conditions, and should therefore be regarded rather as an *evolution*. There was no abrupt change of style in the art of the people undergoing this evolution, and it is possible that the paleolithic style persisted, in particular cultures, throughout the intervening ages, to survive in the Bushman paintings of historical times.

"In general," as Gordon Childe has pointed out, "naturalistic or seminaturalistic pictures are painted, engraved or carved upon rocks for magical purposes by hunters, but hunters do not necessarily abandon the practice if they begin to supplement the products of the chase by stock-breeding or corn-growing."[3] In fact, although the New Stone Age was to evolve a completely abstract geometric art, there is no reason to suppose that this was an exclusive art. Rather,

as we should expect from our general thesis, it was an extension of aesthetic sensibility, not a limitation of it—not a switch-over to a separate and exclusive mode of expression. I know that some art historians have thought otherwise. It is possible that in the vast stretches of time that intervene between paleolithic naturalism and the naturalism that was to succeed neolithic abstraction, the geometric style had its separate origin, as the expression of a specific psychic state. That is Worringer's thesis, and the general tendency of German thought on the subject. It is even conceivable, as I admitted in the first chapter, that a geometric art, of which we have no knowledge, because it left no traces, preceded the naturalistic art of the Paleolithic period. A few small ornamental ivories, engraved with geometrical patterns, have been found on paleolithic sites in the Ukraine and in Moravia.[4] We also find geometrical motifs of uncertain signification associated with the animal drawings in the south of France (there is a very precise rectangle beneath a drawing of a red deer at Lascaux).[5] But these exceptions do not alter the general picture of a naturalistic phase of art preceding a geometrical phase. Much as I hesitate to disagree with Worringer, my intention is to show that in relation to the naturalistic art of the Paleolithic period the geometric art of the Neolithic period represents an extension of aesthetic sensibility, and not, as he has suggested, a contraction. We should expect an extension of aesthetic sensibility to bear some relation to the historical development of culture in general—even, if my general theory is sustainable, to be the predetermining condition for such a development. If only because the neolithic culture represents a social advance on the paleolithic culture, we should expect the accompanying art to represent a wider range of aesthetic sensibility. On analysis, that is what, in my opinion, it proves to be.

That this extension of aesthetic sensibility was accompanied by economic activities of a parallel nature seems to be fairly evident. The aesthetic evolution is comparable in its scope and significance to the economic evolution during which many new crafts were discovered, and it leads to the discovery of formal composition. This is an easy phrase to let fall, but we must try to realize what it implies. I have suggested that the paleolithic drawings were automatic projections of the memory image: the compositions and designs of the

neolithic period involve mental processes which are inventive and comparative. Images are assembled, ranged, reversed and moved into position within a coherent frame: multiplicity is reduced to unity, and therefore what Coleridge called the esemplastic power of the imagination is, for the first time in human history, vividly present.

More than imagination is involved. Imagination, I would agree with R. G. Collingwood, is a form of experience other than sensation, but closely associated with it—"so closely," as he says, "as to be easily mistaken for it, but different in that the colours, sounds, and so on which in this experience we 'perceive' are retained in some way or other before the mind, anticipated, recalled, although these same colours and sounds, in their capacity as sensa, have ceased to be seen and heard."[6] Paleolithic man, of course, had imagination in this sense of the word; otherwise he would not have been able to recall the images of the animals he painted in the depths of the caves. But the mental process we have to account for in neolithic art is not imagination in this sense, but is rather an abstractive process. The image is not retained in all its actuality, but *transformed*.

How was this mental power evolved? By abstraction, I am going to suggest, from practical activities. But do not let us underestimate the faculty of abstraction: it was the foundation, not only of fine art, but of logic, of science, of all scientific method. If a distinction is to be made between *homo faber* and *homo sapiens*, it lies in this faculty of abstraction. What is involved is not the practical imitation of a prototype (such as occurs when the form of a basket is imitated in clay), but the isolation of form from its practical function and the transference of this disembodied form to quite a different context. But the nature of the process can be more easily demonstrated in concrete examples (Plate 12).

The development of the crafts in the Neolithic period is a separate study which belongs to general anthropology rather than to aesthetics. But it was of the utmost significance, in my opinion, for the next phase in the development of aesthetic consciousness. Prehistoric basketwork has, of course, perished without a trace, but if we compare the geometrical designs on the pottery with the basketwork of primitive peoples of historical times (such as the Tlingit Indians of Alaska), we are at once struck by the identical nature of the patterns

(Plates 12 and 13). Similar patterns were a by-product of weaving mats, and these patterns of weaving were sometimes transferred to the clay surface of pottery, before the pots had been dried or baked. Other abstract markings arose from the actual manipulation of the clay: thumbmarks due to pressing the coils of clay together—the technique used before the potter's wheel was invented—or from shaping a handle or rim.

Two crafts alone—the plaiting of reeds and osiers, and the molding of clay vessels—would account for the genesis of a physical awareness of both pattern and volume. Plaiting involved the creation of complex geometrical patterns by the manipulative action of the fingers; pottery involved the shaping into volume of a plastic material. These are the basic sensational experiences in design, and the only connection that had to be made, in the mind of prehistoric man, was that between form and content. I do not say that form and content had to be consciously differentiated: there is no need for the intervention of a conscious intellect at this stage; an intuition of form would suffice. But an intuition there had to be, an unconscious perception of the physical pattern or Gestalt as such, derived from the craft operation, and the subsequent filling of this pattern or Gestalt with an image—an image derived from a quite separate sensational experience.

The operations of basketry and weaving, that is to say, created patterns of interweaving or interlacing into which the perception of objects automatically fitted; the pattern (Gestalt) had been, as it were, preselected. An unconscious perception of formal similarity between the raw material of the craft—between reeds or osiers, for example—and certain animals—snakes, for example—was no doubt the first stage in the process. But much more intractable material was to be drawn into the geometrical maze of the craft patterns, so that one must suppose that the muscular habits themselves involved in practical craft activities established somatically a formal prototype for expression. A correlation was made between the dawning visual image of bird or animal and the ready-made physical pattern. The image flowed into the mentally ready-made mold; the geometry triumphed over vitality. Subsidiary naturalistic elements, in so far as they did not fit into the matrix, were suppressed, became rudimentary features of

a design into which it is only possible to read the original image because we possess sequences of objects which illustrate the gradual geometricization of the natural feature. Some of the painted vases from Susa in Mesopotamia, which date from before 3200 B.C., catch, as it were, the ornamentation in a transitional stage (Plate 14); the frieze round the lip of a beaker will still be recognizably composed of waterfowl with elongated necks, the central motif still recognizably an ibex, its body and horns only one step from abstract geometry. In the decoration of a bowl it will be difficult to recognize, in the comb-shaped motifs, two animals back-to-back—only the rudimentary heads betray the origin of the motif. The significance of many of the motifs is more obscure, though most archaeologists would admit that they had some significance, probably magical. A chalice in the Louvre from Sialk, near Kashan, Persia (Plate 15), shows a decorative motif that has become completely geometrical, but which, from specimens which show earlier stages in the development of the design, we know represents waterfowl swimming.

We cannot assume that all geometric ornamentation in the Neolithic period originated in this manner. A large proportion of it, consisting of angles and straight lines, in clear and systematic combinations, is, as I have already indicated, derived from markings incidental to the making of vessels in other materials, notably pottery, metal-casting, and basketry. Such ornamentation no doubt had a general significance. Max Raphael, in his book on *Prehistoric Pottery and Civilization in Egypt*, has described it in a paragraph which I would like to quote:

The beginnings of pottery were rooted in necessity, the beginnings of its ornamentation were rooted in mathematics, in the sense that there was a will to abstraction, i.e. to achieve a certain detachment from the physical quality of the object, to distil and bring forth from amorphousness something simple, limited, fixed, enduring, and universally valid. The neolithic artist wanted a world of forms illustrating not changeable and transient activities and events . . . but rather the relations of people to one another and to the cosmos within an unchanging system. The intention was not to suppress the content of life but to dominate it, to compel it to surrender its physical ascendancy to the power of creative will—to man's drive to manipulate and refashion his world.[7]

These sentences suggest the intervention of some purposive will, some acquisitive impulse, urging the human race to an ever greater control of its material environment. There was undoubtedly a progressive development of skill and technique, and such progress is always inspired by an instinctive desire to dominate the physical universe. But nothing could be more superficial than to suppose that because we can trace a connection between craft patterns and geometrical ornament, we have thereby exhausted the significance of geometrical art in general. We have not explained why man should have been content to abandon the vital image—why he should for centuries hence take refuge in an abstract symbol. We have not explained "man's drive to manipulate and refashion his world"—a phrase which perhaps implies a too-conscious motive in the activities of neolithic man. There must have been some compelling stress, at least comparable in force to the hunting stress which we gave as an explanation of the eidetic accuracy of paleolithic imagery, to cause these artists to express themselves, not in living images, but in hieroglyphic signs.

We know, from survivals of such geometric types of art among aboriginal tribes today, that the emotion which inspires this non-representational tendency is fear—fear of the unknown, fear of events for which they have no causal explanation. We suppose, on the basis of analogous feelings of our own, that neolithic man was afflicted with a cosmic anxiety, a fear of existence or being. Fear breeds secrecy, a desire to communicate in a language that is not understood by the uninitiated—by the hostile forces. Once we assume the need for a secret language of this kind, then particular motifs within the grammar of ornament might acquire symbolic meaning. An angle pointing upwards may be interpreted as an arrow, and, by association, as the death-dealing power of man; an arrow pointing downwards may be identified with the pubic triangle, and, by association, as the life-giving power of woman.

There may have existed a whole magic lore of geometric signs in the Neolithic period, but their interpretation does not belong to the realm of aesthetics. It is the forms as such, evolved to establish, to give fixity to, a new consciousness of reality, that illustrate our theme. For the new consciousness that first appears in this period is

of form itself, form as an imagined and articulated entity, as a product of constructive effort. The forms emerge from the practical activities of neolithic man, and as they emerge are immediately endowed with aesthetic significance: they become symbols for specific feelings. There can be no doubt, as Max Raphael suggests, that the plastic quality of clay, and the intimate reaction to feeling which its manipulation by the fingers permits, were in themselves mainly responsible for the formal discoveries of the Neolithic period. The feeling for form came into human consciousness through the fingers, and what the fingers had feelingly shaped, the eye perceived and approved. The shapes of neolithic pottery are numerous, but they are always elegant, and can be resolved into harmonic proportions. But neither the shapes, nor the geometric patterns which ornament them, can be adequately accounted for by materialistic or technical explanations.[8]

Max Raphael, in the book from which I have already quoted, distinguishes seven distinct features in neolithic geometric style:

synthesis, reflecting the will to create a visual unity out of a multiplicity of elements; *simplicity*, indicating the will to build complex structures from a few elements; *formal necessity*, deriving from the will both to represent and to conceal content in an adequate sign; *detachment*, arising from the will of the artist to raise himself above all content of the inner and outer worlds, the sensual emotions as well as the physical objects; *definiteness*, . bespeaking the will to embody eternal contrasts in self-evident form; *energy*, expressing the will to master by magic that which transcends man's physical powers, even life itself; and, finally, *connection of content and meaning* with two worlds, those of life and death.[9]

This is a prodigious list of qualities to read into a style of art which most people, conditioned to the naturalistic and illustrative types of art of our own civilization, find dry, exiguous, even meaningless. But neolithic design is a type of symbolic language for which we must have the appropriate sensibility. To unmusical people the score of the most beautiful symphony looks dry, exiguous, and meaningless: it lies waiting for interpretation. The comparison is not quite exact, because in music the instrumentalist intervenes, and in the plastic arts we are in immediate contact with the symbol. But once we have exorcized our naturalistic prejudices, then a new scale of aesthetic emotions is revealed, intimately responding to another

plastic language. We then perceive that nothing can be so alive as a design that has hitherto seemed so dead. We are driven to the paradoxical conclusion that vitality, which we found to be the distinctive principle of naturalistic art, is also the distinctive principle of geometric art. But, of course, the motivating energy in one case is organic or animate, in the other case, mechanic or inanimate. We have to use a word like "energy" to express both vital and nonvital movements, but the one word covers two different if analogous phenomena. The distinction, however, is not always easy to sustain. The energy displayed in the decoration of the geometric vase illustrated in Plate 16 is entirely abstract (see also Plate 36): it is a play of mechanical forces, to which no organic interpretation can be given. But again and again in the history of art—and notably in the Byzantine period and in the art of Northern Europe during the first millennium A.D., the linear, geometric ornament takes on a life which we feel to be in some sense as vital as the organic ornament of other periods; and it does, in odd and unobtrusive ways, often break out into naturalistic elements, as when a snake's head suddenly appears in the interlaced ornament of a Celtic manuscript (Plate 17). But before we reach the stage of budding naturalism, the abstract ornament itself, in all its geometric purity, can take on what Worringer has well described as "that uncanny pathos which attaches to the animation of the inorganic."[10]

There is, of course, a nonorganic explanation for such abstract vitality: the designs have a magical significance, and their magical potency endows them with a quasi-vital form. But it would be merely superstitious, on our part, to ascribe aesthetic values to magical forms; magical significance is read into designs which have acquired vitality in virtue of their formal features. It is possible that one of these features, that which Raphael calls "formal necessity," arises from a psychological tension set up by "the will both to represent and to conceal content in an adequate sign."[11] But if so, it was a paradox that could not be sustained. According to Raphael's interpretation of the development of neolithic art in Egypt, the new magic which made use of geometric signs after many centuries failed, and the history of neolithic Egyptian ceramics records this failure. A geometric art, however magical in significance, could not

cope with, among other things, the growing desire for a second life, the lust for immortality. A "syncretistic" style was therefore evolved, embodying some of the elements of the geometric style, but essentially abandoning the abstract geometric symbol in favor of a sympathetic identification with the vital forms of nature. But the artist did not abandon the discoveries of the geometric period; he returned to naturalism immensely reinforced by a consciousness of abstract form that had been acquired in the intervening phase of development. Formal composition had become the distinctive characteristic of a humanistic art.

Let us observe the process of assimilation more closely. The first, and in a sense the most obvious, principle of composition to be discovered had been that of *symmetry*. Man carries its paradigm in his own body; it could be observed objectively in the bodies of animals. Symmetry occurs in paleolithic sculpture, notably in the representation of the human figure, where it was inescapable. But it might be argued that in certain of these statues the symmetry is consciously emphasized; and it has been argued[12] that some of the artifacts of the Paleolithic period, arrowheads and axes, also show a consciousness of symmetry. But there is a difference between the consciousness of symmetry and *the conscious use of* symmetry. In shaping a tool to a sharp point, prehistoric man discovered, presumably by trial and error, that the tool was more efficient if its flanges were symmetrical. But such a discovery remained on the pragmatic level; one cannot speak of a consciousness of *symmetry as such* until the principle is isolated and used on a compositional device. Such a conscious use of symmetry was first made in the Neolithic period, and takes the form of the symmetrical confrontation of animals. The dating of surviving monuments and artifacts from predynastic Egypt, from Sumer, from the Indus valley and farther East is too uncertain to allow us to give priority to any particular example of symmetry. At Hierakonpolis in Upper Egypt there is a mural painting which Raphael describes as the highest artistic. achievement of the New Stone Age,[13] and a detail of the scene depicted perhaps provides a clue to the origins of this formal device. The painting as a whole represents the funeral by water of a man of high rank. The ships of the dead pass in procession, and round them,

on the shores of the river or in imaginary space, incidents are represented some of which may be scenes from the life of the deceased; others no doubt represent funeral ceremonies.

One of these scenes (in the middle foreground) shows a human figure standing upright, between two rampant animals confronting each other. This is the prototype of a whole series of such compositions, beginning in the Neolithic period and coming down to historical times. A striking example is the shell inlay from the royal tomb at Ur, showing four scenes of performing animals (Plate 18). The scene at the top of the plaque is almost identical with the scene on the wall painting at Hierakonpolis. Other examples have been found at Ur and other Sumerian sites, and farther afield we find the Lion Gate at Mycenae, and the figure of the Sword God at Yasilikaya (Asia Minor), belonging to the Hittite period.

A silex knife with a curved ivory handle, now in the Louvre, is another good example of the device (Plate 19). It was found at Gebel-el-Arak in Upper Egypt but is probably of Mesopotamian origin.[14] One side of the handle is carved with a battle scene, and does not concern us at the moment. The other side shows in the centre a hump, which may be a hut, and round it lions attacking domestic animals. Above there is a standing figure with confronted lions, exactly in the same symmetrical arrangement found in the mural painting at Hierakonpolis and in the Ur plaque. The figure is bearded, and has hawklike talons. He may be a magician, and he seems to be engaged, as is the figure at Hierakonpolis, in taming the lions.

The taming of animals must have been one of the earliest and most essential activities of the new sedentary, stock-raising tribes, and no doubt the power of taming animals was a specialized ability belonging to the magicians or priests. The representation of this power, in a work of art, called for faculties of invention or imagination in the artist which were not required by the depiction of animals which had merely to be identified, hunted, and slaughtered. In the first place, it did not suffice to represent merely the figure of the magician and the animal: the ideas of his function and of his power had to be conveyed. These are concepts, not objective phenomena. They can be visually or plastically represented only by conceiving a symbolic

attitude. Talons instead of human feet might indicate a magical rank; but the man's power over the animals must be indicated by placing the animals in an artificial pose, and one which showed their willing submission to his will. We still show our power over a domesticated dog by training it to sit upright on its haunches and beg; the same idea may be present in these depictions of neolithic magicians training lions. Would the idea have been adequately conveyed by depicting the magician with one lion in the ritualistic act of submission? That image, it seems to me, would have been too ambiguously realistic— the lion might have been attacking the magician! The ritual significance of the situation could be conveyed only by duplicating and reversing the images—by avoiding the vital image, by making use of a pattern which was a human creation and could be read as a symbol of man's magical power.[15] But observe what had happened: not only had the wild animals been tamed, but the wild imagination of man himself had been tamed. It had been compelled to surrender the direct, eidetic image of the phenomenal object, and to create in its place a formal composition. Form itself, the abstract notion of it, had been born and had been applied to the representation of natural objects with incalculable consequences for the history of art.

Another object from the Louvre will illustrate a further stage in this evolution of form—a sculptured block of bituminous stone from Susa, perhaps of the third millennium B.C. (Plate 20*a*). Here the confronted figures are human, and the central feature is an animal, perhaps a sacrificial lamb; the center of the slab has been damaged, so it is difficult to give a precise interpretation of the scene. But above the clasped hands of the men we find a second motif: two interlaced serpents—again, perhaps the earliest example of a compositional device that was to have an endless progeny.[16] A more elaborate example of the same motif, a few centuries later in date (Neo-Sumerian period, twenty-fourth century B.C.) is a lamp lid of steatite, also in the Louvre, carved with the same interlacing motif (Plate 20*b*). Again one may seek a symbolic explanation—serpents no doubt had some significance in Sumerian religion. One may also point out that the idea may have been suggested by the natural habit of snakes. But snakes do not normally interlace themselves into symmetrical patterns. Is there any other explanation of the origin of such a device?

It could have arisen only from activities such as basketmaking, or weaving, that induce an archetypal pattern—the consciousness of a pattern as a thing-in-itself—by abstraction from the repeated action of interlacing. A direct formal effect, an effect of aesthetic pleasure, is conveyed by the abstract pattern made by plaited straws; snakes plaited in the same manner convey the same aesthetic pleasure because they repeat the same abstract pattern. It may still be necessary to explain, psychologically, why a plaited pattern induces an aesthetic reaction of pleasure: but it does, and *that* it does was first discovered by Sumerian artists five thousand years ago.

More significant than the aesthetic apprehension of the formal devices of symmetry and interlacement was the achievement of asymmetrical balance in a composition. One might say that there is a certain inherent psychological defect in geometrical art which arises from those features of regularity and exactitude to which geometrical design inevitably tends. The sensitive craftsman is always aware of this danger, and will deliberately introduce irregularities into his repetitive design. But this does not altogether avoid the decreased vitality to which the regular repetition of identical motifs inevitably involves. Vitality is intimately related to a sense of duration; regularity (in the sense of uniform repetition) and exactitude are intellectual (mechanical) concepts, interrupting the organic flow of life. A subtler intuition of the relation of parts to a whole was needed for the maintenance of aesthetic vitality, and this was found in the principle of *balance*. Fundamentally, balance is no more than the achievement of perceptual ease in a formal design; it is the discovery of a *"good"* Gestalt. But it is one thing automatically to register, in vision, a certain order in the phenomenal field, and quite another thing to project such an order by a deliberate act of representation. Let us look at an early prototype of such a balanced design —a limestone plaque (16 inches high) of about 2900 B.C., carved with a representation of the king of Lagash, Ur-Nina, as a builder (Plate 21). The king carries on his head a basket, such as builders would then use, containing the corner brick of the temple he is about to erect. Before him we see his wife and sons (whose names are inscribed upon their garments) and below, in the second register, Ur-Nina is seated, holding a goblet. The relative sizes of the figures are no doubt

dictated by their relative importance, but their disposition, within the two-dimensional frame, is dictated only by the visual sensibility of the artist. It is not necessary to make a geometrical analysis of the composition to perceive that the seated figure of the king is moved nearer to the center to balance the standing figure which occupies an extreme lateral position; note, too, the consequent greater weight given to the cupbearer in the lower register. The disappearance of the queen from the libation scene may have had a ritualistic justification; but she would have been awkward to accommodate in the design. There are several subtler compositional features to observe: the tangential swinging of the details round the hole pierced in the center, giving the composition a swastikalike effect—and the swastika had already been isolated as a geometrical motif; the diagonal division of the surface along a line indicated by the forearms of the king; the whole constituting a close unity of multiple forms.

Such a balanced composition is entirely instinctive; our formal analysis is intellectual, and irrelevant. What is significant, for our present thesis, is the materialization of an aesthetic awareness of balance. Balance, discovered in the course of the evolution of geometrical art, is now instinctively transferred to figurative art, with results that were aesthetically satisfying. The Sumerian artist, in coördinating the images necessary for his narrative purpose in this particular way, *felt* it to be the right way. He would not have got that feeling of satisfaction if, within the given area of his stone slab, he had disposed his figures in an unbalanced order, or reduced them to an insignificant uniformity.

Such *coherent form* is quite distinct from the *integral vitality* of a paleolithic drawing. The consciousness of the paleolithic artist is confined to the eidetic image: it does not shift to take in separate images, and relate them to a common ground. There is a multiplicity or repetition of images, but no over-all unity. The images of paleolithic art are thrown out into boundless space: they are objects focused, within an unfocused context. The Sumerian images are confined within an artificial space—the rectangular space of the slab —and the artist's concentration shifts from the integral object to the area at his disposal, and to the problem of accommodating his images within this given area. Composition is born out of containment, out

of imposed discipline. The vital surrenders to the abstract—the image to the concept. Their union is the prototype of all pictorial composition down the ages: the unity which we now regard as the essential feature of a complex work of art. So far as composition on a two-dimensional plane is concerned, no further development of aesthetic consciousness was necessary or possible—further stages in this evolution involve the consciousness of a third dimension, of space in depth.

We may convincingly give a materialistic origin for such formal devices as symmetry and interlacement; if they are not derived from craftwork by direct imitation, at least the consciousness of these formal patterns was first suggested by the manipulation of the materials used in the crafts. But unity and balance involve a coördination and comparison of forms, and such a synthetic activity must have been a development of consciousness itself, a leap forward into the apprehension of reality. We may assume that it was a mere objectification of the laws of perception, but these laws would not have been illustrated in the forms of art had they not entered into human consciousness as sensible evidence. Symmetry, balance, all the laws of geometrical composition, were first made evident in art; the first science was a notation of the discoveries of the artist; mathematics arose as a meditation on artifacts.

We cannot assume that the laws of composition were discovered by mere accident, that there was in the evolution of art a survival of the fittest, that is to say, of the most pleasing forms. That would be to assume the equally mysterious development of faculties to be pleased by such formal discoveries. Orderly perception, the coherence of vision, that must have been a biological necessity, a strictly evolutionary development, sensorimotor in its functioning. But the perception of order on the intellectual level is a vastly different thing, and the process by which it developed must have been intuitive. Bergson maintained that the artist has no knowledge of things—only of relations. In a work of art, he said, the artist abandons the stream of life, to reconstruct an organic system of relations. What exists is no longer the object, but the object dissolved in a scheme that fixates some of its arbitrary aspects. We have seen that this is not altogether true of prehistoric art and we shall see that it is not altogether true of certain types of modern art. But it is true enough of the composi-

tion—the very word suggests an assembly of parts. For centuries of aesthetic development the composition was to be the essence of the work of art: art was conceived as a process of composition. But the composition, with its laws of harmony and proportion, its unity and serenity—what is it but the paradigm of that intellectual ideal which the Greeks were to call *to kalon*, and which we call beauty. What in the course of the Neolithic period had been born was therefore the first consciousness of beauty. It is the second great principle in art, the first being vitality, established in the Paleolithic period.

These distinct principles of beauty and vitality might perhaps be identified with those two opposed forces which Nietzsche, in *The Birth of Tragedy*, saw as underlying the development of Greek art. Undoubtedly the principle of beauty, as we have described it, tallies with Nietzsche's Apollinian force, which he always conceived as an achievement of harmony and proportion, as "the form-giving force which reached its culmination in Greek sculpture." But Nietzsche's opposed force, which he called Dionysian, is conceived as a blind will, a fever, a frenzy, and is too negative for our own philosophy of art. It is true that Nietzsche occasionally seems to identify his Dionysian energy with the life force; it is true that he also sees that Greek art, in its highest reaches, is in some sense a synthesis. But the taming of a wild force—and his Dionysian energy was always envisaged as wild and destructive—is not a true synthesis. In a true synthesis the two opposed forces must be equal, and they must be reconciled in a unity which is greater than either. Vitality, like beauty, is self-sufficient as an aesthetic principle. This Nietzsche did not realize, and for this reason his otherwise immensely suggestive interpretation of the Greek genius is lacking in balance and truth.

Other principles were awaiting discovery in the far future of historical times; but for many centuries the human spirit was able to express its consciousness of reality with these two aesthetic modes of sensibility, vitality and beauty. Man was, of course, to use these creative principles to express a great variety of feelings and conceptions, and at times, as in later Greek art, the artist seems to be growing restless and dissatisfied with his means of expression—feeling round the walls of his limitations, to adopt a fine metaphor of the great medievalist, W. R. Lethaby, "like a swallow in a barn." Beauty has

never been deposed as the mode in which man expresses those intuitions of form that lift his being out of our environing chaos and casualness. But the serenity thus achieved was not enough—there always remained a nagging sense of the numinous, of a world beyond the world of immediate sensation, some transcendental realm. To bring that realm within the scope of human consciousness—such was to be the next adventure.

III

SYMBOLS FOR THE UNKNOWN

BEFORE entering on the next stage of our inquiry, I would like to emphasize once more that art, in my sense of the term, must in no way be conceived as merely secondary or instrumental in the history of culture. One of the greatest of modern art historians, Max Dvořák, used the phrase "Kunstgeschichte als Geistesgeschichte" as the title of one of his books: the history of art conceived as the history of spiritual or intellectual development. My own conception of the process is precisely the reverse of this: Geistesgeschichte als Kunstgeschichte, the history of mind or intellect as the history of artistic development. It is only in so far as the artist establishes symbols for the representation of reality that mind, as a structure of thought, can take shape. The artist establishes these symbols by becoming conscious of new aspects of reality, and by representing his consciousness of these new aspects of reality in plastic or poetic images.

We are trying to reconstruct certain decisive stages in the aesthetic apprehension of reality. Our success will depend on maintaining a feeling of process, of organic activity. That process is essentially biological—it is a coördination of all human faculties vis-à-vis the totality of the universe experienced through the senses. My contention has been that this existential position is expressed primarily in symbols that are articulated by the senses—plastic images, significant signs—and that various forms of discourse follow, forms of discourse which depend on the successful articulation of such primary symbols. It follows that any extension of awareness of reality, any groping beyond the threshold of present knowledge, must first establish its sensuous imagery. Nowhere is this more evident than in the transition from magic to religion.

The distinction between magic and religion, and the stages of human development which led to the making of those distinctions, were first logically established by Sir James Frazer in a famous chapter of *The Golden Bough*. Our understanding of both magic and religion may have deepened since Frazer's time, but his main distinction remains useful. Religion is "a propitiation or conciliation of powers superior to man which are believed to direct or control the course of nature and of human life. Thus defined, religion consists of two elements, a theoretical and a practical, namely a belief in powers higher than man and an attempt to propitiate or please them."[1] Thus defined, religion "stands in fundamental antagonism to magic as well as to science, both of which take for granted that the course of nature is determined, not by the passions or caprice of personal beings, but by the operation of immutable laws acting mechanically. In magic . . . the assumption is only implicit, but in science it is explicit."[2]

It used to be supposed that magic preceded religion in the history of humanity—that "ancient magic was the very foundation of religion."[3] Frazer regarded this as an evident truth, for, he says:

we have seen that on the one hand magic is nothing but a mistaken application of the very simplest and most elementary processes of the mind, namely the association of ideas by virtue of resemblance or contiguity; and that on the other hand religion assumes the operation of conscious or personal agents, superior to man, behind the visible screen of nature. Obviously the conception of personal agents is more complex than a simple recognition of the similarity or contiguity of ideas; and a theory which assumes that the course of nature is determined by conscious agents is more abstruse and recondite, and requires for its apprehension a far higher degree of intelligence and reflection than the view that things succeed each other simply by reason of their contiguity or resemblance.[4]

Obviously! But how was the transition made? To pass from the *perception* of discrete phenomena, of objects that have a spatial or sequential relationship, to the *conception* of invisible agents manipulating these objects according to some cosmic plan, is an advance in human intelligence, in sheer mental capability, for which we must have some convincing explanation. The birth of a metaphysical faculty is involved.

Frazer's own explanation is typical of the rationalistic tradition within which he worked:

With all due diffidence, I would suggest that a tardy recognition of the inherent falsehood and barrenness of magic set the more thoughtful part of mankind to cast about for a truer theory of Nature and a more fruitful method of turning her resources to account. The shrewder intelligences must in time have come to perceive that magical ceremonies and incantations did not really effect the results that they were designed to produce, and which the majority of their fellows still believed that they did actually produce. This great discovery of the inefficacy of magic must have wrought a radical, though probably a slow, revolution in the minds of those who had the sagacity to make it. . . . It was a confession of human ignorance and weakness.[5]

So we have to imagine a "primitive philosopher," a "philosophical radical" as Frazer actually calls him, a sort of prehistoric Benthamite, from whose eyes "the old scales had fallen," a man "sadly perplexed and agitated till he came to rest, as in a quiet haven after a tempestuous voyage, in a new system of faith and practice." The first "failure of nerve"—magic was abandoned as, centuries later, the nascent science of Greece was to be abandoned, and man laid his weary doubts in the bosom of unseen powers, other beings, "like himself but far stronger," who directed the course of the world and "brought about all the varied series of events which he had hitherto believed to be dependent on his own magic."

But exactly how, let us ask, did this theoretical doubter come into being? By what process of experience or training did one part of the human race become shrewder than the rest? Was intelligence an evolutionary mutation? Attention, concentration—these are the faculties by means of which a process of theoretical thought becomes possible. What, then, inculcated a habit of attention, a power of concentration?

To such questions Frazer, and anthropologists generally, provide no answer. A suggestion of an answer which we shall find in consonance with the function which I am ascribing to art in these lectures will be found in two short books written about the same time and in close association: Gilbert Murray's *Four Stages of Greek Religion*, originally delivered as lectures at Columbia University in

1912,[6] and Jane Harrison's *Ancient Art and Ritual*, written in 1913.

Gilbert Murray refers to the concept of *mana*, "that primitive word which comprises force, vitality, prestige, holiness, and power of magic, and which may belong equally to a lion, a chief, a medicine man, or a battle-axe,"[7] and he suggests, following Robertson Smith,[8] that this vital power, originally ascribed to magical animals such as the bull, was absorbed or transformed to human beings in a sacramental feast." You devoured the holy animal to get its *mana*, its swiftness, its strength, its great endurance, just as the savage now will eat his enemy's brain or heart or hands to get some particular quality residing there."[9] But we are still in a world of magic and the question till remains: how did primitive man make the transition from the real animal with its *mana* to the superhuman god?

Gilbert Murray then points to those early representations of men wearing the head or skin of a holy beast (Plates 22, 24). He is thinking of the Egyptian gods depicted as men with beasts' heads and of Minos and the Minotaur, of Athena with an owl's head and of Heracles in a lion's skin; and since Murray wrote his book we have found the same ambiguous figure even in prehistoric art—the human figure at Lascaux has a birdlike head (Plate 23). Murray sees in such a man-beast the original *theos*, "the incarnate medicine or spell or magic power," who subsequently became differentiated, the visible part becoming merely human, the supposed supernatural part becoming what we should call a god. To explain how this differentiation came about Murray adopts the same theory as Frazer: the medicine man was bound to have his failures, but the failures were ascribed to the medicine man as man, as a mere man who has momentarily lost contact with the god inhabiting him. The god thus becomes detachable, is conceived separately, and retreats into the mountains or the clouds.

One might say that the path from the divine beast to the anthropomorphic god was trod in ritualistic dance. These mixed figures, often represented as dancing, were generated in the emotional stress of the religious dance—both Gilbert Murray and Jane Harrison quote plenty of evidence for this supposition—and "this spirit of the dance," Murray suggests,

who leads it or personifies its emotion, stands more clearly perhaps than any other daemon half-way between earth and heaven. A number of difficult passages in Euripides' *Bacchae* and other Dionysiac literature find their explanations when we realize how the god is in part merely identified with the inspired chief dancer, in part he is the intangible projected incarnation of the emotion of the dance.[10]

Jane Harrison develops this theory and shows how

at the bottom of art, as its motive power and mainspring, lies not the wish to copy Nature or even improve on her . . . but rather an impulse shared by art with ritual, the desire, that is, to utter, to give out a strongly felt emotion or desire by representing, by making or doing or enriching the object or act desired. . . . This common *emotional* factor it is that makes art and ritual in their beginnings well-nigh indistinguishable.[11]

Thus far the theory is acceptable as a generalization, as a description of a process that was throughout integral: art and ritual developing together, undifferentiated. But later in her book Jane Harrison breaks up this integral process into evolutionary stages and in this manner life flows out of the art, and the art out of the ritual.

"The god arises from the rite," she says, truly enough;

he is gradually detached from the rite, and as soon as he gets a life and being of his own, apart from the rite, he is a first stage in art, a work of art existing in the mind, gradually detached from even the faded action of ritual, and later to be the model of the actual work of art, the copy in stone.

The stages, it would seem, are: actual life with its motor reactions, the ritual copy of life, with its faded reactions, the image of the god projected by the rite and, last, the copy of that image, the work of art.[12]

But no! First was actual life with its motor reactions—agreed. Then arose a unity: the *dromenon*, the deed done, and this deed was either a dance, which is a pattern of movement, or a painting or a carved figure, which are patterns of perception, and the life of the ritual was identical with the life of these patterns.[13] The image of the god was not "projected by the rite"; the rite was the image, and the image was both work of art and god. Only after centuries of development did that dissociation of action and sensibility take place which led to the rationalization of religion and the intellectualization of art.

I will presently try to make this distinction clear by reference to specific works of art, for the *words* I have used, and that others use, are quite inadequate to describe the realities we experience as art and as ritual. Let us remind ourselves that most of our words were invented for other purposes in later civilizations, and to equate certain incarnations of emotion which took place in other far-distant ages with the expressions of a subjective egoism is certainly illogical. We use the expression, "work of art," for a wide variety of *dromena*, "things done" from a wide variety of motives, most of which are emotional, and most of which can be reduced to measurable vibrations.[14] There is a common factor which permits us to use the same terminology for a ritualistic dance, a realistic representation of a natural object, a plastic symbol for a state of feeling, and a plastic symbol for an unconscious desire. All this is part of the aesthetic tangle which we are trying to unravel. We card and spin by means of generalizations that are deceptive because they necessarily make use of an inadequate and confusing terminology.

What I now wish to suggest is that a sense of the numinous arose not from any process of discrimination, but from the power of creation which man discovered in himself. Magic is based on a logic of invariables—a bull is a bull and man has only to act in a certain way and the bull will inevitably fall into his trap and be killed. But religion has quite a different logic; for if religion involves, as Frazer says,

first, a belief in superhuman beings who rule the world and, second, an attempt to win their favours, it clearly assumes that the course of Nature is to some extent elastic or variable, and that we can persuade or induce the mighty beings who control it to deflect, for our benefit, the current of events from the channel in which they flow. Now, this implied elasticity or variability of Nature is directly opposed to the principles of magic as well as of science, both of which assume that the processes of Nature are rigid and invariable in their operation, and that they can as little be turned from their course by persuasion and entreaty as by threats and intimidation.[15]

But man would never have reached that notion of variability by the contemplation of natural objects or natural events. Why should he, within the scheme of nature, depart from his magical explanation of

thunder, or of disaster, or of death? But the first time that he made with his own hands an object which he could credibly endow with an invisible presence, he himself was contradicting the scientific logic of his magical world, escaping from "the operation of immutable laws acting mechanically". The paleolithic goddess of fertility had been a scientific representation of a pregnant woman, part of the visible order of creation; but a neolithic symbol of fertility may only with difficulty be identified as part of the visible order of creation (Plate 25). It has been abstracted from the natural order and given a form and a being that is arbitrary—that is arbitrary because it is a human creation. The neolithic artist might be asserting no more than his own caprice, but caprice was precisely the first attribute to be ascribed to a superhuman deity. We might say, how could man ever have conceived a god if he had not first discovered a godlike creativity in himself?

The real crux of the question is not the creation or incarnation of a god—a god could be identified with a monument or a graven image. The decisive step forward was, as Frazer and Murray suggest, the disincarnation, the dematerialization of the god—the creation of a spirit and a power with real but unseen existence. In one word, what distinguishes religion from magic is the notion of *transcendence*, of the being beyond the threshold of experience, the notion of the numinous. But this growing awareness of the numinous, I am now going to suggest, could only develop concurrently with a growing awareness of *space*—of space first as an indefinite and then as an infinite continuum. Before the gods could be conceived as invisible but conscious agents in human life, a space had to be conceived to which they could be relegated. The whole notion of transcendence, which reaches its purest form in the scholasticism of the Middle Ages, is conditioned step by step by the aesthetic awareness of space— *Raumgefühl*, as the Germans call it.[16]

We must first recognize, however, that the progressive awareness of spatial relations, both in the human race and in the child, takes place on two quite distinct levels, which the psychologists distinguish as the *perceptual* or *sensorimotor* level, and the *representational* or *intellectual* level. There is a *sense* of space, and an *idea* of space, and they have quite distinct origins. It is commonly assumed that

representational space is merely a registering of perceptual space, but in reality, as Piaget has made clear in his studies of the development of space consciousness in children,[17] the sensorimotor awareness of spatial relations is a separate and genetically earlier stage of development. From the very beginnings of existence this sensational awareness is linked with the progress of both perception and motor activity, and undergoes considerable development before speech and image representation make their simultaneous appearance. Then, on the basis of this symbolic activity and of intuitive thought generally, a representational structurization of space becomes possible. This method of space construction proceeds quite independently on the intellectual level, giving rise to those systems of perspective which at a later stage of human development were to play such havoc with the sensory foundations of art.[18]

No structural notion of spatial relations exists in magical art, only a topological sense of contiguity, an enumeration of things on a two-dimensional plane. A perceptual sense of space on the sensorimotor level there must have been; even animals may be presumed to possess this. But a development of imagination (the capacity to retain images) and of a symbolic logic to elaborate and combine these images was necessary to enable man to conceive and represent space on the intellectual level, abstract space. This development could only have come about by a growing awareness of the discrete elements involved in the creation of complex symbols, and of the position and relation of these discrete elements in a space separately and intellectually conceived.

I have already noted that there are art historians who would discover spatial representation in prehistoric art. I think they are making the confusion between perceptual space at the sensorimotor level and representational space at the intellectual level. In depicting a hunting scene prehistoric man was enumerating the objects in his consciousness topologically; he was separating them as images. The same topological sense continues to develop throughout the Neolithic period, and it is only gradually, and more particularly in relation to the craft of building, that a consciousness of space as such becomes evident in any of the early civilizations. Even a temple can be built as an imposing mass and express no awareness of a contained space.

The Egyptian and Greek temples are monolithic in origin, solid structures hiding an altar or an image of the god, but with no suggestion of the numinous, of infinity. As for Egyptian and Greek sculpture, that too remains clamped to the surface, striving to conform to a strictly two-dimensional plane of reference.

We know too little of Greek painting to generalize about space consciousness in that art, but a survey of the painted pottery, on its best level a subtle and delicate art, suggests that though the artist may have been aware of theories of perspective developed by the mathematicians, and may even have made systematic use of a vanishing point, we must still affirm that this purely theoretic and synthetic conception of space is not an awareness of space as such, space as a sensational experience to be plastically realized (Plate 26).

This limitation of Greek sensibility had compensations in other directions which I shall come to later. The Greek was incapable of transcendentalism, but invented idealism, that very different range of consciousness. The transcendentalism I am now going to discuss had quite a separate development, associated with the invention of the dome and the vault—a development that was to reach its limit in Gothic art. But before we deal with this combined development of space consciousness and transcendental consciousness, let us glance towards the Far East for another illuminating contrast.

The cultural divergence of East and West has always been most obvious in two realms—the spiritual and the artistic.[19] In the Near East and the West, the transcendental consciousness represented by the Christian religion; in the Far East, the monism represented by Indian and Chinese religion, based on a belief in the ultimate identity of God and Man. But, also, in the Near East and the West, the infinite space consciousness developed by Byzantine and Gothic art; and in the East, conventions which indicate a strictly limited consciousness of space.

The Chinese attitude to space has been clearly described by George Rowley in his *Principles of Chinese Painting*. Professor Rowley points out that the sense of infinitude in Chinese landscape painting (Plate 27) is achieved only by sacrificing the visible tangibility of space, by which I think he means what I have called representational space. Our Western notion of perspective depends on the representation of

a continuous receding ground plane on which all the vertical elements rest, diminishing in size according to their distance from the spectator. The sensibility of the Chinese painter, however, was satisfied with three discontinuous planes, foreground, middle distance, and far distance, each parallel to the picture plane. The eye of the spectator is required to leap from one plane to the next, through a void. Each place is a place of rest—of arrest. A similar convention exists in early European painting, but the Chinese discovered such artistic potentialities in this principle of discontinuity that even when in later times they became familiar with European principles of continuous perspective, they still preferred a convention which to them was more satisfying.[20]

Professor Rowley's observations are confined to the art of painting; from the point of view of the present discussion, the contrast would be even more striking in the art of architecture. The most obvious feature of Chinese architecture is perhaps its impermanence. Apart from military fortresses, it was not built to last; it was either economically utilitarian, or merely decorative. The pagoda and the pavilion are the typical forms, and they are conceived for human enjoyment, as part of the cultivated landscape or environment—in any case, to be apprehended externally, as plastic structures, not experienced as spatial volumes. There is no need to point to the obvious contrast of the Christian basilica, conceived as a dwelling place of the Holy Spirit, and gradually elaborated internally into that symphonic spatial structure, the Byzantine or Gothic cathedral (Plate 32).

These contrasts between the East and the West in painting and architecture are patent. But it would be a superficial interpretation to see in them merely a reflection of prevailing modes of thought. It is fantastic to suppose, for example, that from the tenth to the thirteenth century (the Sung period) there prevailed in China a coherent philosophy of life which was then "expressed," as we say, in the architecture, sculpture, painting, and ceramics of the time. It was, ideologically considered, a period of intellectual confusion, of spiritual conflict (Buddhism against Taoism), of rebellion and invasions, of the growth of superstition and obscurantism. "Old systems of magic," writes one historian,

subtle philosophies were sought out; the dim ages before the Han were seen as the Golden Age of all virtues and all the great secrets. Thus, it was a twofold stream, of philosophical withdrawal and of love for the past, which found expression in a poetical and dreamy delicacy or refinement beyond compare; the poems were pictures, and the pictures poems. All the most elusive emotions in Nature and thought strove to materialize in the work of this time, but always with an archaic setting. . . . Delicacy in form and treatment, a light freshness in the colouring, harmony along with gracefulness, a dreamy inspiration, transparent mists, moonlight, suggestion but not ornament—these are the characteristic features of the Sung style.[21]

This excellent description of the art of the period, by the French art historian, Soulié de Morant, is typically careless in that at one moment it speaks of philosophical ideas "finding expression" in art, and at another moment of elusive emotions "striving to materialize." There is a confusion here which goes to the root of my argument. The Sung style, for all its archaicism and eclecticism, is one of the most definite and unified styles in the history of art, comparable to the Gothic style. The Gothic style, it has been said,[22] presents a unified appearance because it is a reflection of the great philosophical synthesis represented by medieval scholasticism. I shall presently query the formulation of even that idea, but certainly the Sung style has no similar foundation;[23] its unity is independent of philosophy and of religion; there is no accompanying social or intellectual cohesion of any kind.[24] But there is a unity with nature, with the physical world. Sung painting, like Sung poetry, is the expression of a growing consciousness of the subtlety of the formal harmonies that lie before our eyes: the interplay of mountains and mists, of rivers and trees, of birds and branches, of flowers and geometry, of the male and the female, the Ying and the Yang, as these opposed but complementary principles were called. Ideas might creep into this formal dialectic, when the forms permitted; but the art did not strive to express ideas: it was the plastic materialization of a state of intense pantheistic awareness. Throughout the Sung civilization, the Sung sensibility was becoming aware of new intimations of reality, which were also, in the Wordsworthian sense, new intimations of immortality.

This sense of "place," which we also find in the Greek notion of "ethos," leads to a natural philosophy which, in its more concentrated and meditative moments, may become mystical, though I doubt whether either Taoism or Zen Buddhism, which are the spiritual disciplines most in question, are ever mystical in the Western sense of the word. For them the spirit is immanent: mind and matter are "interfused," as Wordsworth used to say; there is "splendour in the grass" and "glory in the flower." But mysticism in the true meaning of the word demands a separation of spirit and matter; spirit, transcending matter, is placed in a realm beyond our normal experience, and is reached by a special faculty, the *intuitus* of the Scholastics. Communication with this realm is only obtained in a state of grace, and by supernatural agencies. We may symbolize such agencies, as when we give haloes to saints or wings to angels, but only to emphasize the feeling of distance, the sense of separation.

Once space began to be experienced, not as a complex of "places," a continuum in which each object had its relative position, but as a thing-in-itself, an immaterial emptiness of infinite extension, then the way was open to the creation of a transcendental religion. Not only could the gods be relegated to a heaven, which might be merely a convenience, as the ethical Greeks discovered; but also the vastness itself, the all-enveloping Nothingness, Jasper's "Umgreifende," became a cause of wonder, of awe, and of anxiety. These emotions on the brink of limitless space crystallized into the concept of the Absolute, but the process of crystallization is aesthetic; the concept is read into the realized symbol.

It is not our present business to speculate on the course of that development. What I am concerned to establish as a reasonable hypothesis is that a sensibility for space-as-such could only have developed in mankind as a result of his creative activities. Space consciousness was a by-product of the compelling need for "realization"—that is to say, for the plastic materialization of insight, of numinous awareness, of what might be called "Gestalt-free" perception.[25] But what, in this productive process, determined that bifurcation in human development which leads on the one hand to an ethical immanence, a *place* sensibility, and on the other hand to a religious transcendence, a *space* sensibility?[26]

The usual, the materialistic, explanation finds the determining factors in climate. Transcendental art is, in Europe, the art of the North; and in the evolution of Early Christian art one can observe the obvious transformation of a classical art, evolved in a temperate climate, as it moves northward into regions where the indigenous art had been determined by much more rigorous climatic conditions. It is Worringer's theory of the conflicting trends of empathy and abstraction: the reaction of the human sensibility to favorable or unfavorable environments. All the stylistic vagaries of art history can be interpreted by means of physical and psychological laws of development. But the origin of the symbols adopted to express each particular mode of sensibility remains a mystery.

Worringer's "fundamental proposition"—that what is achieved in art represents the fulfillment of what was desired—is true in the sense that what man always desires is a firmer grasp of reality. That is a direct consequence of his insecure existence, his cosmic anxiety. Art, as the primary process of definition, provides the essential language for this affirmation of being. But I have grown a little suspicious of the tendency, typical of German art historians, to see every phase of art as the expression of a specific act of will. Artistic volition, or "the will to art," is difficult to grasp as a psychological entity. It is true that in late phases of civilization a desire to be artistic, or, individually, to be an artist, does exist, but by that time art is already decadent. In its origins art is not a distinct species of volition: it is the evolving consciousness itself, the mastering of reality itself by sensuous perception. We must assume that this desire for a firmer grasp of reality is implicit in the nature of Being.

Space was discovered in this process of "realization"; space became an entity of consciousness, a thing-in-itself. Man strove to represent this entity, to materialize it. How he did it, in the earliest stages of sapience, we do not know, but it was no doubt a very gradual process, and many experiences, of cave life, of forest life, of movement and of meditation, of shelter and sanctuary, must have contributed to the formation of the space sensation, of space perception. But the process was genetic: it was a parallel evolution of perception and representation, and its final artistic achievement was to be spatial constructions like the dome and the vault, and eventually the infinite

orchestration of these elements in the Gothic cathedral[27] (Plates 31, 32). But long before space had in this manner been enveloped as architecture, it had existed in human consciousness as a bodiless mystery of which man was aware, but which he could not conceive. It was not a tangible place in which a familiar spirit could have existence; it was a nothingness out of which all imaginable powers could emerge. Some of these powers might be beneficent, others destructive, but all alike had to be propitiated. The work of art became an act of containment and of propitiation.

It is now generally accepted that those elements which enabled Christian architecture to develop its consciousness of space—the dome and the vault—were first evolved in Asia Minor, and a correlation has still to be made between the lost architectural monuments of Mesopotamia and Persia, and the equally unfamiliar religious beliefs of those regions. Transcendentalism as such—the correlation of deity and infinity—had its origins in this mythical Garden of Eden, and spread eastward to India and westward to Syria, Palestine, and Egypt, the fertile seedbeds of Christian gnosticism and mysticism.

The dating of the early Christian churches of Syria and Palestine is still in dispute, but enough archaeological research has now been done on the ruins of these churches to establish the fact that it was in these regions that the dome was first developed as a significant feature of Christian church architecture, and from the first a specific symbolic significance was attached to it. This symbolism was not introduced by the early Christians; it was inherited from remotest times, for the dome was probably the earliest form of roof—the natural means adopted to cover a round pit or stockade. We have once more to try to project ourselves into the mentality of prehistoric man, of man in his prelogical state, for whom thunder and lightning, rain and sunshine, the stars and all other cosmical events, were precipitated from the roof of the sky—a solid integument stretched like a tent above him. To such a man the roof he constructed—the tent of skins, the dome of mud or thatch—became the symbol of this superior dome of the sky, and was invested with mysterious forces that descended from the sky. Man constructed a round roof—a *domus*—his shelter against the elements; and it is significant that the Christians took over this word for the human

house, *domus*, and used it for the house of God—the Italian *duomo*, the German *Dom*.

The first domes—in the modern architectural sense of the word— were of wood, and these had developed from roofs of pliable materials, arched over the round hut. The wooden prototype was afterwards imitated in masonry, to make a securer shelter, to provide a wider span. It is now known that the priority in these inventions belongs to the Sumerian civilization, and that the essential features were already established in the fourth millennium B.C.[28] The whole of this development has been traced in fascinating detail by Professor E. Baldwin Smith in his book on *The Dome* (which incidentally is sub-titled "A Study in the History of *Ideas*"). In this treatise I was delighted to find a direct confirmation of the underlying thesis of these lectures, namely, that first there was a shape or an image, then an idea. But let me quote Professor Smith's own words:

Behind the concepts involved in domical development was the natural and persistent instinct to think in terms of customary memory images and to attribute actual being and inner power to inanimate objects, such as the roof and other parts of the house. To the naïve eye of men un-interested in construction, the dome, it must be realized, was first of all a *shape* and then an *idea*. As a shape (which antedated the beginnings of masonry construction), it was the memorable feature of an ancient ancestral house. It is still a shape visualized and described by such terms as *hemisphere, beehive, onion, melon*, and *bulbous*. In ancient times it was thought of as a *tholos, pine cone, omphalos, helmet, tegurium, kubba, kalubé, maphalia, vihâra, parasol, amalaka tree, cosmic egg*, and *heavenly bowl*. While the modern terms are purely descriptive, the ancient imagery both preserved some memory of the origin of the domical shape and conveyed something of the ancestral beliefs and supernatural meanings associated with its form.[29]

As always, the further development of the primitive domical roof would have been dialectical—first the shape, then the idea, then the extension or elaboration of the shape to accommodate the imagina-tive growth of the idea. As the shape developed (for constructive reasons) so symbolic values accrued to it. The dome acquired its cosmical significance: it became the very vault of Heaven, inhabited by Christ and his saints (Plate 33). To quote Professor Smith again:

By the fourth century the widespread popularity of these ideas and the belief that the domical shape was a heavenly shelter, going back to an ancient and ancestral past when the gods and men lived together in an idyllic paradise on earth, gave the dome, especially in Syria and Palestine, its growing appeal to the Christians, with their Cult of the Dead, their Veneration for the Martyred Dead, and their desire for some tangible proof of a heavenly Domus.[30]

We need not trace the slow steps—the technical inventions—by means of which the architects of the first Christian millennium were able to lift the dome above the rectangular basilica (Plate 28) with perfect transitional grace and thus gradually articulate a space of infinite significance. The dome, as we now say, "floats" above the nave, transept, or choir of the church; the mind of the worshiper floats there, too, seeking union with God[31] (Plate 31).

So long as the early development of Christian art was confined by historians to the Roman catacombs, we are confronted by the paradox of a transcendental religion grafted on to the decadent stock of a pagan art. Dvořák[32] was the first to show that this art of the catacombs was anything but decadent. It seems artless only so long as it is measured by the standards of pagan classical art, which were realistic and materialistic. The new paintings in reality were exploring new areas of sensibility, precisely those areas of mystery and infiniteness which, in a more favorable economic environment, were being enclosed by dome and vault. A new symbolism made concrete the obscure longings and vague intuitions of a new mysticism; and round the symbols and their ritual usage a new religion took definite shape.

It would, of course, be misleading to suggest that the sense of infinitude first came into existence with Christian architecture, or that the dome was necessarily the first tangible image of transcendental feeling. The first temples, the first *monumental* buildings of any kind, were the ziggurats of Mesopotamia. Professor Henri Frankfort, in his lectures on *The Birth of Civilization in the Near East*, has observed that

the significance of the ziggurats is revealed by the names which many of them bear, names which identify them as mountains. That of the god Enlil at Nippur, for example, was called "House of the Mountain,

Mountain of the Storm, Bond between Heaven and Earth." Now "mountain," as used in Mesopotamia, is a term so heavily charged with religious significance that a simple translation does it as little justice as it would to the word "Cross" in Christian . . . usage. In Mesopotamia the "mountain" is the place where the mysterious potency of the earth, and hence of all natural life, is concentrated.

And Professor Frankfort adds in a footnote:

It is sometimes said that the Sumerians, descending from a mountainous region, desired to continue the worship of their gods on "High Places" and therefore proceeded to construct them in the plain. The point is why they considered "High Places" appropriate, especially since the gods worshiped there were not sky gods only but also, and predominantly, chthonic gods. Our interpretation takes its starting point from "the mountain," not as a geographical feature but as a phenomenon charged with religious meaning.[33]

This interpretation suits my purpose admirably, especially if we assume that the mountain *had* "religious meaning," and was not "charged" with it by some separate agency. The deities that were worshiped in these first temples were, as Professor Frankfort states, personifications of "chthonic forces," and these forces had their origin and were active in the mountains. "Thus the mountain is essentially the mysterious source of a superhuman activity or power. The Sumerians created the conditions under which communication with this power became possible when they erected these artificial mountains as their temples." The "bond between Heaven and Earth" thus materialized in visible form was accepted as a symbol of the infinite distance between Heaven and Earth; the concept of infinity was thus first realized. It has remained the animating principle of all religious architecture, in every civilization in which such a concept created a feeling of awe. For the Indian-Greek monist religions, however, the heavenward-pointing mountain was never a significant symbol, and for them the aspiring arch and dome had no appeal. Different symbols were accompanied by a different kind of sensibility, a sensuous appreciation of the limited, the measured, and the contained.[34]

The Greeks always sought to contain space, to reduce it to a

rational formula. "Time and space," Professor Morey has observed, "to us the symbols of infinity, were barred by true classic style, sometimes by means of subtle niceties of composition, more often by obvious arrangement. In classic relief the terminal figures ordinarily turn inward toward the center, avoiding suggestion of continuity to right or left; extension in depth is likewise canceled by a neutral background." And Morey proceeds to quote Aristotle's dictum: "Evil is a form of the unlimited, and good of the limited."[35] But the material fact on which Aristotle based his dictum was the positive inability of the Greek artist to represent infinity, to create a plastic symbol of infinite space. Parmenides' principle, which Professor Morey also quotes in order to reverse its meaning, exactly expresses the Greek position: "What is not, is unthinkable."[36] It is, in a positive sense, the principle underlying the thesis of these lectures: what has not first been created by the artist, is unthinkable by the philosopher.

When the Christian architects of Asia Minor first began to over-step the Greek limits in order to extend the concrete consciousness of space by means of daring structures of dome and vault, they were developing an independent tradition—the tradition of the Near and Middle East. In the process the eyes of mankind were lifted from the "earthly sphere of the ground plan" to "the image of the changeless and perpetual world set over against it" in the vaults. I take these phrases from a study of monumental art in Byzantium by Otto Demus, who further says:

Byzantine architecture is essentially a "hanging" architecture; its vaults depend from above without any weight of their own. The columns are conceived aesthetically, not as supporting elements, but as descending tentacles or hanging roots. They lack all that would make them appear to support an appropriate weight: they have no entasis, no crenellations, no fluting, no socles; neither does the shape of the capitals suggest the function of support. This impression is not confined to the modern beholder: it is quite clearly formulated in contemporary Byzantine *ekphraseis*.[37] The architectonic conception of a building developing downwards is in complete accord with the hierarchical way of thought manifested in every sphere of Byzantine life, from the political to the religious, as it is to be met with in the hierarchic conception of the series of images descending from the supreme archetype.[38]

But the images came first, giving birth to the hierarchic concep-
tion. The Byzantine church is, as Demus says, "the 'picture space' of
the icons"—it is itself an icon "giving reality to the conception of the
divine world order." But I would rather say, a plastic reality from
which an intuition of the nature of the divine world order was
derived, for a conception is already conscious, and there was no clear
consciousness of any order, divine or human, until the artist had
made it actual in his icons.

There is, of course, in the whole process I have been describing, a
dialectical give and take. To the visual thesis of the artist defining
space, corresponds the conceptual antithesis of the philosopher or the
theologian filling this space with a god; religion is the synthesis, and
in due course a new phase of art develops from this position of
achievement. But man's first instinctive response to any challenge
from across the threshold of knowledge, from the numinous void,
is to strive to make it evident to the senses, visibly and haptically.
To *realize*: that is the literal sense, the *primitive* sense, of the artistic
process. From this point of view many of the phrases we instinctively
use in writing the history of art have to be reversed. I take, as
examples which are immediately at hand, some sentences from
Morey's *Mediaeval Art*.[39] "Christianity," he writes, "was the leaven
that wrought this orientalizing of the antique." Should he not rather
say that the orientalizing of the antique made possible the transcen-
dental notions of Christianity: not necessarily directly inspired them,
but created the symbols of an imaginative discourse? Again, when
Morey says that "the color scheme of Hellenistic painting, as we see
it on the walls of Pompeii, was extrovert and lively, delighting in
strong contrasts, and even sometimes garish in its tones; as the
emotions generated by Christian transcendental content deepen, the
tones also deepen, until in Byzantine art the observer is conscious of
an appropriate color accompaniment to the sacred theme, a sonorous
and thoughtful harmony of blue, green, purple, and gold, with lesser
lighter notes of violet and white," should we not rather say that it
was the sonorous and thoughtful harmony that inspired the sacred
theme, that it was the very depth of the emotions generated by the
art that made the transcendental content of Christianity conceivable?
When, therefore, we speak of the Gothic cathedral as a concrete

illustration of the scholastic synthesis, "the *Summa* of Thomas Aquinas in stone,"[40] we must remember that when St. Thomas was still a student in Paris, Notre Dame had already risen in its synthetic glory, its logical splendor. Panofsky avoids this metaphor; he prefers to speak of a "synchronous development" of Gothic architecture and Scholasticism; "parallelism" is also a word that has been used. Panofsky says that "early Scholasticism was born *at the same moment* and in the same environment in which Early Gothic architecture was born in Suger's Saint-Denis."[41] We can perhaps accept the notion of synchronicity without abandoning our thesis if it is recognized that a plastic realization of the underlying metaphysical concepts was essential to the Medieval synthesis.

Morey has an excellent phrase to describe the subsequent course of medieval art; he speaks of "the insistent Gothic quest of the concrete," a quest that led to the most surprising phenomenon of medieval art—the shift to natural ornament. This new spirit of naturalism, which begins to creep like ivy over the severe outlines of Early Gothic transcendentalism, belongs to another phase of aesthetic consciousness which I propose to consider in a later chapter. It is a shift away from the numinous, towards the phenomenal. But the distinctive achievements of Christian art, which are inseparable from the Christian conception of a transcendental reality, lie in the earlier phases of its development. In those pristine days, the infinite was made real, space was made real, and the Christian God, and all the saints and prophets, were found inhabiting that realized space. In his *Psychology of Art* André Malraux, referring to the Torcello *Virgin* (Plate 33), which I too would choose as a type to represent this phase of the history of art, says finely that the whole significance of Early Christian art is incarnate in this figure, "standing aloof in the recess of the dark cupola so that none may intrude on its coloquy with fate."[42] But that figure would not be aloof, nor raised to such impressive grandeur, did it not stand within a space, infinitely deep and intensely vibrating, but more real to the senses than the incalculable and incomprehensible sky.

IV

THE HUMAN AS THE IDEAL

The creation of any ideal is surrounded by all the secrecy and wonder of birth.

<div align="right">WERNER JAEGER</div>

It must already be evident that the notion of reality underlying this book is, in the philosophical meaning of the word, empirical. Reality is a construct of our senses, a chart which slowly emerges as we take soundings of our feelings, trace the contours of our sensations, measure distances and altitudes of experience. The chart changes as our knowledge increases, as our recording instruments improve in precision. A new kind of instrument may result in a completely revised chart, and those of us who are skeptics will always regard the latest edition of the chart as provisional.

But if we try to draw that chart of reality, to make ourselves conscious of its form and internal features, then we begin to guess, to fake. There intervenes, between our experienced reality and our representation of that reality, a mental function to which the psychoanalysts have given the name *superego*: it is a conscious form or structure given to the otherwise amorphous life of feeling and desire. This conscious creation we call idealism. In its more primitive stages it is no more than the articulation of feeling in coherent images and in speech, then the elaboration and combination of these elements to realize or represent more complex states of feeling or more intense moments of intuition, and to give these unity and significance. An ever-present desire to stabilize the area of consciousness, to define neat compartments of intellectual awareness, stimulates thought and leads to the evolutionary development of a *Weltanschauung*, a culture with all its myths, superstitions, and ideals. But such a culture is

always a surface phenomenon; underlying it is the vaster underworld of unrealized subjective feeling, the personal or collective unconscious of modern depth psychologies.

It was no doubt inevitable that sooner or later man should attempt to comprehend and represent the subjective source of all the images and symbols he creates in his attempt to construct an external reality —that he should attempt to realize and represent the Self. There were two possibilities: to become conscious of what is unique in each individual—his subjectivity; or to become conscious of what was common to all men—their humanity. In the event, the consciousness of the universal preceded the consciousness of the particular, and it would be relatively easy to find reasons for this priority; for example, the urgent need for group solidarity in an environment still predominantly hostile to the human race would account for it.

We shall deal with the realization of man's subjectivity in a subsequent chapter. The task of defining and realizing an objective image of Man was accomplished by that complex of races and regional civilization which we conveniently call the Greeks. The Greek artists for the first time, and for all time, became conscious of the ideal Man. What is not generally recognized is that, in the process, they made possible the structure of thought which we call Humanism. The path from animism and magic to idealism and metaphysics is architectonic; it is literally a piecemeal carving of the human form, and the contemplation of this form on its isolated pedestal. The other arts, particularly poetry, contributed to this apothesis of man. The gods were given a human shape, and humanism formed like a commentary round the artifacts. Ernst Cassirer says that Greek art "paved the way to a new conception of the gods," and that "the work begun by Greek poetry was completed by Greek sculpture."[1] I doubt if there is any possibility of establishing historical priority among the arts in this process, but at any rate the origins of Greek sculpture are easier to retrace than those of Greek poetry. It is with visible evidence that we can still reconstruct the sure steps that lead from the discovery of plastic harmony in the Neolithic period to the idealization of the human form in the Classical Age of Greece.

We begin where we left off at the end of Chapter II, with the discovery and harmonization of general proportions in late neolithic

art. Beauty had been born, not, as we so often conceive it nowadays, as an ideal of humanity, but as *measure*, as the reduction of the chaos of appearances to the precision of linear symbols. Symmetry, balance, harmonic division, mated and mensurated intervals—such were its abstract characteristics.

Man had become conscious of these qualities during the long development towards a geometric art in the New Stone Age. This development has already been considered in Chapter II, but in a very general context. We can now take up the story in the narrower context of Greek art by referring, in the first place, to the art of pottery. The tenth and ninth centuries B.C. had witnessed what Beazley calls "a long conflict . . . between the curve and the straight line, and in the Geometric period that follows the Proto-geometric the straight line and sharp corner, both in shape and decoration, tend to prevail."[2] During the ninth and eighth centuries the Greek artists exploited with endless variations all the subtleties of linear design. Marked intervals of space, intersections of straight lines, the relative acuteness or obtuseness of angles, the counterpoint of straight lines and curved lines, the balance and symmetry of enclosed areas—all these features of the Geometric style are evidence of a progressive refinement of the human sensibility in relation to physical dimensions (Plates 16, 34). Right through from the first dawn of a geometric art in the New Stone Age to the first dawn of the historical period in Greek art, a gradual extension of plastic sensibility is exhibited both in the increasing refinement of the shapes given to volumes—the three-dimensional mass of the vessels which we generally read as an outline or *galbe*—and in the increasing complexity and variation of the linear ornament. The general result, by the beginning of the seventh century, was a widely diffused consciousness of geometrical elements as such, of their concrete and particular existence. Then came the first geometricians and the first philosophers —Thales of Miletus at the end of the seventh century, Pythagoras and his School in the sixth century. Greek civilization was launched on its great adventure; the artists had made it possible.

We may have different views of the most distinctive achievement of that civilization. But the irreducible element in Greek culture is the aesthetic element. It is at the root of Greek mathematics and

Greek geometry, and Greek philosophy in general begins as a meditation on universal qualities like geometry and harmony. But Greek philosophy would have remained forbiddingly abstract, and Greek civilization would have been as abortive as the civilizations of Mesopotamia and Egypt, had not a new element entered into its composition—an element that has never ceased to inspire mankind. This element we call Humanism; it is the idealization of Man himself, and this again was first achieved in art and through art.

We can best observe the process, as I have already said, in the art of sculpture, but it is also clearly indicated in the development of vase painting, so let us continue for a moment with this art. The Geometric period was followed by the period known as Proto-Attic, in which definite changes of style begin to appear (Plate 38). I cannot do better than quote Beazley's description of the process:

> In scores of vases one can watch the Geometric figures gradually rounding out, until the matchlike look has disappeared. This is part of the transformation that came over Greek art, to some extent under the influence of Oriental models, at the end of the eighth century and in the first half of the seventh. Wild animals come in, especially lion, panther, and sphinx; plants, growing, or in pattern bands. The human figures grow larger and more substantial, their stances firmer, movements bolder, proportions more just; and presently myth—the legends of gods and heroes—becomes, for choice pieces, one of the artist's favorite themes. The style is enterprising, unconstrained, and, especially perhaps in Attica, has a childlike gaiety and vigor. Sometimes one even seems to sense the wondering delight of the naïve artist who has *never drawn a man before*[3] (Plate 41).

We have now to distinguish two distinct but often parallel developments: an instinctive *expressionism* and a growing *idealism*. These cannot be combined, for one is an *externalization*, the other an *internalization* of feeling; one is form dictated by feeling, the other is a containment of feeling in harmonic form.

Certain arts lend themselves to the immediate expression of feeling because they are intrinsically fluent; there is no delay in the impulsive act of expression because there is no material hindrance. Painting and drawing, all forms of graphic art, have this characteristic. Other arts, such as sculpture and architecture, encourage or induce deliberation

because, by the nature of the tools and materials, they require muscular effort, calculation, divided attention to separate stages of execution.

Pottery, both in the process of molding or throwing the form, and in the process of applying or incising decorative ornament, is a quick, instinctive art. The painting of the pottery is particularly so, because the earthenware body, or the slip that covers it to make a ground for painting on, is generally absorbent, and it is impossible to correct the first instinctive stroke of the brush. If for the moment we assume that there existed, between the tenth and sixth centuries, a desire to project perceptual images in all their actuality, then in this art of painting on pottery the very technical limitations imposed on the artist would demand quick instinctive movements; and by laws of mimesis or empathy, a sympathetic correspondence would be established between the action of the painter and the action of, say, the animal he was depicting. One can see, for example, in the Broomhall krater belonging to the Earl of Elgin (Plate 35), how the centaur on the shoulder of the pot and the horses below are formed with a few rapid strokes of a well-filled brush, and how this economy of means leads to an instinctive emphasis on lines of vital energy. But this is the aesthetic process which we found characteristic of the drawings of the Stone Age, and indeed the animals on these early Greek vases, utterly refined as they may become, are not essentially different in style from the animals of the Paleolithic period. One might even compare them—much to the scandal of all classical scholars—with the animal drawings of the African Bushmen.

The human figure is also depicted with the same expressive vitality. We may take as an example the figure from a valediction scene painted by an artist whose name we know, Lydos, about the middle of the sixth century (Plate 37). The open mouth and uplifted arms are conventional gestures, and Lydos's drawing is stylized. Nevertheless there is "passion and reality"[4] in the figure, just as, to take rather a different example, there is serenity, and equally reality, in the head of a girl from a late seventh-century amphora in Munich[5] (Plate 36)—a drawing which throws us forward to the portraiture of the Italian Renaissance. Expressionism is not necessarily a question of *violent* feeling, as modern examples might lead us to suppose.

If we turn now to the art of sculpture we shall find a development which, I am going to suggest, is intrinsically different, and much more significant for the history of Greek culture. I do not wish to minimize the contribution made to that culture by the art of vase painting, or Greek painting in general. We can agree with Professor Beazley that "Before the end of the seventh century, the elusive multiplicity of the visible world had been condensed into a few well-pondered, crystalline forms, which are adequate to express the main activities and attitudes of man and beast—standing, walking, running, sitting, reclining, riding, thrusting, throwing" (Plate 40). We can agree further that "This small world of forms is a nucleus capable of expansion and transformation; it is the foundation on which Greek art of the fifth century was based, and through it all Western art."[6] But these activities and attitudes, in their immediate, vitalistic sense, had been, if not established, at any rate adumbrated in their essentials, by the paleolithic artists. The distinctive Greek contribution was a development of neolithic art, and consisted essentially of an application of the abstract principles of symmetry and harmonic proportion to the human figure.

Beazley admits that "In the creation of *types*, or say of *standard forms*, Athens did not take the lead; a greater part was played by seventh-century Corinth." It would carry us too far from our subject to discuss the stylistic differences of Attic and Corinthian vase painting (Plate 39). The creation of types, or "standard forms," can be studied more easily in Greek sculpture, to which I now turn.

If we take, as a point of departure, the Cycladic figures of the Bronze Age, we find a geometricization corresponding in style to the contemporary vase painting. For example, a detail from the large Corinthian krater in the National Museum, Athens[7] (Plate 36), shows the human figure represented by an abstract form very similar to the violin. But the human figure is found in almost exactly the same form in two marble figures of the Bronze Age, in the Louvre Museum (Plate 42). The presentation of the human figure from this frontal point of view is rare in vase painting, and destined to disappear very quickly until revived in the late "free style" of the second half of the fifth century. For the expressionistic purposes of the painter the profile view of the human figure is always more apt—

an observation which we may confirm in modern caricature, which usually presents its victims in profile. But in sculpture the whole emphasis from the beginning was on the frontal view of the human figure, with results which eventually destroyed the aesthetic integrity of sculpture as an art.[8] But it was only by attacking the human figure in this frontal way that the artist could apply to the configuration of its plastic form those principles of symmetry and harmonic proportion which now, after centuries of geometrical refinement, obsessed his sensibility.

The transition from an almost completely geometric abstraction of the human figure to a conventional *schema* was no doubt gradual, but already in the Bronze Age the articulation had become more precise—at once precisely geometrical and precisely anatomical. We pass by way of the Cycladic idols, which might be described as an orchestration of triangular motives (Plate 43) to more rounded forms which, though carved in marble, seem to be influenced by clay-modeling techniques. Then, with the second half of the seventh century, we reach the first formulation of the idealized human figure that was to evolve, by stages that can now be fairly precisely determined, to the classical ideal as conceived by the great sculptors of the fifth century.

I am not, in this book, taking account of either economic or racial influences. It is generally accepted that towards the end of the eighth or early in the seventh century, orientalizing influences were at work throughout the Eastern Mediterranean, and the impact of such influences may have been first felt in an island like Crete rather than on the Attic mainland. A bronze figure of about 640–630 B.C., found at Delphi (Plate 50), is confidently ascribed to Crete by the archaeologists.[9] But it already anticipates the essential features of the *Cleobis*, also from Delphi[10] (Plate 47), and of the Rampin horseman from the Acropolis (Plate 46).

These figures, and others of their type, have been frequently and often brilliantly described. From Winckelmann onwards, through Goethe and Lessing, Ruskin and Pater, to modern writers like Beazley and Humfry Payne, an eloquent literature devoted to the praise and exposition of classical Greek sculpture has accumulated. I do not propose to add anything by way of appreciation; I would

only like to point out that, until we reach our own time, most of this writing commits the psychological fallacy of retrospective interpretation. That is to say, the sculpture of the seventh century is approached with intellectual conceptions derived, if not from the humanistic philosophy of the Renaissance, at any rate from a form of Greek idealism that is later in development than the sculpture in question. The seventh-century sculptor had not yet formulated his idealism; nor had it been formulated for him by contemporary philosophers. He was feeling his way towards a synthesis of two kinds of sensibility —sensibility for the vital image of a man and sensibility for the abstract elements of a geometrical harmony. Only when this synthesis had been achieved was it possible to conceive a philosophy of the human ideal, the philosophy we call humanism.

If we contrast figures of the Bronze Age (Plate 44) with the *Cleobis* from Delphi we may note certain similarities and certain differences. The similarities are formal or geometrical: the same frontal pose, the same accurate symmetry, a still obvious linear emphasis. But the geometry is latent, a supporting structure rather than a symbolic abstraction; and round it is woven a rhythmical counterpoint of organic significance (Plate 45). Again we sense "the wondering delight of the naïve artist" who has, in this case, never *carved* a man before. The transition from the sculpture of the end of the seventh century to the mature classical style of the fifth century was to be one of increasing naturalism, but the quality of that mature style (Plate 51) is not called "realism," but rather "idealism," and this quality was the unique achievement of Greek art. How exactly did it come about?

This question was answered in great detail by Hegel, in his *Philosophy of Fine Art*; but, not for the first time in history, it is necessary to turn Hegel upside down. His discussion of the subject is a rationalization of the attitude that had been prevalent in Germany since Winckelmann's time. Sculpture, says Hegel—and he is, of course, referring specifically to Greek sculpture—"sculpture . . . conceives the astounding project of making Spirit imagine itself in an exclusively material medium." This personification of sculpture is a little difficult to accept, but at least it has the merit of situating the motive power within the art, and of not making the art merely the

instrument of some external moral or ethical force. The function of sculpture, Hegel goes on to say, "is to present the Divine simply in its infinite repose and sublimity, timeless, destitute of motion, entirely without subjective personality in the strict sense and without the conflict of action or situation."[11] He defines the Divine as the "unperturbed and unparticularized being of Spirit," and contrasts it with "the process of disruption into contingent existence, a world that is broken into complex forms or varied movement." Such being the function of sculpture, the artist must, as it were, make the best of the human body as the house of the Spirit. But he must then distinguish between his own *subjectivity as such*, which is Spirit as self-consciousness, and "the truly objective content of Spirit," which is something determinate, stable, and universal. The sculptor, therefore, says Hegel, takes the human body such as he finds it in his sensuous experience, and then proceeds to build up

true individuals, which he conceives . . . as essentially complete and enclosed within their objective spiritual presence, in self-subsistent repose, delivered thereby from all antagonism as against external objects. In the presentment of an individuality of this character by sculpture, what is truly substantive is throughout the essential foundation, and neither purely subjective self-knowledge and emotion, nor a superficial and mutable singularity, must be permitted in any way to be predominant, but what is eternal in the godlike and our humanity should, divested of all the caprice and contingency of the particular self, be set before our eyes in its unimpaired clarity.[12]

Hegel is saying, in his metaphysical jargon, that those elements which give to the living creature its *vitality* must be reconciled with the ideal elements of symmetry and harmonic proportion. He uses one of those expressive German phrases which puts the whole matter in a nutshell: *die schöne freie Notwendigkeit*—the necessity that is both beautiful and free: the freedom of life reconciled with the objective laws of beauty. He then goes on to describe that "crucial point of transition," which is the point we have now reached in this discussion, "where fine art wakes from its sleep . . . where at last the artist is creative by virtue of his own free conception, where the flash of genius strikes into the material presented, and communicates freshness and vitality to the presentment."[13] Then, says Hegel, the work

of art is pervaded for the first time by a note of spirituality (*ein geistige Ton*).

Hegel only gets round to this essentially true description of the new dimension of consciousness which came into existence with Greek sculpture by hypostatizing sculpture itself, as though the art were a motive force, a conscious will, ever striving to reconcile the particular with the universal, multiplicity with unity, freedom with necessity. His philosophical system demanded an ever-progressive and ever-closer union of Man with Spirit, of Reality with the Ideal; and he therefore conceived this decisive development of Greek sculpture as a synthesis of two forces, one sensuous, the other metaphysical. It is true that a dialectical synthesis did take place, but in my conception of the process, both thesis and antithesis were sensuous, the one being the aesthetic apprehension of *vital form*, the other being the aesthetic apprehension of *formal beauty*. The synthesis was this unique achievement which we call classical sculpture.

The two elements are seen side by side, as thesis and antithesis, when the sensuous and vital form of a human limb is opposed to a geometricization of the folds of a garment. Our two aesthetic principles of vitality and beauty are then seen, pathetically isolated, side by side (Plate 49). They were to become merged in the mature art of the fifth century, and nowhere more perfectly than in the monumental figures of the Parthenon frieze (Plate 48).

The art of sculpture rests here on its still center, perfectly balanced between vitality and harmony. That breathless balance was to be maintained for only two or three decades, the mature years of Phidias and Praxiteles; then the life slowly bleeds from the limbs, and the sense of harmony is lost in virtuosity. The decadence of Greek sculpture does not concern us. The human consciousness had attained a new dimension—an awareness of the perfect harmony of Being and Idea. Man never wholly lost that awareness: it was distilled into Greek poetry and Greek philosophy; and when, centuries later, the human sensibility once again became aware of the beauty of the Greek synthesis, there were artists like Donatello and Piero della Francesca ready to give a new representation of it. But that was a rebirth, a Renaissance; the original expansion of the human consciousness had been achieved in Greece, two thousand years before.

The whole of this historical development might be called a harmonization of the vital image, and the result of the process was a consciousness of a realm of *essence*, altogether new to human experience. But as Greek philosophy became aware of this realm of essence, an apotheosis took place. Ideal qualities as such, according to our present hypothesis, had been discovered empirically, in the course of a gradual geometricization of perception; the geometry was an abstraction from nature, and the ideal qualities, the harmonies of form and configuration, were deductions from the geometry. These processes of geometricization and deduction were then forgotten; they had never been conscious teleological aims, but impulses engendered by cosmic anxiety, or by economic stress. But when the early Greek philosophers, particularly the Pythagoreans, began to meditate on harmonic forms and proportions, they took these qualities over as god-given entities, divine *qualities*, for which signs and symbols must be invented. They gave verbal definition to elements, such as the line, the angle, the circle, which had been discovered empirically by the artist. A process of conceptualization took place; the quality of a straight line became straightness, and the perceived identity of shapes and pleasing divisions of lines became symmetry or harmony. Intervals of measure were identified with intervals of time, and an increasingly complex science, which we now call mathematics, became possible.

This system of harmonics, originally derived, as we have seen, from the gradual geometricization of naturalistic motives, was then, by a paradox which is one of the most astonishing events in the history of human culture, read back into the natural phenomena from which it had originally been derived. First came a stage of vital empathy, of *mimesis*; plant forms, animal forms were used as decorative motives in all their natural vitality. Then these forms became more and more stylized, finally geometricized, and then, and only then, they entered human consciousness as abstractions. Lines were seen as lines, measurable, related to one another in proportions that were pleasing to the sensations; similar properties were perceived in angles and curves, rectangles and circles, and a whole science of harmonic relations was established by the early Greek philosophers. But then, when harmony had been realized as such, it was

rediscovered in nature—in the motions of the planets, in the forms of flowers and plants, in man himself. This was the basis of Greek *naturism*, of the idealization of nature as the illustration of divine mathematical laws.

The final stage was reached when the whole of this system of harmony was divorced from the world of sensuous experience and given an a priori existence in another world—a world of essence. But the Greeks knew instinctively that their contact with this celestial realm must never lose its sensuous basis, and philosophy became an exhortation unto men to copy the patterns of that other world of divine essences. This they could do only by direct sensuous experience, by glimpsing, as it were, the Elysian fields in all their actuality and beauty.

The sensuous nature of this conception is vividly illustrated in the myth of the soul as related by Plato in his *Phaedrus*. The soul, according to this myth, is of a dual nature, part human, part divine. It is provided with a pair of wings and is in perpetual motion; it is therefore immortal. Its wings, however, are liable to molt, and then the soul descends to earth and becomes mortal. But it retains a memory, more or less dim, of the world of divine essences, and is ever striving to grow feathers, to stretch its wings, and fly to heaven for renewed sustenance.

Plato's description of heaven, in so far as it is concrete, is geometrical. There are circles and revolutions, numbered hosts and chariots drawn by symmetrical pairs of horses. The highest realm of essence is beauty—beauty to which alone "is given the privilege of being at once most conspicuous and most lovely." Such beauty, Plato says, is to be apprehended through the medium of sight, "for sight is the keenest of our bodily senses."

Those who have in this manner experienced a vision of heavenly beauty are thereby made sensitive to beauty on earth. Plato gives a description of the process which is physiological in its detail. Anyone who

beholds in any godlike face or form a successful copy of original beauty, first of all feels a shuddering chill . . . as he continues to gaze, he is inspired with a reverential awe . . . Afterwards follow the natural results of his chill, a sudden change, a sweating and glow of unwonted heat. For he

has received through his eyes the emanation of beauty, and has been warmed thereby, and his native plumage is watered. And by the warmth the parts where the feathers sprout are softened, after having been long so closed up by their hardness as to hinder the feathers from growing. But as soon as this nourishing shower pours in, the quill of the feather begins to swell, and struggles to start up from the root, and spread beneath the whole surface of the soul; for in old time the soul was entirely feathered.[14]

Plato adds, with a final twist of realism, that this is "exactly the same sensation as that experienced by children when cutting their teeth, a sensation of itching and soreness about the gums."

The myth continues with equally vivid detail, but I have quoted enough to make my point, which is that the fusion of the vital with the beautiful was conceived by Plato as a somatic or sensational experience, and that in the process the vital frame was physically affected. Beauty, as Plato puts it, is "the sole physician for the soul's bitterest pains."

Plato's theory of art has been subject to much misunderstanding and misrepresentation.[15] I cannot go into the question now, but I think there is no doubt Plato believed that the vision of beauty, which, as we have seen, he conceived as a sensuous experience, could be apprehended only through the mediation of art, more particularly through the practice of, or active participation in, the various arts.[16] The work of art is a sensuous embodiment of ideal forms, of beauty in its essential aspect of harmony; and just because it is sensuous, it is vital, it is sympathetic, it is attractive. It invites what might well be called "mystical participation," and in that state of psychic identification, the vital forces of life, mingling freely with the ideal forms of beauty, receive the impress of these forms. Such is the revitalizing experience to which in the ideal community all citizens should aspire, and all our education and laws should be devised to make that kind of experience possible. It is still a credible political philosophy, though not one that appeals to modern politicians.

The limitations of idealism in art were discovered by the Greeks themselves. It was found, for example, that a strict application of the laws of proportion to architecture produced a total deadness. Corrections were therefore made to produce a visual satisfaction: curves and

swellings introduced into the horizontal and vertical elements, irregularities into the spacing of columns. But if it was comparatively simple to correct architecture in this way, perhaps by a process of trial and error, perhaps by mathematical calculations, it was not easy to apply the same kind of corrections to sculpture and painting. Architecture was, essentially, a geometrical art, not a mimetic one; the calculations remained in a purely intellectual context. But to vary the ideal proportions of the human body, or the ideal proportions of any natural object, was either an immense act of presumption—an interference with divine law, so to speak—or it could be an arbitrary act, a display of subjective wilfulness. Hellenistic art, the art which is so patently decadent by comparison with the art of the fifth and earlier centuries, is either an art which has lost all vitality, and mechanically reproduces standardized types according to academic rules, with variations that are merely sophistications, or it is an art of caricature, a manneristic art that seeks to produce an effect of vitality by exaggeration. The still center has been lost—the point of equilibrium where an inner vitality responds and corresponds to an outer measure.

To state the causes of that decadence would be to state a philosophy of history. Hegel, who had a philosophy of history, believed that art had to be superseded, to pass away, because the human mind had developed beyond such a concrete form of cognition, and could henceforth find satisfaction only in abstract forms of thought—in "universal forms, laws, duties, rights, and maxims." Hegel saw an inevitable contradiction between the sensuous basis of art, its "unregulated caprice," and the conceptual basis of philosophy, or "reflective culture" as he called it. He was right in his diagnosis. If it is in the true function of art "to bring to consciousness the highest interests of mind," then art is doomed. But it is still possible to believe that a sensuous culture might be preferable to a reflective one, and that what modern philosophy has effected, and what later Greek philosophy effected, is a certain corruption of consciousness which is the real explanation of social decadence.

V

THE ILLUSION OF THE REAL

The supreme misfortune is when theory outstrips performance.

LEONARDO DA VINCI

As we approach the Modern Epoch—by which I mean the civilization of the Western World since the end of the Middle Ages—our task becomes immensely more complicated simply because it is increasingly difficult to differentiate between consciousness and the secondary activities of imagination and intellection. A great part of modern culture, even the part of it we designate as fine art, is now only distantly related to the process of sensation as such. Just as the process of reasoning can proceed on the basis of signs and symbols which involve no sensational response, so now the processes of art proceed on the basis of tropes and images which are not directly derived from individual experience but are so many counters acquired on the cultural exchange. Schools and academies are established which teach men not to use their senses, not to cultivate their awareness of the visible world, but to accept certain canons of expression, and from these to construct rhetorical devices whose subtlety appeals to reason rather than sensibility. Art becomes a game, played according to conventional rules.

Or it becomes a science. The Italian Renaissance was responsible for a confusion which, as we shall see, again and again ended in the frustration of art. Nevertheless, in this same Modern Epoch, amid so much confusion of values, our consciousness of reality was greatly extended, and, as always, the process was primarily sensational and aesthetic. New dimensions of reality had first to be measured along the nerves before they could be used by the imagination.

In the previous epochs that we have considered, my general thesis,

that aesthetic activity preceded any coherent intellectual activity, was not difficult to sustain. In the beginning was the image. But in the modern epoch sensation and imagination, feeling and thinking, are no longer so separate or so sequential. Philosophy has become a distinct tradition, independent of myth and symbol, and prides itself on possessing a scientific method, by which is meant an impersonal method. Although during the Middle Ages philosophy had continued to follow on art, like a commentary on a vision, by the time we reach the Renaissance, art has become too ambiguous, and philosophy too various, for any simple correlation to be established between them.

The main effort, both of art and of philosophy, was still cognitive. If art was still, as Fiedler would say, "a continuous, incessant working of the mind to bring one's consciousness of the visible world to an ever richer development,"[1] then philosophy was a continuous, incessant working of the mind to bring one's understanding of the nature of being to an ever clearer statement. But more and more philosophy was to become a semantic or logical activity. It was agreed that if the terms of philosophy could be defined—terms like sensation and imagination, feeling and thinking—then logical propositions would become possible and reality itself might be comprehended by such means. Descartes, Hobbes, Spinoza, Leibniz, Locke, Berkeley, Hume, and Kant—all these philosophers were engaged in apparently futile attempts to determine whether what we see exists actually, and whether any universal truths can be established on the basis of human consciousness. The present philosophical position, after several centuries of intense analytical activity, seems to be more uncertain than ever. According to Wittgenstein, there are no statements that are universally valid; any philosophical proposition is no more than an expression of subjective feeling.[2]

The artist has always instinctively known this, and his activity, in so far as it has been consistently aesthetic, has been an attempt to establish an individual clarity of consciousness. Not a *Weltanschauung* —not a theory of reality or of the nature of being: but just the reality that he himself can perceive, standing in a particular place at a moment of time, the purity and singleness of an act of vision.

Such an aesthetic apprehension of the world proceeds quite

independently of the intellectual apprehension of the world. That is what is so difficult to understand in an age like ours, dominated by philosophy and science. But it must be obvious, on reflection, even to the most logical scientist, that the world of experience is in some way apprehended, and valuable truths expressed about the nature of reality, by the world's greatest artists—that there are two ways of understanding, two totally distinct mental activities, one represented by an artist like Rembrandt, the other by his contemporary, the philosopher Spinoza.

The artistic activity begins as a clarification of the artist's state of consciousness. But what is this state of consciousness, and what is its relation to such mental activities as sensation, feeling, and imagination?

Answers to these questions that I consider true were put forward by the late R. G. Collingwood, in his *Principles of Art*. I must give some account of his definitions, because there follows from them a notion of the possible corruption of consciousness which is very necessary for any understanding of the dramatic course of art during the past five centuries.

Collingwood defines consciousness as

the kind of thought which stands closest to sensation or mere feeling. Every further development of thought is based upon it, and deals not with feeling in its crude form but with feeling as thus transformed into imagination. In order to consider likenesses and differences between feelings, classify them or group them in other kinds of arrangements than classes, envisage them as arranged in a time-series, and so forth, it is necessary first that each one of the feelings thus reflected upon should be attended to and held before the mind as something with a character of its own; and this converts it into imagination.

Consciousness itself does not do any of these things. It only prepares the ground for them. In itself, it does nothing but attend to some feeling which I have here and now. In attending to a present feeling, it perpetuates that feeling, though at the cost of turning it into something new, no longer sheer or crude feeling (impression) but domesticated feeling or imagination (idea).[3]

This activity of consciousness so clearly described by Collingwood obviously involves an effort on the part of the individual; it is

not mere passive awareness, involuntary perception, but a concentration on a selected segment of perception, a segment brought into the center of our attention by some predisposing instinct, as when we notice a particular woman in a crowded room, or a particular flower by the wayside. This process of focusing on a particular detail in the field of perception I shall call "realization": it is the attempt to realize the entity or singular nature of a particular object or group of objects in the field of vision. The distinction is clearly expressed in our current speech: our normal sensational activity is known as "seeing" or "hearing"; but we "look" or "listen" when our attention is engaged by some particular object or event in the field of sensation, such as a painting or a piece of music.

What we do when we pass from "seeing" to "looking," or from "hearing" to "listening," is to become aware of ourselves seeing something, or hearing something. Our attention, as distinct from our awareness, has a double object. To quote Collingwood again:

What we hear, for example, is merely sound. What we attend to is two things at once: a sound, and our act of hearing it. The act of sensation is not present to itself, but it is present, together with its own sensum, to the act of attention. This is, in fact, the special significance of the *con* in consciousness: it indicates the togetherness of the two things, sensation and sensum, both of which are present to the conscious mind . . . Thus, the difference between seeing and looking, or hearing and listening, is that a person who is said to be looking is described as aware of his own seeing as well as of the thing he sees. There is the same focusing on both sides. As in looking, I focus my attention on part of the visual field, seeing the rest but seeing it "unconsciously," so at the same time I focus my attention on part of the multiform sensory action which at the moment is the totality of my seeing, and thus that part of it becomes a conscious seeing or looking, the rest becomes "unconscious" seeing.[4]

I must apologize for wearying the reader with these elementary definitions, but the logic of my argument depends on them. Art is an attempt to perpetuate or record feelings. That, as we have seen, is the activity of consciousness itself. "Attending to a feeling means holding it before the mind; rescuing it from the flux of mere sensation, and conserving it for so long as may be necessary *in order that we should take note of it.*"[5] Now, taking note of a feeling may be

merely a mental act, an act of the imagination; but it may be concurrently an act of expression, an external notation of the particular feeling. In both cases a sustained act of sensation is involved.[6]

And there the trouble begins. It is very difficult to hold on to a sensation without in some manner dissociating oneself from it, becoming critical of it. This is what Collingwood calls "the corruption of consciousness." "A true consciousness is the confession to ourselves of our feelings; a false consciousness would be disowning them, i.e. thinking about one of them 'That feeling is not mine'."[7] Or, to add my own gloss, "That feeling should take this required form."

Collingwood points out that

the possibility of such disowning is already implicit in the division of sensuous experience into what is attended to and what is not attended to, and the recognition of the former as "mine." If a given feeling is thus recognized, it is converted from impression into idea, and thus dominated or domesticated by consciousness. If it is not recognized, it is simply relegated to the other side of the dividing line: left unattended to, or ignored. But there is a third alternative. The recognition may take place abortively. It may be attempted, but prove a failure. It is as if we should bring a wild animal indoors, hoping to domesticate it, and then, when it bites, lose our nerve and let it go. Instead of becoming a friend, what we have brought into the house has become an enemy.

"I must pay cash for the paper money of that simile," adds Collingwood.

First, we direct our attention towards a certain feeling, or become conscious of it. Then we take fright at what we have recognized: not because the feeling, as an impression, is an alarming impression, but because the idea into which we are converting it proves an alarming idea. We cannot see our way to dominate it, and shrink from persevering in the attempt. We therefore give it up, and turn our attention to something less intimidating.[8]

Such is the corruption of consciousness. Incidentally, Collingwood admits that he is describing something already recognized by the psychoanalysts and by them called variously repression or projection, dissociation or fantasy building. He also points out that long

before the psychoanalysts, Spinoza had recommended a truthful consciousness as a foundation for a healthy mental life.

But what we have to insist on now is that a truthful consciousness is the foundation of all genuine art: "a bad work of art is the unsuccessful attempt to become conscious of a given emotion," and "a consciousness which thus fails to grasp its own emotions is a corrupt or untruthful consciousness."

One more quotation from Collingwood and then I have a sufficient basis for my further argument:

Nobody's consciousness can be wholly corrupt . . . Corruptions of consciousness are always partial or temporary lapses in an activity which, on the whole, is successful in doing what it tries to do. A person who on one occasion fails to express himself is a person quite accustomed to express himself successfully on other occasions, or to know that he is doing it. Through comparison of this occasion with his memory of these others, therefore, he ought to be able to see that he has failed, this time, to express himself. And this is precisely what every artist is doing when he says, "This line won't do." He remembers what the experience of expressing himself is like, and in the light of that memory he realizes that the attempt embodied in this particular line has been a failure. Corruption of consciousness is not a recondite sin or a remote calamity which overcomes only an unfortunate or accursed few; it is a constant experience in the life of every artist, and his life is a constant and, on the whole, a successful warfare against it. But this warfare always involves a very present possibility of defeat; and then a certain corruption becomes inveterate.[9]

This is a subtle and sufficient theory to account for the psychological difference between good art and bad art, but I doubt if Collingwood would have been willing to face the consequences of applying his criterion to the history of European art since the Middle Ages—though he did recognize that the corrupt consciousness is "the true *radix malorum.*" Medieval art, the whole tradition of art which we dealt with in Chapter III, art as the expression of a consciousness of the numinous, had ended in a corruption that took the form, as always, of symbols divorced from sensibility, of an elaborate artificiality that exhibited, not an awareness of the numinous, nor of any sensational experience, but merely a mannered manipulation

of forms that had become clichés of design, a conventional ornament devoid of feeling.

The artist, that is to say, was content to give a deliberate illustration of intellectual concepts and religious dogmas that had never entered his consciousness as sensation or feelings, but were present to him as already received ideas, as lifeless formulas (Plate 52). In such circumstances corruption of consciousness becomes endemic, and is only to be restored to a healthy state by the revolutionary impulse of one or more exceptional individuals.

The consciousness of the Gothic artist had been corrupted by gradually imposing on him the duty of illustrating dogma, rather than allowing him the glory of witnessing to "the miracle of pure Being." The Gothic cathedral had reached the physical limits of expressive aspiration, and now threatened to collapse if man attempted to scale any nearer to Heaven. Plagues and wars had induced a weariness of the spirit, and had, in a terribly physical sense, sapped the vitality of art. A new effort of consciousness was required if art was not to perish.

At this point we must recall the two basic principles of art which we established in connection with prehistoric times: the principle of vitality and the principle of beauty. In medieval art these are recognizable in the contrasted principles of naturalism and idealism, to whose differentiation Max Dvořák devoted a famous essay.[10] The idealism of early Christian art had been an attempt to express the Unknown, the numinous, the transcendental emotions of mankind. The attempt ended in systematic symbolism, ordained ritual, forms without feeling.

During the course of the thirteenth century a new consciousness of organic vitality became apparent: it was expressed in a closer observation of natural phenomena, which gradually transformed all types of ornament (Plate 53), and in a reaffirmation of classical humanism (which in the last chapter I interpreted as a synthesis, in the human figure, of the basic principles of vitality and beauty). This rebirth of organic sensibility had its first lowly manifestation in the *Fioretti* of St. Francis of Assisi, which are a poetic crystallization of the Franciscan sensibility. It would not be impossible to find expressions of the same feeling in the plastic arts, but in order

to concentrate our attention on the revolutionary nature of this change of sensibility, we may perhaps give priority to St. Francis but only if in so doing we insist on the aesthetic nature of the expression he and his followers gave to a new consciousness of the beauty immanent in the natural world.

St. Francis himself practiced an art, the art of poetry, though only "The Canticle of Brother Sun," written in 1225, has survived. But we may consider him as a poet in the Provençal tradition, bringing fresh inspiration and freer rhythms into the traditional forms of literature. The Franciscan movement is associated with religious or ethical concepts like poverty, chastity, and obedience, but long before a Giotto or a Sassetta had realized these concepts in visual symbols they had been realized as vivid images in the consciousness of St. Francis and his followers. At this stage in the development of human consciousness the association of sensation and image is poetic rather than plastic. We nowadays speak of poetic "images," and the use of this word is an acknowledgement of the fact that the phenomenon is visual rather than linguistic.[11] Images, as we have had to reaffirm in our own time, are basic to poetry. It is because poetry is imagist that it can, as in the Franciscan *Fioretti*, take precedence over the plastic arts as an expression of a state of consciousness.

To treat our subject adequately, we should have to follow the arts in their separate courses, noting when one form of imagination, for reasons which we might be able to indicate, from time to time takes precedence over other forms of imagination. One can agree with Berenson that "poetry and the figure arts seldom keep pace in their evolution"; but it is going too far to say, as he does, that

a great movement in the minds of men, the yearnings which inspired it, the strong feelings it engendered, will have found expression in song and legend long before sculpture and painting stir with the new life. We may go further and say that it is only when literature has translated an epoch into a series of splendid myths, that the figure arts can be called in to give the ideals of that epoch visual form.[12]

That is to ignore not only the epochs in which the plastic arts, to the best of our knowledge, preceded song and legend, but also an

epoch like our own, where there is little song and no legend, but manifestly a vital movement in the plastic arts.

But Berenson, in the context from which I have quoted, is dealing with the transformation of the Franciscan legend into figurative art, and in this case his observation is true. The specific kind of consciousness present in the *Fioretti* and other legends of St. Francis was not to find adequate expression in painting until the fifteenth century, and notably, as Berenson pointed out, in the work of Sassetta (Plate 57). But meanwhile, as Berenson would agree, another kind of consciousness slowly revealed itself during the thirteenth and fourteenth centuries, to find its full expression in the work of "the generation of 1430," as Max Raphael calls it, "the generation of Van Eyck, Masaccio, Konrad Witz, and Fouquet—which after the breakdown of the feudal conception of heaven felt the solid ground of earth under its feet, from which the world could be securely and calmly examined with the new conviction that 'being is, and non-being cannot be' (Parmenides)." Max Raphael points out that this new sense of empirical existence had nothing in common with the adoration or imitation of nature—nothing in common, therefore, with Franciscan sentiment. "It is rather an affirmation of the world as imperishable, objective and dynamic, not an affirmation by man, but a self-assertion, self-creation, and self-revelation of its substance."[13]

This affirmation of an imperishable objective world is first discernible in the paintings of Duccio and Giotto, but it took a whole century for this specifically new consciousness of real or substantial existence to reach its full development in the work of Masaccio (Plate 54). It is an evolution that is now a commonplace of the history of Italian painting, and I do not propose to retrace it. But there are important distinctions to be made, and there can be no understanding of what subsequently happened to art unless we hold on firmly to these distinctions.

The common assumption is that a phenomenal reality exists external to our perception, the world of nature, as we call it, and that beginning with Duccio and Giotto there was an attempt, on the part of the artist, to give an exact account of this external reality. In order to do this the artist had gradually to discard first of all any

form of idealism which suggested the possible existence of another mode of reality, and therefore any symbolic forms which merely represented the artist's fantasy. Purity of consciousness was to be cultivated, and the artist was to give a true report of his purest state of consciousness. A tremendous effort to clear the consciousness of the conventional symbols that corrupted it was implied.

If we compare, as is often done, firstly, Masaccio's treatment of the human figure (Plate 55) with an earlier Byzantine treatment of a similar subject, and then Masaccio's treatment of the human figure with Giotto's (Plate 56), the progress in the direction of an affirmation of the objective existence of the human being depicted is immense. In Giotto's paintings the figures, for all their realism, are still seen as reliefs emerging from a curtainlike background; but Masaccio's figures stand free in a credible space. Not only do we believe that such a man must have existed in the city of Florence round about the year 1420, but the man who is present to our consciousness as we look at the picture is no longer a symbol of a man, as in the Byzantine painting, and no longer a typical man, as in Giotto's painting, but a real presence, a substantial presence. Masaccio, by technical means which we can analyse, has created this illusion of a real presence.

Let us recall, before we go further, that paleolithic man also created a real presence, the vital image of the animal. It is very important to ask whether Masaccio is doing more than this, and in what consists this "more."

The obvious difference is that Masaccio's figure is situated in a space that is just as real as its own bodily substance. Other figures are placed in the same spatial continuum, and are related to each other with physical credibility: the substance of each figure exists in its own right and does not displace the substance of any other figure.

Again, I wish to spare the reader the dreary analyses which have been devoted to paintings of this kind. It is only necessary to realize that Masaccio's grasp of substance and of space was wholly intuitive. Essentially it does not differ in this respect from the paleolithic artist's grasp of the substance of the animal, but this same faculty is applied, not only to a different species, the human figure, but also to the intangible substance of the space occupied by this figure.

It might be argued that in so far as the depiction of two distinct species is concerned, there is no aesthetic distinction to be made between Masaccio's painting of a human being and the figure of a bison as painted by a paleolithic artist. In strictly formal terms, there is not; but there is this tremendous difference—how tremendous we shall see later—that the apprehension of the vitality of the animal was the apprehension of another modality of existence, the apprehension of a being that is external and objective, whereas the apprehension of the substance of another human being is complicated by the artist's subjective and haptic knowledge of his own substance. The artist will try to exclude these subjective feelings, but we shall see that he cannot really do so without corrupting his consciousness.

This process of "realization" was not achieved without intense conflict. The greatness of Masaccio consists in the fact that he was able to resolve this conflict: he succeeded in rendering his consciousness of space and substance without sacrificing the integrity of his consciousness. That is to say, he did not surrender his sensational awareness of the phenomenal world, or the felt harmony of his composition, to some merely logical or "scientific" formula. Perspective was employed, not to establish some mistakenly objective notion of the true or the real, but in the interests of the painting as such, as an aesthetic entity. The great value of perspective in Masaccio's work consisted, as Jacques Mesnil, one of the best of his critics, has pointed out,[14] in the fact that it lent coherence to the composition—"it established a precise relationship, of a specifically aesthetic kind, between the spectator and the content of the work of art." Previously the spectator had been invited to participate in the imaginative bond between feeling and symbol. Perspective ensured that this relationship should be first of all sensational—even determined the precise location where the spectator could see the work of art with maximum aesthetic effect. But the balance thus achieved was precarious, and after Masaccio, perspective tended to become a science of representation rather than an art of expression. An objective criterion now existed, external to the artistic feeling—the criterion of the theodolite, we might call it, the criterion of the measuring instrument.

Obviously a conflict of values was involved, and it is a conflict

between pure consciousness and intellectual awareness: the artist, that is to say, is no longer giving a true report of the contents of his consciousness (which are certainly not methodically perspectival), but is trying to make those contents fit into a preconceived and intellectual scheme of representation. Almost any artist of the period will reveal a conflict between this growing science of "composition" or "representation" and feelings which demanded a more direct and spontaneous expression. We might take Giovanni di Paolo as an example (Plate 58).

The conflict in Giovanni di Paolo was described long ago by de Nicola as one "between typological realism and scholastic idealism."[15] I am not quite sure of the meaning of the word "typological" as applied to "realism"; it suggests a contradiction in terms, for the type, in the sense in which we find it in Byzantine painting, is never realistic. Giovanni di Paolo's realism, like Giotto's, is merely naïve. I see no reason to doubt that Giovanni di Paolo shared the growing consciousness of substance and space common to "the generation of 1430"; but, as John Pope-Hennessy has pointed out in his monograph of this painter, he

lived in a town, in a country, in a period, in which the demands of tradition and ecclesiastical patrons were strictly formalized . . . The temper of his early *Suffering Christ* is generated not by the abrogation of representational convention but by a heightened realism inside accepted visual formulae. Naturalistic detail, its bleeding wounds, swollen joints, bruised ribs, transforms the figure into an imaginative symbol.

Mr. Pope-Hennessy very daringly suggests that Giovanni di Paolo "exchanged realism for what, were the term not contaminated by psychology, we might call superrealism, the effort, that is, to achieve a total authenticity by means not in detail realistic."[16] My terms, I am afraid, are thoroughly contaminated by psychology, and I see in Giovanni di Paolo's style a conflict between a consciousness of real substance and a consciousness of the numinous that is equally real but has no substance, and must therefore be expressed in symbolic language. In this sense we may, even in the fifteenth century, still speak of the Byzantinism of the Sienese school.

We might spend a considerable time tracing the gradual perfection of means developed by artists of the *quattrocento* in their desire

to realize the substantial existence of the external world. For our present purpose it is sufficient to note the perfection of this new dimension of consciousness in Piero della Francesca, Alberti, and Leonardo. All these artists left documentary evidence of their views, in the form of treatises or notebooks, and the fact that they were conscious theorists is perhaps their most significant characteristic.[17]

The searching question we must ask is whether any new dimension of consciousness was attained by these artists and, if so, in what way did it differ from the Greek sense of beauty, or from the paleolithic sense of vitality. That the fifteenth century witnessed a great advance in the mathematical sciences is no doubt true; but it may well be doubted whether the consciousness of space as such—space in the scientific or representational sense—advanced at all between the twelfth and the fifteenth centuries. The architects of the Middle Ages were extremely learned men, scholastics in their own field, as Panofsky has pointed out,[18] and we have only to look at the notebooks of Villard de Honnecourt, which may be dated about 1235, to realize that it was not for lack of an elementary knowledge of optics or geometry that painting before the fifteenth century failed to apply a coherent system of perspective to the representation of reality.[19] There must have been an assumption, unformulated perhaps, that a science that was very necessary for the construction of buildings had no necessary connection with art. At any rate, the medieval artists saw no connection between this particular science and the expressive arts of painting and sculpture. "High Gothic design," to quote Panofsky,

remains inexorably linear; and High Gothic space, though already continuous, remains inexorably finite . . . The action . . . unfolds in a direction parallel to the representational plane, passing across our field of vision rather than advancing or receding within it. We see a world of forms communing with each other within their space but not, as yet, a world of forms communing with the spectator within a space in which he shares. . . . In short, High Gothic art, its world constructed without reference to the visual processes of the beholder and even without reference to his very existence, is still unalterably nonperspective. And now we can almost predict that "modern" space was to come into being when the High Gothic sense of volume and coherence, nurtured by sculpture and

architecture, began to act upon the illusionistic tradition that had lingered on in Byzantine and Byzantinizing painting; in other words, in the Italian Trecento.[20]

There seems little doubt, therefore, that space consciousness, whether composite and finite in the Greek and Roman sense, or continuous and infinite in the modern sense, was slowly developed from the practice of artists. The struggle to represent realistically, to create an illusion of reality, caused the artist to disengage, from his vague field of sensation, first the voluminousness of physical entities like human beings, then the relative position of such entities in groups, and finally a felt and substantial space, welling up between such entities and binding them together in a space which is also the space within which the spectator is situated. Space as such, conceptual, infinite, was a consequential induction from the concrete spaces first realized by the artist. But a fatal possibility then existed: to make space creation the sole criterion of art.

The kind of painting that developed from the time of Masaccio onwards was constructive in the sense that it applied an architectonic science to the representation of man and of Nature. The claim made by Alberti—we may take him as representative—was that a knowledge of the laws of optics would enable the painter to be more effective in producing his purely aesthetic, sensuous effects. That is what the Van Eycks and Masaccio had been doing—using perspective, not schematically or scientifically, but as an effective compositional device, as a perfect rendering of the "good" Gestalt. Alberti specifically disclaims any intention of making art a science of representation. He says: if the result does not please the eye, it will be of no interest to the painter. His favorite word is "concinnitas," and this implies an agreement of the parts of a composition with the whole of it that can be grasped only intuitively. Sensibility is the final criterion.[21]

That was to be forgotten, but before we deal with the fatal dissociation of sensibility that followed in the sixteenth century, let us note a subtle variation of sensibility in relation to perspective. It was possible to treat perspective—the perspectival image—as a thing-in-itself; not merely as a symbol, as Panofsky has shown in another

brilliant essay,[22] but as an emotional factor, as a thing of beauty inspiring ecstasy. For this purpose there was no need for the perspective to be exact: it could be exaggerated—there could be more than one system of perspective in a single picture; but these receding lines of vision, these diminishing figures, the harmonic graduation of every element represented—the whole perspectival complex—worked on the senses, much as Gothic vaulting had worked on the senses, and the results, in a painter like Jacopo Bellini (Plate 59) or Piero della Francesca (Plate 60), were wonderfully moving—the most exquisite variation on space consciousness ever achieved by the miniature and two-dimensional craft of the painter.

But only an artist of Bellini's or Piero's intelligence and sensibility could maintain such a delicate equilibrium. To keep the artistic consciousness uncorrupt would have meant keeping the *sensation* of perspective distinct from the *idea* of perspective, and that proved too difficult. "Our art," Bernard Berenson has observed, "has a fatal tendency to become science, and we hardly possess a masterpiece which does not bear the marks of having been a battlefield for divided interests." The decisive battlefield was to be the mind and art of Leonardo da Vinci.

To see in Leonardo anything less than a supreme genius would have an air of paradox and impertinence. But it is a tragic fact—indeed, the fact of tragedy—that a man can be at the same time great and disastrous: it is the destiny typified in Faust, exemplified in Napoleon. We cannot deny to Leonardo a purity of consciousness in which feeling—his feeling for the personality of the particular woman he used for a model in the Uffizi *Annunciation*, for example (Plate 61)—remains suspended as in a kind of crystalline equilibrium, in poetic innocence. If science intervened, it was only to serve as an instrument which the painter unconsciously grasped. But in those lost or never completed monumental transcripts of reality, of which the Anghiari battlepiece was the type, the science is all too evident, and the immediate sensibility, present in the preparatory sketches, is lost in the conscious effort of composition (Plate 62).

This great but divided nature is revealed in all its tragic grandeur in the notebooks, the last testament of classical art. They show with a detail and careless abandon that have never been exceeded the workings

of a great mind. There, side by side, we find feelings and sensations recorded in all their poetic actuality, and these same feelings and sensations converted to idea, coldly analysed and dissected, materia physica, what Donne, in a phrase which Charles Eliot Norton loved to repeat, called

Those unconcerning things, matters of fact.

Here, from the notebooks, is an experience, a thing seen, held in the pure consciousness, as sensation (Plate 63):

Amid the whirling currents of the winds were seen a great number of companies of birds coming from distant lands, and these appeared in such a way as to be almost indistinguishable, for in their wheeling movements at one time all the birds of one company were seen edgewise, that is showing as little as possible of their bodies, and at another time showing the whole measure of their breadth, that is full in face; and at the time of their first appearance they took the form of an indistinguishable cloud, and then the second and third bands became by degrees more clearly defined as they approached nearer to the eye of the beholder.

And the nearest of the above-mentioned bands dropped down low with a slanting movement, and settled upon the dead bodies, which were borne along by the waves of this great deluge, and fed upon them, and so continued until such time as the buoyancy of the inflated dead bodies came to fail, and with slow descent they sank gradually down to the bottom of the waters.[23]

This is pure observation, such indeed as a scientist would make. But the analytical reason has not yet intervened with its *why* and *how*, and therefore the vision, realized in words, is conveyed in all its integrity to the reader, and a direct emotional response takes place. The same faculties would be engaged in giving a plastic representation to the same scene in paint. But when Leonardo, in another place, begins to instruct the painter in methods for making such a representation, he lays down precepts which were to corrupt the artistic consciousness of Europe for the next three centuries. "Holding up the mirror to Nature" is the substance of it all, and this is what Leonardo actually recommended:

When you wish to see whether the general effect of your picture corresponds with that of the object represented after nature, take a mirror and

set it so that it reflects the actual thing, and then compare the reflection with your picture, and consider carefully whether the subject of the two images is in conformity with both, studying especially the mirror. The mirror ought to be taken as a guide—that is, the flat mirror—for within its surface substances have many points of resemblance to a picture; namely, that you see the picture made upon one plane showing things which appear in relief, and the mirror upon one plane does the same. The picture is one single surface, and the mirror is the same. The picture is intangible, inasmuch as what appears round and detached cannot be enclosed within the hands, and the mirror is the same. The mirror and the picture present the images of things surrounded by shadow and light, and each alike seems to project considerably from the plane of its surface. And since you know that the mirror presents detached things to you by means of outlines and shadows and lights, and since you have, moreover, amongst your colours more powerful shadows and lights than those of the mirror, it is certain that if you but know well how to compose your picture, it will also seem a natural thing seen in a great mirror.[24]

The mirror might have been made an image of the pure consciousness, but only metaphorically speaking. This literal application of the mirror represents a corruption of consciousness because consciousness is not thus mechanically inclusive. Even the eye, as experimental psychology has proved,[25] does not receive the kind of image that is reflected by a flat mirror—various distortions arise when an effort is made to represent the peripheral objects in a field of vision in relation to the point of focus. A mirror reflection corresponds to the laws of perspective, but in vision objects "regress" (in different degrees in different people), and what is actually seen is not a perspective representation but a phenomenal shape that approximates to it. But the real objection to Leonardo's precept springs from the fact that consciousness is never simply visual: it is a total sensational experience in which are combined sensorimotor responses of a complex range—not merely conditioned reflexes to color, for example, but also associated tactile sensations. Some of Leonardo's precepts are recommendations to the painter to observe his own sensational reflexes, so that he is not deceived into copying conventional types; but the majority of his precepts are in effect nothing but formulas for such conventional types: the fixation of emotional clichés. Here is an example from the notebooks:

A man who is in despair you should make turning his knife against himself, and rending his garments with his hands, and one of his hands should be in the act of tearing open his wound. Make him with his feet apart, his legs somewhat bent, and the whole body likewise bending to the ground, and with his hair torn and streaming.[26]

A whole repertory of such histrionic attitudes, for most of which Leonardo was responsible, passed into the academies which began to rise up all over Europe in the seventeenth century, and not till Constable, Delacroix, Manet, and Degas revolted against such artificiality was the artistic consciousness again purified. Even then it took the best part of a century for consciousness to recover its complete integrity.

Leonardo was fully conscious of the dangers of a theoretical approach to art, and again and again warns the novice not to place theoretical precepts above the observation of nature. But conscious as he was that "the supreme misfortune is when theory outstrips performance," he nevertheless insists on the conscious, analytical approach in art. He did not discount the imagination; but

you should apply yourself first of all to drawing, in order to present to the eye in visible form the purpose and invention created originally in your imagination; then proceed to take from it or add to it until you satisfy yourself; then have men arranged as models draped or nude in the way in which you have disposed them in your work; and make the proportions and size in accordance with perspective, *so that no part of the work remains that is not so counselled by reason and by the effects in nature.*[27]

He is preoccupied throughout his notebooks with the science of perspective, which he calls "the bridle and rudder of painting."

Those who are enamoured of practice without science are like a pilot who goes into a ship without rudder or compass and never has any certainty where he is going.

Practice should always be based upon a sound knowledge of theory, of which perspective is the guide and gateway, and without it nothing can be done well in any kind of painting.[28]

Leonardo realized that perspective is an ambiguous term—recognized, indeed, a distinction between "natural" perspective and "accidental" perspective,[29] the former being scientifically geometrical, the latter "that which is created by art," an adaptation of

theoretical perspective to the flat surface on which this perspective is represented in a painting. But the whole purpose of his precepts is to recommend the artist to check the accidental perspective of art by the natural perspective of science, and there is no sign anywhere in the notebooks that he regarded perspective as in any sense "symbolical"—that is to say, as a technique to be used for the expression of subjective feeling. The phenomenal world is the only reality, and art is the representation of this phenomenal world in all its actuality—"the eye is the universal judge of all objects." That the heart might wish to represent things differently from the way the eye sees them never seems to have occurred to Leonardo—unless that realization came to him when he wrote, at the foot of a "page of mathematical and architectural drawings, and others anatomical of the generative functions," *I have wasted my hours.*[30] And there is a note in the Forster MS that is still more tragical: "If liberty is dear to you, may you never discover that my face is love's prison."[31]

I will attempt to summarize the main conclusion of this somewhat rambling chapter. Out of a conceptual notion of "real" space had arisen an illusion of the real itself, of a positive and measurable reality. An external world was posited, solid and substantial in its continuum of space, and the artist was expected to represent this external reality by practical methods that could be acquired in academies of art. A prodigious skill was developed in Western Europe, the main object of which was no longer to create symbols for feeling or intuition, but rather to construct an illusion of space through which objects could be seen in perspectival coherence. The objects could, of course, be arranged to tell a story, but the story must then be judged by a moral criterion—the criterion so forcibly advocated by Tolstoy in *What is Art?* But more often reality was its own justification—the reality of the landscape or the still-life, sufficient in its own there-ness. This simulacrum attained, with no emotional satisfaction, pathos or sentiment is then introduced: feeling is indulged, not defined. But the purpose of art is not to expend feeling, or excite feeling, but rather to give feeling *form*, to find its "objective correlative," so that we may recognize it for what it is, for what it signifies in our discourse. Art is always the

instrument of consciousness, as apprehension, realization, materialization.

The metaphor of the mirror was to be replaced, during the Romantic period, by other metaphors of a more appropriate kind—Coleridge's fountain, Hazlitt's lamp[32]—but no metaphors are really adequate for the artistic process. Art itself is a metaphoric activity, finding (rather than seeking) new symbols to signify new areas of sensibility. The post-Renaissance period should be regarded as one in which an infinite refinement of accepted symbols took place, and, as a parallel or consequent development, there was an infinite refinement of imagination and thought. But a time came when all that could be done had been done: refinement ended in sophistication, and little remained but repetition and return. But out of this very weariness and fantasy a new consciousness was to be born—the consciousness of the unconscious. A further attempt was made to circumvent all ideals, whether of God or of Man, and to present not the illusion of the real but the reality of consciousness itself—subjective reality.

VI

FRONTIERS OF THE SELF

*And is it not true that even the small step of a glimpse through the micro-
scope reveals to us images which we should deem fantastic and overimagina-
tive if we were to see them somewhere accidentally, and lacked the sense to
understand them?*

PAUL KLEE

THE self has been defined as "simply that which knows and wills and
feels."[1] As such it is not a thing of which we can be aware, even by
introspection. "I am quite unable to convince myself," writes Pro-
fessor Paton, the author of the definition I have just quoted,

that introspection ever takes place at all. I can observe a color, I can even
perhaps observe a table, but what I cannot observe is my act of seeing or
observing. I can remember, but I cannot observe remembering; I can
think, but I cannot observe thinking. I can also will, and I can distinguish
between voluntary and involuntary movement of my body but, curiously
enough, in spite of the utmost efforts to do so, I have never been able to
observe willing. In all cases of attempted introspection I seem to find
myself observing not a mental activity but the object to which it is directed
or by which it is accompanied.[2]

And Professor Paton concludes that

we have no direct or relatively immediate acquaintance with a special
object or fact called the self which is capable of being observed in isola-
tion from other objects as sound or color can be said to be observed in
isolation from other objects.[3]

And yet, at some stage in human development, man conceived the
idea of a self, of a distinct personal identity, and made this self an
object of pride, an object to be exhibited as separate, and valued for

its separateness, its distinctiveness, its eccentricity. How did this awareness of a self come about; how was it isolated from the continuity and wholeness of experience which is characteristic of man as an animal and as a member of a social group?

The philosopher's answer to this question is somewhat tautological. Professor Paton, for example, who will not admit (rightly, in my opinion) that we can have any knowledge of the self by immediate observation, or introspection, substitutes words like "reflection" or "inference" which are logically, or philosophically, more exact, but which do not give us much idea of the genetic process involved. "The distinction between self and objects or the consciousness of objects as objects arises . . . only from a self which has reflected. It is by reflection that the self makes itself a self and makes its objects objects."[4] But there is no clear definition of this key word, "reflection"—it is just the activity by means of which we become aware of the distinctions between subject and object, the knowing and the known, and in spite of his protest to the contrary, it seems to me that Professor Paton is merely introducing the idea of introspection under another name.

The distinction he tries to make between these two terms is based on the definitions of another British philosopher, Samuel Alexander, who held that the *awareness* involved in the relation between subject and object, between the knowing and the known, was one of enjoyment. Self-knowledge is, according to Professor Paton, this kind of awareness—it is a primitive feeling of enjoyment of which we become conscious by dwelling on it:

To say that a mind enjoys itself and contemplates its objects is to describe not a primitive unreflective experience but a highly developed and reflective experience. The distinction between self and objects or the consciousness of objects as objects arises . . . only from a self that has reflected . . . The self is not a self till it is self-conscious. And there are no objects until they are distinguished from the self.[5]

I will leave aside for the moment the problem of what is happening in the mind in the intermediate or transitive stages between one reflective experience and another—there is, for example, an anticipatory state of consciousness which is the intention-to-reflect. We

speak of "absence of mind," of gaps in consciousness. As William James observed, "there are innumerable consciousnesses of emptiness no one of which taken in itself has a name, but all different from each other. The ordinary way is to assume that they are emptiness of consciousness, and so the same state. But the feeling of an absence is *toto coelo* other than the absence of a feeling."[6] In other words, there are perceptions which never become articulate to the conscious mind, and these too, we must assume, are an essential part of the self. Is it possible that one of the functions of art is to bring these inarticulate perceptions into consciousness?

If we accept Professor Paton's view that it is by reflection that man becomes aware of his self, we are left under the necessity of accounting for the origins or development of this faculty. By what process do we articulate a consciousness of the self in such a manner that we experience a conscious enjoyment of that self *as a self*?

In Chapter II I suggested ways in which man might have become conscious of geometrical patterns—of forms as such abstracted from his practical activities of weaving, basketmaking, potting. But these experiences were not individualized; it may be doubted whether this process, taking place over long periods of economic development, was even conscious. I suggested rather that the human brain was impressed with something in the nature of an engram, or an archetypal pattern: the elements of the abstract designs were a by-product of practical activities, and later naturalistic representations were "composed" in patterns predetermined by the existence of these engrams or archetypes in the mind of the artist. Conditioned modes of configuration became part of the sensible endowment of man at a certain stage of his development.

Even when in later historical times the artist was differentiated from other craftsmen, and his skill was developed as an individual talent, even then there was the strongest impulse to achieve an ideal uniformity, and although distinct personalities do emerge among the sculptors of classical Greece, it is very difficult to ascribe any personal accents to the work of a Myron or a Praxiteles: they may differ in skill, in their nearness of approach to an ideal perfection, but they do not express, and were not expected to express, the uniqueness of an individuality. Their *style*, we might say, is impersonal, and it is only

when we can speak of a personal style that we can expect to find any manifestation of a consciousness of the self.

Dr. Meyer Schapiro has investigated the problem of style in a brilliant essay[7] which leaves little more to be said on the subject. From this essay emerges a very clear differentiation between "style" as characteristic of an individual and "style" as characteristic of a group. In each case style implies a constant factor—"a system of forms with a quality and a meaningful expression through which," as Dr. Schapiro says, "the personality of the artist and the broad outlook of a group are visible."

But between style which is a "manifestation of the culture as a whole, the visible signs of its unity," and style which is a manifestation of the unique personality of an artist, there can only be an ambiguous connection. In the one case we have a common denominator, something so universal that it contradicts the very notion of self-assertion; in the other case, something so particular that its possession by more than one person would give rise to charges of plagiarism or unconscious imitation. It is true, of course, that the style of a particularly strong personality may infect the personalities of weaker artists of the same or a later period, and that is one of the possible explanations of the origin of a period style. But we are concerned with style as the expression of the "man himself," and I wish to ask whether a specific dimension of consciousness is involved, and, if so, how it arose and how it has developed. When does awareness of style in this sense first appear, and how is it related to that process of reflection by which, according to Professor Paton, the self makes itself a self and makes its objects objects?

"Know thyself" is one of the earliest precepts of philosophy, as it is one of the latest prescriptions of psychology. But exactly how shall we know ourselves? We can pinch ourselves, weigh ourselves, look in the mirror, and recollect our behavior over as long a period as we dare. We can savor our sensations and analyze our emotions. But what is the entity of which we then become conscious? Narcissus looks into a pool and becomes aware of a distinct image of himself, an image as distinct as the flower he sees on the edge of the pool or as distinct as the reflection of this flower in the pool, which he can compare with his perception of the actual flower. But such mirror

knowledge is objective, and superficial. If it bears any correspondence to the self, it is merely symbolic; a man's face is no more than a vellum on which certain signs have been etched by inner experience. Even if we concentrate for a moment on these signs, and try to read them as the representation of our "self," we are bound to read backwards from the sign, and to take from the stream of consciousness what few items fit the external image of ourselves. The self is a fluctuating element: it cannot be focused; it therefore cannot be photographed, or even depicted by less mechanical means. Our existence is a continuous process, but the area of consciousness has no spatial or temporal limits. What we abstract at any moment as the "self" is merely a fixed point where our attention forces certain images to converge and constitute a "state of consciousness," a moment of reflection. But this state of consciousness is not a consciousness of a "self," but only of certain points on the frontiers of the self.

We therefore cannot *know* a self; we can only *betray* our self, and we do this, as the phrase indicates, fragmentarily and unconsciously. We betray ourselves in our gestures, in the accents of our speech, in our handwriting, and generally in all those forms or configurations (Gestalten) which automatically register the track of the stream of consciousness. All art is in this sense an unconscious self-betrayal, but it is not necessarily an awareness of the self betrayed.

The general tendency throughout the history of mankind has been to suppress all traces of a self—*not* to betray the self, but to remain faithful to what is superior to the self, namely, the group: to the herd or tribe with its taboos, to society with its conventions. In dress, in speech, in handwriting, the instinct is always to conform. In other words, social consciousness has in general been far stronger and far more imperative than self-consciousness. For the greater part of human development self-consciousness, indeed, does not exist. The consciousness of individuality was subordinated to the consciousness of solidarity, of group or class conformity.

This might be demonstrated in an obvious way by a history of handwriting. Handwriting, indeed, is itself a modern word; we speak of Greek or Roman script, and even of "the script of Humanism." We are even astonished nowadays by the uniformity of the

script of our parents or grandparents; it was only the exceptional or eccentric person who, in the eighteenth or nineteenth century, developed a highly individualistic style of handwriting. The ideal was "copperplate script," possessing beauty but not individuality. Only in the signature or autograph would an individual occasionally attempt to display any diversity.

But this is just a simple illustration of the prolonged pressure to conform to a social or period style; it is, of course, equally obvious in the resistance which, since the break-up of the strict stylistic conventions of the Middle Ages and earlier periods, has been accorded to every expression of personal subjectivity in the plastic arts.

Handwriting may be used as a perfect analogy for the process which we are going to investigate, for in a plastic art like painting the personality first betrays itself in the particular configuration given to the brush strokes. This configuration is something which is peculiar to the individual painter, and it is very difficult to imitate consistently. For this reason, infrared photography or a microscopic examination of a painting's brushwork are used by art experts to identify the authorship of a particular work, or to detect a forgery (Plate 72). There are many other factors which can be used in style analysis—range of colors, typical forms, typical compositions—but though all these stylistic traits build up to an index of the painter's personality, they do not in themselves indicate the painter's awareness of a self. Shakespearian experts in the same way will identify the authenticity of a passage in a doubtful play by an analysis of the rhythm and meter, of the vocabulary, of the word lengths, of the frequency of certain vowel combinations, etc., but again, these traits of Shakespeare's personality were not a deliberate expression of a conscious self, and do not even indicate a specific awareness of the existence of that self. They do not, that is to say, indicate an awareness of a self to be expressed by these particular means.

In literature there is a special category for those works which aim at self-description—we call them autobiography. There is every reason to assume that the art of writing would encourage the isolation and recognition of a self, but this has not been the case. Autobiography is not a typical art of the ancient world, for example. "We must not overlook the fact," the famous classical scholar von

Wilamowitz-Moellendorf once admitted, "that just as the Hellenes produced no real historical works, they were unable to conceive an individual man in the full reality of his existence."[8] Personal narratives there are, of course, but what happens to a man is not equivalent to what a man is. There is self-betrayal and even self-portrayal in Cicero, Seneca, Epictetus, and Marcus Aurelius, but such writers, as de Quincey said, "reflect the mind as spreading itself out upon external things, instead of exhibiting the mind as introverting itself upon its thoughts and feelings."[9]

St. Augustine's *Confessions* is the great and almost solitary example of this type of literature in the ancient world. Augustine, says Professor Misch in his *History of Autobiography in Antiquity*, "grasped the psychological problem implicit in the task of making one's inner life intelligible and credible to other men."[10] Even in the modern world autobiography was, until Rousseau made it fashionable, an exceptional art, generally indulged in for confessional reasons; that is to say, the self was betrayed to God, in an act of contrition, not realized for its own sake.

A parallel to autobiographical literature in the ancient world may have existed in portraiture. There are records of a few self-portraits in ancient art—there is even a copy the original of which may have been Phidias's self-portrait[11]—but these fragments are either too small or too summary to have any significance for our argument. The psychological penetration of many of the Roman portrait busts (Plate 65) indicates that contemporary self-portraits of a revealing subtlety may have existed. The strange little enclave of portraiture which has survived from the early Christian tombs at Fayum in Egypt and the Byzantine portrait medallions of gold-leaf under glass (Plate 64) again have extraordinary expressiveness, but even if we could assume one of these to be a self-portrait, we should still be in the presence of a *persona*, a mask which might represent a certain state of feeling which the artist wished to express about himself, but which would reveal the inner self only in details of the composition—the vigor or smoothness of the brush strokes, the exaggeration of some feature, such as the eyes, at the expense of other features, the choice of posture and background, color and linear emphasis. Yes, we might say: that is a real man, such as I might meet

in Egypt today, and I should recognize him from this portrait. But in what sense should we "know" the man? Only in the sense that we know or recognize a horse or any familiar inanimate object.

I have been trying, in this book, to avoid the jargon of psycho-analysis, but as we approach the problem of self-realization we cannot avoid certain distinctions which have been made by individual psychology, and among them is this concept of the *persona*, a term I used in the preceding paragraph and which I adopt from Jung. The *persona* is not to be confused with the personality; on the contrary, it is the mask we present to the world, and is usually an effective dis-guise for the inner self. The self-portrait is a re-presentation of the *persona*, and there can be no doubt that the self-portrait, from Greek or Roman times down to the end of the nineteenth century, is only a partial and deceptive description of the integral self. Even that integral self can never be realized in any final form, for, as Jung says, "just as man is always that which he once was, so he is always that which he is yet to become." The personality expands as it increases its self-awareness. "This growth of personality proceeds from the unconscious, whose frontiers cannot be defined. Therefore the scope of the personality which is gradually being realized is practically illimitable."[12]

There are a few insignificant self-portraits in medieval art, but it is not until we reach Van Eyck and Fouquet that self-portraits with any psychological penetration begin to appear, and then they come thick and fast throughout the Renaissance period. As examples I illus-trate two or three drawings, since these are more instinctive, less consciously deliberate than paintings. Leonardo da Vinci's draw-ing of himself, for example (Plate 66a), is a shrewd and unflat-tering portrait: we feel we know the man from this rendering of his physiognomy, but what we see is the *persona*, the mask, and though we may accept these lines as a symbol of the self beneath the mask, the real dimensions of that self remain hidden. Even if we are intuitive in this respect, a so-called "good judge of character," it is the character that we judge, and not the passions and desires, the anxieties and the dreams, that constitute the self.

It is possible, of course, to be less objective than Bellini—to be more subjective and to that extent more revealing of the inner life.

Dürer's self-portrait (Plate 66b), a pen drawing made when he was about twenty (1493), shows the young artist, probably reflected from a mirror, but striking an attitude, as it were—an attitude of skepticism or even self-disgust. But we still see only the mask, and only one aspect of the artist's inner self. There are several other self-portraits by Dürer which illustrate other moods, but even a thousand such portraits would not reach the frontiers of that self. Titian, Tintoretto, El Greco, Rubens, Goya—all these great portraitists are not least great when portraying themselves. Yet, expressive though they are, the self-portraits still present only an outer facet of the inner reality. But with Rembrandt begins an attempt to get below the mask, to render an inner subjective state irrespective of fidelity to outward appearances. Rembrandt depicted himself, in oil paintings, etchings, and drawings, close on one hundred times, and each time we learn something more about Rembrandt. To some degree, therefore, Rembrandt fulfils Jung's requirement and exhibits the personality as a developing phenomenon. Technically, the progress is towards an increased subtlety of texture, the psyche seeming to penetrate the painted mask and make of it a vibrating register of the inner life of the artist (Plate 67a). But Rembrandt evidently felt that even this degree of revelation was inadequate, and the *persona* gradually disintegrated under the stress of the inner reality (Plate 67b). The surface lost its smoothness, its conventional symmetry and coherence. The portrait of Aix (about 1659) is a sketch for a more finished painting, but that gives it a more instinctive, confessional quality, a *furor germanicus*, as Wilhelm Pinder says. A little of the same *furor germanicus* is needed to do justice to this self-portrait. It was painted in the mood, Pinder says, with which Michelangelo attacked his hateful, beloved marble—brush strokes like blows of the chisel, directed against the artist's own image.

An in-spite-of-everything feeling must have excited him, perhaps even a fierce recollection of the fire of his long-past youth, a protest against the modest self-depreciation of the London portrait, a protest in whatever manner possible against this particular portrait and its witness to his own aging, and yet at the same time a dialectical completion and correction of the self. . . . The eyes lurk like robbers in their caves, the brow rises like a rugged mountain range, the mouth menaces like a cleft rock, and

everything is in movement and yet rises up out of the swirling waves as through magic incantations. It is what is left after the outbreak of a volcano.[13]

But still, I would add, not the inner self.

Between Rembrandt's time and our own we have a whole series of expressionistic self-portraits. I shall mention only three of them, and first the remarkable drawing by Caspar David Friedrich in the Berlin Nationalgalerie (Plate 68a). Friedrich was an exceptional personality—exceptional to a psychotic degree—and he has unconsciously projected, in this drawing, the abnormal intensity of his ravaged mind. He does this while remaining scrupulously exact: the exactitude is part of the obsession. In the case of Van Gogh, the distortions are more evident, but justified by the expression they give to an inner state of mind. Again, as in the case of Rembrandt, we can trace a progression from self-description to self-analysis, reaching its limit in the last *Self-portrait*, painted in the last year of his life, just after he had recovered from an attack of madness (Plate 68b). Knowing his history, familiar with the pathetic letters of the period, one may read into this portrait all manner of anguish and spiritual despondency, but in his letters of this month Van Gogh speaks only of his lucidity and self-confidence. "They say in painting you must look for nothing, and hope for nothing, except a good picture and a good talk and a good dinner as the height of happiness, without reckoning the less brilliant parentheses. It is true, perhaps, and why refuse to take what is possible, especially if so doing you give your illness the slip."[14] It is not the language of a psychopath, but of an artist.

The development of the self-portrait from Van Gogh onwards shows a progressive disintegration of the outer or objective image, and the substitution of symbolic forms that represent inner feelings (Plate 69a). At first an attempt is made to accommodate such symbols within the mask: the mask is distorted until it becomes a mask of terror, or ecstasy, or, less deliberately, a projection of the Shadow, that darker aspect of our psyche which we normally keep hidden. This development reaches its limit in a self-portrait such as Paul Klee's (Plate 69b), where all objective record of the lineaments is lost, and the symbol of the self exists in self-sufficient independence.

The self, the artist is now telling us, has little or nothing to do with the conventional mask I present to the world: it can be adequately represented only by signs or symbols which have a formal equivalence to an inner world of feeling, most of which is submerged below the level of consciousness.

I believe that the artist would have reached this conclusion without the aid of psychoanalysis: indeed, the artist has been exploring the unconscious for a considerably longer time than the scientist.[15] The foundations of a scientific theory of the unconscious are to be found in eighteenth-century literature and philosophy; and in Schelling and Jean Paul, and later in Schopenhauer, von Hartmann, and Nietzsche, the material for a theory of the unconscious is drawn from the imaginative experiences of the poet and painter. German romanticism was a movement in art largely inspired by the dreams of its participants. "The dream," wrote Ludwig-Heinrich von Jakob, one of the eighteenth-century explorers of this subject,

is the state in which a nervous excitation is sufficient to activate the imagination, but not the senses . . . the intellect does not possess the necessary strength, and only imagination gives rise to representations. The intellect associates them according to certain laws, but its action is feeble. In addition, it confuses such images with the real objects . . . The poetic faculty plays with these activated images, associates them, combines them, creates new images, etc. *The dream is nothing but involuntary poetry.*[16]

What was achieved in this first phase of romanticism was a dissociation of the will, as the active aspect of the intellect, and the imagination. The will was seen as always inhibiting or distorting the free play of the imagination, and this "free play" was identified with the "real self." The unconscious, the dream world, became a refuge from an impersonal and harsh materialistic world. This artistic retreat to the unconscious can best be studied in the art of literature, where we find a whole epoch of poets, from Jean Paul to Tieck, from Novalis to Nerval, from Schelling to Coleridge, accepting the unconscious as the source of their inspiration. The same tendency was manifested in the art of painting, but the tyranny of the Gestalt, of the logical or perceptually clear arrangement, was to prevail for another century. It is true that the plastic artist nevertheless managed

to express a dreamlike sense of irrationality, and the paintings of Caspar David Friedrich are the best illustrations of Amiel's famous aphorism: a landscape is a state of mind (Plate 70). Friedrich wrote that art acts as a mediator between Nature and Man. "The painter," he said,

should not merely paint what he sees in front of him but also what he sees in himself. Should he not see anything in himself, he should abstain from painting what he sees in front of himself. Otherwise his paintings will be like those Spanish walls behind which we only expect to find the sick or even the dead.[17]

There is still, in German romanticism, a sense of compromise with objective reality, though in itself this reality is an inanimate stage, to be peopled with the lively figures of the imagination. But these last traces of objectivity were to be gradually dissolved, not only in the experience of the poets and painters of the nineteenth century, but systematically by the contemporary philosophers and psychologists. By the end of the century there is nothing left of it. "It is an extra- ordinary thing," we find Victor Hugo writing towards the end of his long life,

but it is within oneself that one must look for what is without. The dark mirror is deep down in man. There is the terrible chiaroscuro. A thing reflected in the mind is more vertiginous than when seen directly. It is more than an image—it is the simulacrum, and in the simulacrum there is a specter. . . . When we lean over this well, we see there, at an abysmal depth in a narrow circle, the great world itself.[18]

I might have quoted similar statements from a wide diversity of poets and philosophers; Kierkegaard, for example, presents us with a complete metaphysics of inner subjectivity, leading to God. But it was not until the present century that the plastic artist—the painter and sculptor—took the final decisive step, and attempted to represent a purely subjective world, the contents of which might be held to have some correspondence to the true dimensions of the self. Though a partial effort was made to organize this movement, and even to link it up with revolutionary political movements, it is best considered as a manifestation of separate and uncoördinated minds. It is justifiable to consider surrealism as a phenomenon of great importance in the

history of modern art, but its importance was precisely that it encouraged the diversity and upheld the validity of all individual attempts to explore the frontiers of consciousness.

A little thought about the nature of the unconscious will soon bring us to the conclusion that there can be no art of the unconscious as such. The unconscious has always been an epithet hesitating to qualify a substantive. It is a relative term, and psychologists are now agreed that there exist several levels or depths of unconsciousness. The deeper we descend, the less personal the unconscious becomes, until we reach the level of Jung's collective unconscious, where the contents, when we can realize or project them, seem to be universal in structure and archetypal in significance. In his desire, therefore, to realize the self, the artist can go too deep, and it may be that the unconscious elements most characteristic of the self lie just below the level of consciousness, in that penumbra which Freud calls the pre-conscious. But we also have a superior level, the superego, a sort of luxurious penthouse, in which we keep those elements which are a transformation of suppressed wishes, an adaptation of selfish instincts to group requirements.

There is no need on this occasion to present a detailed morphology of the unconscious; it is sufficient to admit its existence, the existence of a level of the psyche that is dynamic and purposive, and that, even in a fragmentary presentation, possesses significance as a making conscious of hitherto unknown features of the artist's self. It seems to be an inexhaustible mine of images. Paul Klee, whom I regard as the artist who has gone farthest in this exploration of the self, left behind him nearly nine thousand works of art (mostly water-color drawings, gouaches, etc.) which in their totality might be held to constitute a fairly accurate chart of his inner world. It would be possible, I believe, to classify Klee's works in an order which roughly corresponded to the depths from which they had risen. A good many, for example, are fantasies based on visual experience, on memory images. We see formal elements which are those of a town, or a harbor (Plate 71a), or a garden; but these elements are transfigured. The fantasy has scope in the disintegration and recombination of recovered memory images—vertiginous reflections in the mind of things seen in the outer world. But in other cases, to use Hugo's

metaphor, there is a specter in the well (Plate 71*b*)—a form or figure which does not proceed from any level of conscious or semiconscious memory, but emerges from the dream world, which in itself is a complex sphere of consciousness of which we have very little understanding. We know beyond question that the dream is a purposive activity; we might almost call it a cognitive activity, for when it yields to interpretation, it is found to be concerned with serious matters—matters serious for the dreamer, for one must never forget, as Jung says, that "one dreams primarily, and even exclusively, about oneself and out of oneself."

The self we express in dreams, and in works of art that are an expression of a dreamlike activity, is not necessarily beautiful. Beauty, as the Surrealists insisted, is no longer in question, and it is doubtful if we can speak of "vitality" in the animalistic or sensational sense. Roger Fry used one of Klee's drawings to illustrate what he meant by "sensibility" in a work of art—a certain quality in the execution of a work of art revealed by the sensitivity of the lines, by the relations of tone and color, and by the handling of paint.[19] All this we get in Klee's paintings, as well as that other form of sensibility which is his feeling for the general planning of the design—for what we have called the Gestalt.

It is obvious that these qualities are instinctive; that is to say, they are not acquired by any process of learning, but are a direct product of the artist's nervous organization. As Fry said,

It is almost certain that in these intimate rhythms which make up the texture of a work of art, in those parts which are due to the artist's sensibility, we pass into regions which elude all mathematical statement, as indeed do all but the simplest organic forms. We pass from rigid and exact relations to complex and endlessly varying rhythms, which we may perhaps be allowed to call, hypothetically, vital rhythms, through which the artist's subconscious feelings reveal themselves to us by what we call his sensibility.[20]

According to the Gestalt theory of perception, there would intervene, between those subconscious feelings and their revelation in a painting, a process of automatic organization: the elements *in* perception are given a balanced organization as they emerge *as* perception. It is still an automatic and subconscious process, but, according to the

psychologists, it is the process upon which depends a coherent mode of communication. The effectiveness of the communication requires that the energy involved be "organized" with economy, or with precision.[21] "Psychological organization will always be as good as the prevailing conditions allow"—this is the Gestalt psychologists' law of *Prägnanz*, and by "good" in this formula he means "regular," "symmetrical," "simple," or "satisfying."

The formality of most works of art, as we have already seen, is a result of this "law of Prägnanz," but there are certain modes of expression which seem to evade the law. Handwriting is one of them; its variations, which alone make it significant in relation to the writer's personality, obey no law of Prägnanz—they are "free." The *portamento* in music, an effect produced by gliding the voice gradually from one tone to the next through all the intermediate pitches, occasionally interposed by the composer, is another. Recognizing these exceptions to the law of Prägnanz, a London psychologist, Dr. Anton Ehrenzweig, has recently elaborated a concept, which he says was first suggested to him by some of my own speculations, of Gestalt-free art forms[22]—by which he means organizations of perception and communication which are not "good" in the sense of being regular or symmetrical, but still significant as expressive form —as forms corresponding to certain kinds of feeling. "Our observing surface mind," writes Ehrenzweig, "has at its disposal only fully articulate Gestalt structures for its task of grasping the utterly mobile and fluid structures lifted from the deeper layers of the mind by the oscillations of consciousness." These "fluid structures" are either unarticulated, and thus treated as "gaps" in consciousness—a looseness of thought against which, as I have already noted, William James protested—or they are represented by secondary Gestalts which are *too* articulate. We therefore fail to recognize the inarticulate structure of certain art forms which do correspond to these form experiences which come from the lower layers of the mind.

Ehrenzweig's concept of the Gestalt-free art forms is fully borne out by certain types of modern art, and since he first put forward his hypothesis,[23] there has been a considerable efflorescence of a type of art which gives further support to the theory. This type of art seems to have had its immediate origins in the paintings of Jackson Pollock,

a painter who was at first treated with considerable contempt by the critics. There are, however, many parallels in earlier surrealistic practice. Pollock's method is to dribble paint on a canvas in apparently aimless and inconsequent streaks and spots, and hope for the best. He achieves an allover texture in which the eye wanders as in a jungle, discovering an orchid here and there. There are now a considerable number of artists experimenting in this apparently aimless technique. Sometimes they splash on to the canvas, usually in black paint, an autographic scribble (Plate 73); Soulages, Mathieu, and Hartung paint in this way. There is more than a superficial resemblance between Mathieu's signature and the painting which appears above it—the painting is a free signature. Even in a painting by Ubac, the rounded forms of the brush strokes are clearly related to the form of the signature (Plate 76). Others, such as Fautrier and Dubuffet, put on the canvas a shapeless mass of variegated colors (Plate 77); others, like the poet Henri Michaux, create cellular or amoebic shapes that vaguely remind one of microscopic sections from a biological laboratory. Mark Tobey and Sam Francis create a cloudy texture from which no definite forms emerge, but a close correspondence may exist between this texture and the "fluid structure" of their depth perceptions[24] (Plates 74, 75).

If anything is communicated by such paintings, it can only correspond to some unformulated, some unrealized dimension of the artist's consciousness. One observes that, formless as these paintings are, they are consistent; each artist has his clearly recognizable style. But what does the style express? What do these Gestalt-free paintings reveal? Is it possible that the artist has now found a method for observing the self in isolation from other objects—for attaining a direct knowledge of a self which is not at the moment in the act of willing something, or observing other objects? These paintings are not the result of any process of reflection—there did not first exist an external object, or even an internal feeling, for which the artist then found an equivalent symbol. The symbol has become an automatic register of the dimensions of the self; the awareness of the self is the awareness of a Gestalt that has not yet been organized for formal communication—that is still free. It is, of course, "communicated" as soon as it appears on the artist's canvas; but the communication is not

controlled. Like the dream, it is a betrayal of the secrets of the self.
It is difficult to estimate the value—shall we say, the social signi-
ficance—of such art. Obviously, beauty is not one of its elements, but
there is immense vitality in some of these paintings—those of
Soulages and Hartung, for example. Is it more than the dynamism
of a rapid scribble? In that case it would be no more than the plastic
registration of muscular rhythms, and of no great significance. But
Michel Tapié, and others who have written about this type of art,
made free with the word "magic." They imply that the very auto-
matism of these paintings endows them with a psychic energy, pro-
ceeding from the depths of the unconscious, and that the tapping of
this energy, and its embodiment in a plastic symbol, creates an object
of mysterious potency. I am too much of a skeptic myself to believe
in an individual artist's ability to practise magic in our midst. Magic,
to be effective, must in my opinion be a product of a certain state of
social consciousness; it is one of the symptoms of a mass psychosis.
But the art critic does not necessarily use the term "magic" in a
strictly anthropological sense; and I do admit, and I think we must
all admit, that the self not only has depths of darkness as yet unex-
plored and uncharted, but even channels of communication with
forces that are collective and archaic. We have only to dig deep
enough into the individual to discover the universal, the *Urmensch*—
or one of the Jungian archetypes that determine the character of our
fantasies.

"Presumptuous," wrote Paul Klee,

is the artist who does not follow his road through to the end. But chosen
are those artists who penetrate to the region of that secret place where
primeval power nurtures all evolution.

There, where the powerhouse of all time and space—call it brain or heart
of creation—activates every function: who is the artist who would not
dwell there?

In the womb of nature, at the source of creation, where the secret key
to all lies guarded.[25]

Klee is writing like a mystic, and such revelations of the unknown
do not necessarily form part of any common discourse. The artist
cannot therefore complain if his particular symbols remain un-
recognized, unappreciated. His real task, it might be argued, is to

construct bridges between our disparate personalities, or between his particular personality and universal values. This can be done if the images he creates are "objective"—that is to say, if they embody values that are impersonal or absolute. Klee himself was aware of this necessity:

> What springs from this source, whatever it may be called—dream, idea, or phantasy—must be taken seriously only if it unites with the proper creative means to form a work of art. Then those curiosities become realities—realities of art which help to lift life out of its mediocrity.

It remains therefore to consider, in a final chapter, what "proper creative means" have been adopted in our time to give communal significance to this new consciousness of "that secret place where primeval power nurtures all evolution."[26]

VII

THE CONSTRUCTIVE IMAGE

Where concrete art enters, melancholy departs, dragging with it gray suit-cases full of black sighs.

<div align="right">JEAN ARP</div>

In that high argument for a great philosophic poem which Words-worth called "The Recluse," the poet uses a metaphor which will serve to introduce the difficult notion that is to be the subject of this final chapter. Wordsworth speaks of "the discerning intellect of Man" as "wedded to this goodly universe in love and holy passion"; he proclaims

> How exquisitely the individual Mind
> (And the progressive powers perhaps no less
> Of the whole species) to the external World
> Is fitted:—and how exquisitely, too—
> Theme this but little heard of among men—
> The external World is fitted to the Mind . . .

The "great consummation" of this union is

> The creation (by no lower name
> Can it be called) which they with blended might
> Accomplish.

The idea underlying this argument is not essentially different from that idea of Hölderlin's which I mentioned at the beginning of this book—the idea that poetry is the means of bringing the essence of things into human consciousness: the poet's word is the first establishing of reality.

Reality, we might say, is like a tapestry on a frame, whose design only becomes intelligible as more and more touches of color are added by the weaver. These touches of color are the poet's words or

the artist's images, and Wordsworth may not have meant more than that the poet gradually makes the external world a visual reality by his ability to "arouse the sensual from their sleep of Death, and win the vacant and the vain to noble raptures." But why, then, drag in the intellect?—vivid sensations can be communicated without the aid of the intellect; and why speak of the "progressive powers . . . of the whole species"; and why, finally, use the word "creation" when "revelation" or "discovery" would have been more appropriate?

There are two possibilities, and I think they were both present to the minds of the romantic poets: the idea that the poet reveals a reality already existing on some transcendental plane, and the idea that in some manner he creates a wholly new reality. Coleridge speaks of his own "shaping spirit of Imagination," and we have only to go back to the sources of Coleridge's ideas in Schelling to find that the notion of "shaping" is quite general—it could imply the shaping of a language, the symbolization of a feeling, and, more particularly, the materialization of transcendental intuitions. But a real, and not a metaphorical, process of gestation is implied; Coleridge is never tired of insisting on the "essential difference" between "the shaping skill of mechanical talent" and the shaping power of the imagination, which is "the creative, productive life-power of inspired genius."

It would be outside our present scope to discuss these ideas in relation to poetry, and I only introduce them here because, though formulated in relation to the art of poetry, these same distinctions have determined the whole course of modern painting and sculpture. In what sense is man *creative*? He "creates" a poetic image, or a musical phrase which is also an image in our sense, or a composition of forms and colors, which is again an image, a visual image. But these images are taken from the visible world, which was not created by man; the musical phrase is made up of notes which again are natural sounds, or sounds produced by existing objects; and the pictorial composition, even if it is, as we say nowadays, abstract or nonfigurative, is still a composition of colors that are natural, of forms that are taken from nature—even geometrical forms have their prototypes in plants, crystals, and other natural phenomena.

Coleridge was fully aware of this objection to a "creative" theory of art, and he therefore advanced the concept of organic imagination. He claimed that there was an essential difference between a constructive activity that merely assembles and re-arranges discrete elements and an organic activity that has assimilated these elements into its own system and proceeds to give birth to a new living reality—not an assembly of parts but a new organic whole,[1] an integrated organism.

If we take Coleridge's own examples of what he means by an organic work of art—a play by Shakespeare, for example—we do not at first sight find a new structure—the *shape* of a play by Shake-speare, if it has one, is the traditional five-act drama; nor do we find original plots or original types of humanity—the claim is rather that in this respect Shakespeare faithfully reflects human nature and the spirit of his times. He has humanity, and humor, and tragic grandeur, and these constitute his "greatness." But his "originality" lies in his poetic diction, in his rhythms and his verbal music, in his images and metaphors—all elements that reflect the uniqueness of his personality or self. But the more we strive to isolate these personal elements in a work of art, the less structural they become. The essential feature of a personal work of art is that it is, as we saw in the last chapter, "Gestalt-free."

Naturally, we find such indefinite forms in literature no less than in a graphic art like painting. From the beginning of the Romantic Movement onwards the tendency has been to substitute Coleridge's "organic" forms for geometric or schematic forms. The endeavor of the romantic poet is always to establish an equiva-lence between a subjective feeling and a spontaneous flow of words symbolic of that state of feeling. The final stage of that development was reached by James Joyce in *Finnegans Wake*; and, as we saw in the last chapter, in the paintings of artists like Jackson Pollock or Sam Francis form dies away in an amorphous "Cloud of Unknowing."

The self or personality, we may therefore admit, is most accurately conveyed in amorphous or Gestalt-free paintings or poems, but we live, not as discrete personalities exchanging our paintings like visiting cards, but as members of communities with common

needs and activities, and we are under the necessity of creating, as we intermingle with our fellows, a plan of action. This is, in plastic terms, a certain organization of time and space which makes life not only possible but even agreeable. Maybe the human animal would not continue to live unless he had evolved the capacity to wear a shell—a carapace which is not only the houses of brick or wood that we dwell in but a general realization of human dimensions in space and time. We have plotted the constellations and divided the year into units which conform to cosmic events: we have invented thousands of measures and instruments which enable us to manipulate matter and to impose a human scale on the terrifying chaos of the visible world. All these are extrovert activities— dominations of matter or limitations of consciousness in the interests of internal feeling.

The types of art we have considered so far have always been conceived as symbolic modes of expression: the creation of a form to signify a feeling. But Cassirer, who is the best representative of this symbolic theory of art, has emphasized that the forms of art in addition "perform a definite task in the construction and organization of human experience. To live in the realm of forms does not signify an evasion of the issues of life; it represents, on the contrary, the realization of one of the highest energies of life itself. We cannot speak of art as 'extrahuman' or 'superhuman' without overlooking one of its fundamental features, its constructive power in the framing of our human universe."[2]

In the same way I would say that we overlook the constructive power of art if we regard it as exclusively "superreal," or "personalist." To explore the frontiers of the self—that, I have argued, is also a constructive task. But to open an umbrella over one's own head is one kind of constructive act; to lift a dome over the heads of a wondering congregation is another kind of constructive act. To sink a well into the depths of the individual psyche is also a constructive act, especially if we reach the collective dreamline; but to conceive a system of metaphysics in which all individual visions are unified or reconciled is another and a different kind of constructive act. We seem to be impelled, therefore, to distinguish between two types of art, two kinds of artistic activity, though not, I think, to

express any judgment of their relative value. We cannot say, for example, that the mind that conceived the plan of St. Peter's was greater than the mind that conceived the *Pietà* which he carved and placed within St. Peter's: it was the same mind. We cannot say that a creative source of symbolic forms, such as Klee or Picasso, is more or less significant than a creative source of constructive forms such as Le Corbusier or Mies van der Rohe. Some difference of mental faculty is involved, and this we must try to make clear. That it is not a difference of personality is proved by the fact that in some instances, such as Michelangelo and Le Corbusier, the same artist functions in the two manners, as symbolist and as constructivist.

I emphasize this point because the works of art which I am now going to discuss are radically different in appearance from those I discussed in the preceding chapter; and it is possible that their appeal is more limited because they are impersonal, not personal; objective, not subjective; constructive, not expressive. They must still work on our senses, or they would not be works of art. But they differ as much from the works of art I dealt with in the last chapter as the geometric forms of the Neolithic period differed from the animal forms of the Paleolithic period: they are, in short, images of harmony rather than images of vitality. We have previously recognized that even geometric forms may possess a dynamism similar in aesthetic effect to vitalism. The real distinction is between organic and inorganic forms, and there are no doubt particular reasons why, in our age of anxiety, mankind should once more turn to inorganic types of art.

It is usual to trace the origins of modern abstract or nonfigurative art to Cézanne (Plate 78). From our point of view, and it was perhaps Cézanne's own point of view, his effort was part of that general attempt to represent an objective reality which I considered in Chapter V. Such a reality, I suggested, was an illusion; or, at any rate, the attempt to represent it involved a corruption of the artistic consciousness—involved the introduction, into the perceptual process of art, of conceptual modes of cognition that destroy the aesthetic validity of the representation. A sense of reality should never be confused with a science of optics. Cézanne's agonized

career as a painter is to be understood as an attempt to realize an objective world without abandoning the sensuous basis of his aesthetic experience. He always used the verb *réaliser* in this transitive sense.

Aldous Huxley has recently shown that under the influence of the drug called mescalin a heightened sense of reality, of the "isness" of things, is induced: forms are more clearly defined, colors are more intense, etc., and this heightened sense of reality is due, according to his theory, not to an extension of normal faculties but rather to a relaxing of the inhibitions that normally reduce consciousness to manageable proportions.[3] An artist like Cézanne, it would seem, may be attempting by intense concentration to reach a clarity of perception that can be more quickly reached by drugs, the difference being that the drugged person shows no desire or ability to record his vision in plastic images. But to record this mere sense of "isness," I argued, is not in itself a sufficient aim of art: art is its own reality: it is the revelation or creation of an objective world, not the representation of one. This was Cézanne's great, though perhaps incidental, discovery. He found himself giving to reality—to real things like mountains, trees, and people—a structural configuration which was not the surface appearance of these things but rather their supporting geometry, their spatial depth, their immaculate colors devoid of high lights or shadows. His pictures became what he called "constructions after nature, based on the methods, the sensations and developments suggested by the model."[4] In Cézanne's case this process of realization was never, in any strict meaning of the word, analytical; it was a struggle to achieve a pure state of consciousness before the natural object.

But what was purity of consciousness in Cézanne became sophistication at the analytical stage of cubism. To a large extent the cubist period of Picasso (Plate 79) and Braque represents another corruption of consciousness—a fact which these artists soon recognized, for they abandoned their analytical procedures. But with Juan Gris began that phase of art which was first known as *synthetic* cubism, and which was an attempt to adapt the forms of nature to a sensuously determined picture space of geometrical structure (Plate 80). "It is not picture X," Gris said, "which manages to correspond

with my subject, but subject X which manages to correspond with my picture. . . . The mathematics of picture-making lead me to the physics of representation." The reality was no longer an external illusion to be represented on the canvas; the canvas was divided intuitively into forms of ideal reality to which external objects must conform. It is a return to the practice of the neolithic artist.

Juan Gris died before he could take this development to its logical conclusion, which is an abstract or geometrical art. His direction, or a direction his work inspired, was continued by various artists, among whom Piet Mondrian is outstanding because of the patient integrity of his pursuit of an absolute (Plates 81, 82). We can trace the evolution of his art from an early figurative stage through a stage of synthetic cubism to a completely nonfigurative stage—a slow but logical evolution, always intuitive in its advances, strictly sensuous in spite of its geometrical appearance.

Mondrian claimed that his intention was to create what he called "a new realism." "Gradually I became aware," he wrote,

that Cubism did not accept the logical consequences of its own discoveries; it was not developing abstraction towards its ultimate goal, the expression of pure reality. I felt that this reality could only be expressed through *pure plastics*. In its essential expression, pure plastics is unconditioned by subjective feeling and conception. . . . To create pure reality plastically, it is necessary to reduce natural forms to the *constant elements* of form, and natural color to primary color.[5]

This language differs very little from Cézanne's, but essential to Mondrian's practice was a belief in a "true" reality, which is not the illusion of a scientific perceptual reality such as the Renaissance painters sought, but a basic unity achieved by "the abolition of all particular form," of all "particularities of form and natural color," which merely "evoke subjective states of feeling." One might say that feeling is excluded from this kind of art, that the work of art is no longer a symbol for a state of feeling but rather a logical necessity free from all personal and utilitarian limitations—Hegel's "schöne freie Notwendigkeit." Neither sensation nor feeling is involved, but only intuition—the intuition of formal perfection. Nevertheless, Mondrian did admit that "aesthetic emotion is a factor in art." "Both the plastic expression and the way a work is

executed constitute that 'something' which evokes our emotion and makes it 'art.'" But to avoid any confusion with the emotions evoked by figurative art, he goes on to claim that "art is expressed through *universal* emotion and is not an expression of *individual* emotion. It is an aesthetic expression of reality and of men realized by universal perception."[6]

I confess I do not understand a distinction between individual and universal emotion, but when Mondrian, a little farther on in his essay, goes on to say that the real content of art is an expression of pure vitality revealed through the manifestation of dynamic movement—that a work of art "is only 'art' in so far as it establishes life in its unchangeable aspect: as pure vitality"—we know where we are. We are back to that first principle of art revealed in the prehistoric cave drawings, which I called the principle of vitality, and which, at a later stage, we saw could be represented schematically as in the geometrical abstractions of Neolithic and Celtic art, as well as represented naturalistically, as in the Paleolithic animal style. What, therefore, Mondrian is excluding (as individual emotion) is not anything basic to art—not even the elements of harmony which we identified with the principle of beauty—but rather the humanization of these principles which had taken place in the classical Greek period and which had been revived in the Renaissance period. The expression of pure reality, therefore, is merely a dehumanization of art; but in so far as it is expression—that is to say, makes use of plastic symbols as a means of communication—it does not depart from the basic principles of art and the normal sensuous response to these principles.

But again, what is excluded is the personal rather than the human, for a strong claim is always made for the social significance of this type of art. It enters into collective consciousness as architecture or as industrial design. Geoffrey Scott popularized the phrase "the architecture of humanism," but architecture only becomes human to the extent that it disguises its tectonic significance, its functional elements; to the extent, too, that it relinquishes its claim to exploit space as an expression of transcendental feeling. The human scale in architecture is an arbitrary limitation, and the greatness of Gothic, as we have seen, was due to its superhumanity, to the free exploitation

of abstract elements such as line and volume without any purpose other than "the union of the individual with the universal" —a phrase I had in mind only to discover that it had already been used by Mondrian to describe the aims of pure plastic art.[7] Such an aim is not *in*human; on the contrary, it is the liberation of human faculties from the oppression of our personal, limited vision.

Mondrian never claimed that "a new realism" had been created by himself in his own paintings; on the contrary, he was a modest and saintlike pioneer who wished to show the direction in which artists of the future might lead humanity. He was trembling at the limits of a new dimension of consciousness, and the images he created were merely pointers towards a total reconstruction of our environment. He knew, as all perceptive people know, that the old era of painted canvases and mantelpiece ornaments was at an end. He realized that the traditional concept of the artist—a tradition of twenty-five centuries, it is true, but that is only a tenth part of the history of art—was no longer valid for an age of nuclear fission. The future scale of the artist is not domestic, nor even monumental, but environmental: the artist of the future will not be a painter or a sculptor or an architect, but a new molder of plastic forms who will be painter and sculptor and architect in one—not an adulterous mixture of all these talents, but a new kind of talent that subsumes and supersedes them all. Mondrian realized that he had opened a way which led, as he said,

towards the end of art as a thing separated from our surrounding environment, which is the actual plastic reality. But this end is at the same time a new beginning. . . . By the unification of architecture, sculpture, and painting, a new plastic reality will be created. Painting and sculpture will not manifest themselves as separate objects, nor as "mural art" which destroys architecture itself, nor as "applied" art, but *being purely constructive* will aid the creation of an environment not merely utilitarian or rational but also pure and complete in its beauty.[8] (Cf. Plates 82*b* and 83).

Mondrian was not alone. In addition to his immediate colleagues of *De Stijl* group in Holland, such as Van Doesburg, a younger group of artists, calling themselves Constructivists, took shape in Russia in the 1920s (when Mondrian was already fifty years old). Two brothers, Naum Gabo and Antoine Pevsner (Plates 84, 85), have

been the most consistent and productive artists of this group, and it is Gabo who has given the clearest indications of their intentions. There are differences of formulation as between Mondrian and Gabo, but these relate to the type of imagery which each thought adequate to their common purpose, rather than to their mode of consciousness. Mondrian may have been an idealist—his talk of a "pure" realism suggests it; Gabo is really an empiricist—he believes that reality simply is the world of images constructed by the mind—concrete, tangible, visible images. "The history of mankind," says Gabo,

the history of its material and mental development . . . shows us that mankind never has and never will resign itself to a state of total ignorance and inexorable fatality. Mind knows that once born we are alive, and once alive we are in the midst of a stream of creation, and once in it we are not only carried by it but we are capable of influencing its course. With indefatigable perseverance man is constructing his life, giving a concrete and neatly shaped image to that which is supposed to be unknown and which he alone, through his constructions, does constantly let be known. He creates the images of his world, he corrects them and he changes them in the course of years, of centuries. To that end he utilizes great plants, intricate laboratories, given to him with life; the laboratory of his senses and the laboratory of his mind; and through them he invents, construes and constructs ways and means *in the form of images* for his orientation in this world of his.[9]

"In the form of images"—that is the point. The artist elaborates images which are the images of reality; they *are* reality, for we only discover reality in the degree that we crystallize these images out of the Unknown. The Great Chain of Being—what is it but a chain of images, "an ever-changing chain of images, ever true and ever real so long as they are in use."

If I may use an image myself, human consciousness has been represented in this argument as an octopus of unimaginable dimensions with tentacles ever weaving through the surrounding elements, searching and advancing everywhere, twitching and withdrawing when danger is sensed, but gradually mastering its environment, gradually increasing the range of its knowledge and activity. At the end of each tentacle is the sensitive, image-forming perception

of the artist. To complete the image, one must think of our monster as proceeding in a definite direction, towards some goal not fully realized, animated by some instinct for a fuller and securer life.

This creature has now moved into a new habitat—no longer a habitat of horses and carriages and Newtonian cosmology, no longer a habitat of dark cavelike houses and aristocratic patronage—but a world of electric energy and relativity, of glass and steel, of speed and democratic uniformity. The artist has helped to create this brave new world—with his images. He now moves on towards another and still braver world, and he has the present task of creating images that will adumbrate this world, make it imaginatively conceivable to the alert mentality of modern man. How shall he do this? With images of the past—the Greek image of ideal man, the Gothic image of a transcendental God, the Renaissance image of a serene Arcadia? None of these images has any longer any relevance. The artist must now create new images, images of a possible new world, a world possible in this era of scientific transformation. And this is what the constructive artist is trying to do. "He has found the means and the methods," as Gabo says, "to create new images and to convey them as emotional manifestations in our everyday experience." The images he creates—images such as Gabo himself has created—are not arbitrary or insignificant: they are not, as they are so often called, "abstractions."

They are a factual force and their impact on our senses is as real as the impact of light or of an electric shock. This impact can be verified just as any other natural phenomenon. Shapes, colors, and lines speak their own language. They are events in themselves and in an organized construction they become beings—their psychological force is immediate, irresistible and universal to all species of mankind; not being the result of a convention, as words are, they are unambiguous, and it is for that reason that their impact can influence the human psyche; it can break or mold it; it exults, it depresses, elates or makes desperate; it can bring order where there was confusion and it can disturb and exasperate where there was an order.

But a constructive image, Gabo points out, is not just any image, but one which by its very existence as a plastic vision should provoke in us the forces and the desires to enhance life, assert it and assist its further development.[10]

Can we already detect the transforming influence of such images? We must not be impatient, for human consciousness extends its range very slowly, very cautiously, but we can already discern, in certain tendencies of modern architecture and planning, the presence of images that arise not so much from utilitarian or functional necessity, as from a sense of vitality which is conveyed by this new plastic vision. The façade of the Ministry of Education in Rio de Janeiro, for example, is functional; it owes its superficial pattern to the devices adopted by the architect to exclude the too-strong sunlight of that region. But the sunlight has always been too strong in Rio and other devices have been employed in the past—sun-blinds, shaded balconies, internal patios. The particular device used in the Ministry of Education is an application of the principle of the Venetian blind—slats of metal adjusted to the direction of the sun's rays. But the total effect of the structure conforms to an image— a sense of how to arrange all these elements in a significant pattern. That pattern is a constructive image.

I will make one other comparison, also taken from Brazil. But first consider an example of the work of an artist who does not, I think, call himself a constructivist, but whose images are nevertheless of the kind we have been discussing—Jean Arp (Plate 86). Arp's images are perhaps more biological than architectonic; they seem to be related to elementary forms of organic life as revealed by the microscope. But they are nevertheless well organized and clearly defined and capable of communicating their vitality to the new world which is being created around us. Oskar Niemeyer's project for a theater to adjoin the Ministry of Education in Rio will illustrate the transformation of this image into architecture (Plate 87). This is not an arbitrary structure, a wilful imitation of a piece of Arp's sculpture. It is a living-space perfectly adapted to our modern sensibilities—not functional in the sense so often implied by the word (four square and economical), but functional in the same sense that a Greek temple or a Gothic cathedral was functional—functional in that it is an image of our new spatial and plastic consciousness (Plate 88).

Constructive images of a new kind are being created in our midst, taking their exact shapes like areas of crystallization in the amorphous

fluid of modern consciousness. These images will be proliferated in the years to come, and life will then have been transformed; the constructive image will gradually penetrate all walks of life, and a new style will prevail—a new style of art, a new style in life. Such images, such a style, will no longer be thought of as "constructive," or called "constructive," and it is perhaps already time that we abandoned such a cold and mechanistic word. It is true that a direct relation exists between the constructive image and the concepts of a scientific age: but the image is free—the image-making faculty in man is creative, not constructive. It is the creative image, vital and burgeoning, that we see before us in the work of these artists, and the new reality that takes shape is not the inhuman world of the machine but the passionate world of the imagination.

I take leave of my subject at a point of transition, and if the ideas I have put forward have been expressed clearly enough for the reader's understanding, he will have realized that the history of art and the development of human consciousness are biological processes which we can best study and promote as activities rather than as classified documents. There can be no artificial separation of art and life. We have taken a wide survey of man's creative activities, from prehistory to the present day—a period of perhaps three or four hundred centuries. During the whole of that time—the time in which any records whatsoever exist—we have found not dead rubbish but human artifacts still tremulous with life, still vibrating along our modern nerves, still piercing to our sensibilities, still communicating their vital stimulus.

But that which should accompany such a realization of the primal function of art—a regard for the fundamental significance of art in education and in social organization—can that be said to exist in our contemporary society? Most of us are guiltily aware of the artistic decadence of modern civilization—of that decay of sensibility due to what I have called a corruption of consciousness. We look back on the great cultural epochs of the past, and try to distil their essence in our museums. But the essence that we should be instilling into our own way of life—of that we have little awareness, and that little is merely nostalgic.

In our time we have had great painters and sculptors, great poets and musicians, and they are precious witnesses to the continued development of human consciousness. I believe that such artists have been representative, and that a Wordsworth, a Proust, a Cézanne, a Klee, a Mondrian, a Schoenberg, and a Stravinsky do make conquests of consciousness that are afterwards occupied by the mind in widest commonalty. Perhaps that was always the way; perhaps great artists like Phidias and Praxiteles were also lonely pioneers. But I prefer to regard artists as great conquistadors who lead their people into new dimensions of reality, and I think the very fact that in the most significant epochs of art the artist is a craftsman, often anonymous, not isolated as a laureate, proves my point. We can attach names to certain of the masterpieces of the Middle Ages, but we feel in doing so that we do an injustice to the social integrity of the period. The artists themselves were honored in their time, as good craftsmen and scholars, as we today honor useful scientists and faithful servants of society. It will be said that we also honor our great artists—we give them Nobel prizes or Pulitzer prizes, or seats in a National Academy. But we do not deceive ourselves by such piecemeal patronage. We know that a deep cleavage exists between our mechanical and materialistic civilization and the aesthetic and spiritual values that constitute a culture. We have no unique and typical culture in our time because of that cleavage. Somewhere in the process of upbringing, in the environment we have made for ourselves, there exists a corroding influence, which dissolves the unity of our social consciousness, and by that action prevents the development of aesthetic consciousness. The evil exists in consciousness itself, and we may call it intellectual pride, or spiritual poverty, or metaphysical anxiety; whatever it is, it destroys the innocency of our sensibility, and the gracious spontaneity of our activities.

It is not part of my present purpose to suggest a remedy for our ills, but I have on many occasions in the past made it clear that in my opinion a beginning must be made with a fundamental reorganization of our educational methods. Anxious as we rightly are in this age of technology to sustain the great tradition of liberal culture, we should nevertheless make sure that we do not in the

process muddy with erudition and vain learning those crystal fountains from which flow our most essential creative energies. Those fountains are bedded in the human frame; they are the unpolluted rivers of perception and imagination. Education should therefore be conceived as primarily a cultivation of these sensuous activities, as *aesthetic* education. Such a concept of education has often been proposed by philosophers and poets, and if we find it difficult to accept, it is no doubt because our sensibilities are no longer responsive to the original sources of human vitality and vision. A philosopher whose sensibilities were never dimmed—Henry Thoreau—suggested:

We need pray for no higher heaven than the pure senses can furnish, a *purely* sensuous life. Our present senses are but rudiments of what they are destined to become. We are comparatively deaf and dumb and blind, and without smell or taste or feeling. Every generation makes the discovery that its divine vigor has been dissipated, and each sense and faculty misapplied and debauched. The ears were made not for such trivial uses as men are wont to suppose, but to hear celestial sounds. The eyes were not made for such groveling uses as they are now put to and worn out by, but to behold beauty now invisible.[11]

"To behold beauty now invisible"—to press beyond the screen of habit and convention—such has been the directive impulse of every great epoch of art. We have seen that beauty is not a sufficient word to contain all the attributes of art, but vitality, the quality we must also take into account, brings us still more directly to the realm of the senses, and urges us to repeat Thoreau's questions with renewed force. "What is it, then, to educate but to develop these divine germs called the senses? For individuals and states to deal magnanimously with the rising generation, leading it not into temptation—not to teach the eye to squint, nor attune the ear to profanity. But where is the instructed teacher? Where are the *normal* schools?"

Thoreau, it might be thought, would not have accepted the constructive images of our transitional epoch: he was a rustic philosopher whose vision was cosmic rather than concrete. But he admitted that "This world has many rings, like Saturn, and we live now on the outmost of them."

It is easier to discover another such a new world as Columbus did than to go within one fold of this which we appear to know so well; the land

is lost sight of, the compass varies, and mankind mutiny; and still history accumulates like rubbish before the portals of Nature. But there is only necessary a moment's vanity and sound senses, to teach us that there is a nature behind the ordinary, in which we have only some vague preëmption right and Western reserve as yet. We live on the outskirts of that region.

It is the same voice as Wordsworth's, the poet's voice that would win the vacant and the vain to noble raptures; the same voice as Hölderlin's, telling us that a people without a religion of beauty inhabit a waste land; the same voice as Plato's, prescribing the vision of absolute harmony as the sole remedy for the soul's bitterest pains. Behind all these voices is the conviction that what we call art, and too cursorily treat as an ornament of civilization, is really a vital activity, an energy of the senses that must continually convert the dead rain of matter into the radiant images of life. If we are more than animals, if our minds are transfused by a sense of glory and can therefore lift themselves above a brutal sense of nullity, it is because we possess this gift of establishing images, the bright counters of all our poetic and philosophic discourse. But we only possess this gift and retain it, in so far as we are all, in our degree and capacity, natures in immediate contact with the growth and form of the visible world.

REFERENCES

CHAPTER I

[1] Conrad Fiedler, *On Judging Works of Visual Art*, trans. Henry Schaefer-Simmern and Fulmer Mood (Berkeley: University of California Press, 1949), p. 48. Some account of Fiedler and his work is given in the introduction to this volume, and also in Victor Hammer's introduction to *Three Fragments from the Posthumous Papers of Conrad Fiedler*, trans. Thornton Sinclair and Victor Hammer (Lexington, Kentucky, 1951). The latter is a limited edition, printed and bound by hand.

[2] *On Judging Works of Visual Art*, pp. 43–44.

[3] "Hölderlin and the Essence of Poetry," trans. Douglas Scott, in *Existence and Being*, ed. Werner Brock (London: Vision Press, 1949), pp. 293–315.

[4] See in particular *Epistémologie génétique*, 3 vols. (Paris, 1953).

[5] A translation of his most relevant work, *Die Philosophie der symbolischen Formen* (*The Philosophy of Symbolic Forms*) has been published by the Yale University Press. Vol. I, *Language*, trans. Ralph Manheim, appeared in 1953; Vol. II, *Mythical Thinking*, in 1955; Vol. III, *Phenomenology of Knowledge*, in 1957.

[6] *The Gate of Horn: A study of the religious conceptions of the Stone Age, and their influence upon European thought* (London: Faber & Faber, 1948).

[7] *Art and Society*, 2nd ed. (London: Faber & Faber, 1945), pp. 48–50. Cf. also A. N. Whitehead, *Religion in the Making* (Cambridge: University Press, 1926), pp. 18–19.

[8] A fuller discussion of these problems is given in Herbert Read, *Education Through Art*, 2nd ed. (London: Faber & Faber; New York: Pantheon, 1945).

[9] Worringer, writing in 1906, before the evidence of paleolithic naturalism had accumulated to its present impressive weight, could confidently assert that "the primary element is not the natural model, but the law abstracted from it." He assumes, throughout his epoch-making thesis, *Abstraktion und Einfühlung* (Munich, 1st ed., 1908) [English trans. *Abstraction and Empathy* (London and New York, 1953)] that "the process consists in the subsequent naturalisation of a pure ornament, i.e. abstract form, and not in the subsequent stylisation of a natural object . . . The primary element is not the natural model, but the law abstracted from it" (p. 60).

[10] I prefer to speak of the general technique of prehistoric art as "drawing" rather than "painting", because the instruments used generally had a linear or stippling action rather than a painterly or brushing one.

[11] Max Raphael has suggested that the human hand was used to provide a scale, a "modulor" (to use Le Corbusier's term); cf. *Prehistoric Cave Paintings*, Bollingen Series IV (New York: Pantheon, 1945).

[12] For the various meanings of the word "style" as used in art history and criticism, see Meyer Schapiro, "Style," in *Anthropology Today*, ed. A. L. Kroeber (Chicago: University of Chicago Press, 1953).

[13] "Prehistoric Painting," *The Month*, 1:249 (1949).

[14] G. H. Luquet, *L'Art et la religion des hommes fossiles* (Paris, 1926), illustrates a few small objects (mostly of bone) engraved with plant forms or fishes.

REFERENCES

[15] Leo Frobenius and D. C. Fox, *Prehistoric Rock Pictures in Europe and Africa* (New York, 1937), pp. 22–23.

[16] Strictly speaking, an eidetic image is identical with the image given in perception, but, as I have already indicated, the paleolithic images of animals are to some degree simplified or summary, and are rather to be called memory-images. But the process of simplification may have taken place as the eidetic image was being transferred to the wall of the cave. The "realization" of an image always involves expressive expedients, that is, "stylization." For an interesting comparison of paleolithic art with the art of the blind, see Viktor Lowenfeld, "Psycho-Aesthetic Implications of the Art of the Blind," *Journal of Aesthetics and Art Criticism,* 10, No. 1 (September 1951).

[17] There is a representation of such a disguised human figure in the cave at Trois Frères in the south of France, but what is recognizably human in such a dim image is certainly not realistic. Some of the earlier reproductions of this drawing were hopefully precise. The earlier hand reproduction of the drawing and a photograph of it are shown side by side in *Four Hundred Centuries of Cave Art* by the Abbé Breuil, English ed., trans. Mary E. Boyle (Montignac: Centre d'études et de documentation préhistoriques, 1952), figs. 129 and 130.

[18] C. F. C. Hawkes, *The Prehistoric Foundations of Europe* (London: Methuen, 1940), pp. 41–43.

[19] Vital art, under more favorable climatic and economic conditions, may be an expression of exuberance rather than of intensity, of confidence rather than of anxiety. Cretan art, which is formally of the same character as Levantine or Bushman art, is a refinement, perhaps playfully serious, perhaps seriously playful, of the plastic consciousness developed by the paleolithic artist. The Minoan bulls are distantly, but directly, related to the Altamira bisons. For an interesting discussion of "The Cretan Enigma" see H. A. Groenewegen-Frankfort, *Arrest and Movement* (London: Faber & Faber, 1951), pp. 185–216.

[20] *Henry Moore: Sculptures and Drawings,* ed. Herbert Read, 3rd ed. (London: Lund Humphries; New York, Curt Valentin, 1949), p. xl.

CHAPTER II

[1] Cf. Gertrude Rachel Levy, *The Gate of Horn* (London: Faber & Faber, 1948).

[2] The memory image is itself automatically selective of the significant outlines of an object. Cf. Emanuel Loewy, *The Rendering of Nature in Early Greek Art* (London, 1907), pp. 67–68.

[3] Gordon Childe, *New Light on the Most Ancient East,* new ed. (London: Routledge & Kegan Paul, 1952), pp. 22–23.

[4] See Hans-Georg Bandi and Johannes Maringer, *L'Art préhistorique* (Basle: Editions Holbein, 1952), figs. 18 and 24.

[5] See Abbé Breuil, *Four Hundred Centuries of Cave Art,* English ed., trans. Mary E. Boyle (Montignac: Centre d'études et de documentation préhistorique, 1952), fig. 87.

[6] R. G. Collingwood, *The Principles of Art* (Oxford: Clarendon Press, 1938), p. 202.

[7] Max Raphael, *Prehistoric Pottery and Civilization in Egypt,* Bollingen Series VIII (New York: Pantheon, 1947), p. 76.

REFERENCES

[8] Such as those given by M. Hörner and O. Menghin: *Urgeschichte der bildenden Kunst in Europa*, 3rd ed. (Vienna, 1925). Gordon Childe has an admirable summary of the question (with reference to the pottery from Susa): "The patterns, which are undoubtedly 'magic' in content, are a blend of geometric motives or symbols (swastikas, even-armed crosses, Maltese squares, step patterns, serial triangles, double-axes) and representations (birds, bulls, ibex, mountain goats, dogs, perhaps a horse, more rarely men, quivers and a lance). But the natural objects represented are so stylized as to become pure decorative designs. Frankfort terms this treatment 'abstract' and regards it as indicative of the abstract mentality of the artist. But W. Bremer (*P. Z.*, XVI, 1925, 22) has recently shown in detail that the precise form of the stylization has been conditioned by basket-work, while many of the vase forms might also be regarded as copying baskets (as at Ubaid). In other words, the Susian potter is copying basketry models, and the peculiar shapes he gives to animals are due to the exigencies of plaiting straw. . . . At the same time the birds and animals as well as the geometric symbols are the forerunners of divine or magic signs later engraved upon seals and sometime eventually converted into elements of writing" (*New Light on the Most Ancient East*, pp. 138–139). This last sentence seems to admit the operation of a faculty of "abstraction."

[9] Raphael, p. 89.

[10] Michael Bullock, *Abstraction and Empathy*, English trans. (London: Routledge & Kegan Paul, 1953), p. 77.

[11] Raphael, pp. 90–91.

[12] Gene Weltfish, *The Origins of Art* (Indianapolis, 1953).

[13] Raphael, p. 14.

[14] Cf. Henri Frankfort, *The Birth of Civilization in the Near East* (Bloomington: Indiana University Press, 1951), p. 102. Professor Frankfort points out that symmetrical confrontations of the kind in question are much more typical of Mesopotamian than of Egyptian art.

[15] Professor Frankfort (p. 103) suggests that the aim of the artist was "to produce a decorative design," and that the animals in such designs are "subjected to a purely aesthetic purpose." "In Mesopotamia . . . imagination and design usually prevailed over probability and nature." He does not seem to regard this as an exceptional achievement; in other words, he ascribes to the Mesopotamian artist a ready-made "aesthetic purpose," instead of a newborn aesthetic awareness.

[16] Frankfort (p. 102): "Winged griffins and intertwined snakes are also at home in Mesopotamia from the Protoliterate period onwards and put in a passing appearance in Egypt."

CHAPTER III

[1] James Frazer, *The Golden Bough*, abridged ed. (London, 1922; New York: Copyright 1922 by The Macmillan Co.; quoted by permission of The Macmillan Co.), chap. 4, p. 50.

[2] Frazer, p. 51.

[3] Frazer, p. 53. Cf. note 9 below.

[4] Frazer, p. 54.

[5] Frazer, p. 57.

[6] Oxford and New York, 1912. Later revised under the title *Five Stages of Greek Religion* (London: Watts, 1935).

[7] Murray, *Five Stages of Greek Religion*, p. 19.

[8] *Religion of the Semites* (1901), p. 338.

[9] Murray, *Five Stages of Greek Religion*, p. 28. By quoting Murray, and Murray's quotations from Robertson Smith, I have no thought of giving my support to any particular theory of *mana*. The present scientific attitude to the subject is perhaps best summarized by Mircea Eliade, *Traité d'histoire des religions* (Paris: Payot, 1949), p. 33: "Il s'ensuit que la théorie qui considère le *mana* comme une force magique impersonelle n'est nullement justifiée. Imaginer sur cette base une étape préreligieuse (dominée uniquement par la magie) est implicitement erroné. Une telle théorie est d'ailleurs infirmée par le fait que tous les peuples (et surtout les peuples les plus primitifs) ne connaissent pas le *mana*; et encore par le fait que la magie—quoique rencontrée un peu partout—n'apparaît jamais qu'accompagnée de la religion. Bien plus: la magie ne domine pas partout la vie spirituelle des sociétés 'primitives'; c'est, au contraire, dans les sociétés plus evoluées qu'elle se développe d'une façon prédominante."

[10] Murray, *Five Stages of Greek Religion*, pp. 28–29.

[11] Jane Harrison, *Ancient Art and Ritual*, Home University Library (London: Williams & Norgate, n.d.), p. 26.

[12] Harrison, pp. 191–192.

[13] "The Greek word for a *rite* as already noted is *dromenon*, 'a thing done'—and the word is full of instruction. The Greeks had realized that to perform a rite you must *do* something—that is, you must not only feel something but express it in action, or, to put it psychologically, you must not only receive an impulse, you must react to it. The word for rite, *dromenon*, 'thing done,' arose, of course, not from any psychological analysis but from the simple fact that rites among the primitive Greeks were *things done*, mimetic dances and the like. It is a fact of cardinal importance that their word for theatrical representation, *drama*, is own cousin to their word for rite, *dromenon*; *drama* also means 'thing done.' Greek linguistic instinct pointed plainly to the fact that art and ritual are near relations. To this fact of crucial importance for our argument we shall return later. But from the outset it should be borne in mind that in these two Greek words, *dromenon* and *drama*, in their exact meaning, their relation and their distinction, we have the keynote and clue to our whole discussion." (Harrison, pp. 35–36.)

[14] Cf. A. N. Whitehead, *Religion in the Making* (Cambridge, 1926), p. 116: "Physical vibrations are the expression among the abstractions of physical science of the fundamental principle of aesthetic experience."

[15] Frazer, p. 51.

[16] Cf. Ernst Cassirer, *An Essay on Man: An Introduction to a Philosophy of Culture* (New York: Doubleday, 1953), p. 65: "Not immediately, but by a very complex and difficult process of thought, he [man] arrives at the idea of abstract space—and it is this idea which clears the way for man not only to a new field of knowledge but to an entirely new direction of his cultural life."

[17] Cf. Jean Piaget and Bärbel Inhelder, *La représentation de l'espace chez l'enfant* (Paris: Presses Universitaires, 1948).

[18] See below, pp. 100–101.

[19] One uses "East" and "West" in a very loose sense; Greece, no doubt, would

have to be included in the East. "The truth is that these labels which purport to indicate an illuminating scientific generalization in the background are mostly vain pretence. If one were obliged to stamp a geographical or ethnological mark upon the Hebraic-Zoroastrian group of religions, one could not label them either Eastern or Western, either Aryan or Semite. One could only say that they all arose in some country of the Nearer East, west of India and east of Europe. . . . Spengler was right in seeing that those four great religions [Christianity, Judaism, Islam, and Zoroastrianism] formed a group with certain common presuppositions which distinguished them alike from Graeco-Roman religion on the one side and Indian religion on the other. But I question whether any valuable conclusion regarding their character can be drawn from the fact that they all arose within a particular geographical area." Edwyn Bevan, *Symbolism and Belief* (London: Allen & Unwin, 1938), p. 71.

[20] George Rowley, *Principles of Chinese Painting* (Princeton: Princeton University Press, 1947), p. 64.

[21] G. Soulié de Morant, *A History of Chinese Art* (London, 1931), p. 168.

[22] Cf. Erwin Panofsky, *Gothic Architecture and Scholasticism* (Latrobe: Archabbey Press, 1951).

[23] Cf. Oswald Sirén, *Histoire de la peinture chinoise* (Paris, 1935), vol. II, p. 8: "La rivalité entre les deux écoles principales de la pensée chinoise, cause de tant de haines, de luttes, et même de persécutions, ne semble pas avoir gêné l'activité des artistes. Plusieurs peintres réussissaient également bien les sujets confucéens et les sujets taoïques et possédaient des amis dans les deux camps. Les questions doctrinales les touchaient peu."

When a philosophical synthesis of Confucianism, Taoism, and Buddhism was attempted by the philosopher Chu Hsi (1130–1200) late in the Sung period, it obviously owed its inspiration to the perception of a cosmic unity already represented by the Sung artists.

[24] Louis Bréhier, in *L'Art byzantin* (Paris, 1924), pp. 15–18, was perhaps the first to draw attention to a dualism which exists within Byzantine art, the two strains which he calls the hierarchic and the popular. It was the former, he argues, which was responsible for the monumental art of the churches and palaces, the latter for the lively popular literature and the realistic wall paintings and illuminated manuscripts of the monasteries. "C'est dans ce milieu aussi que s'est développé un art, beaucoup plus vivant que l'art officiel de Constantinople et beaucoup plus près que lui de la tradition syrienne et orientale. Des techniques moins luxueuses, la peinture murale substituée à la mosaïque, un style tout réaliste, une recherche des éléments pittoresques, du mouvement, parfois confus, et de l'émotion dramatique, telles sont les caractéristiques de cet art monastique et populaire, d'origine syriaque et palestinienne comme les poésies rythmées des mélodies, avec lesquelles il a tant de ressemblance."

I am prepared to argue that a similar dualism exists, and should exist, in all civilizations; cf. *Grass Roots of Art* (New York and London, 1946; new edn. 1955), chap. 4. It is not merely a question of different social levels, élites and masses, but rather of a divergence of human sensibility on the lines of introversion and extraversion. The artist finds the level of his psychological type, i.e. of the type of his sensibility.

One must also make a distinction between primary and secondary types of art. By primary types I mean types involving the apprehension of reality in the sense already defined (see p. 73). By secondary types I mean the use of pictorial means to symbolize existing concepts, art as illustration. The two types were combined in many Byzantine and Gothic churches, but they were never confused, as they are by our modern social (or socialist) realists.

[25] For a definition of "Gestalt-free" perception, and of the "Gestalt-free" art form, see Anton Ehrenzweig, *The Psycho-Analysis of Artistic Vision and Hearing* (London: Routledge & Kegan Paul, 1953).

[26] Celtic art, which is one of the sources of early Christian art, can be conceived as a blind filling of space: as not so much an abstract reaction to a distrust of the organic, which is Riegl and Worringer's theory, but rather as a closely-wrought screen set up against the horrors of infinite space. The monster that inhabits this infinite space, the worm of Ouroboros, sometimes is caught in the mesh, firmly held in a geometrical cage. The numinous awe of space in this case is given a negative representation.

[27] Edwyn Bevan, *Symbolism and Belief*, pp. 28–81, takes "height" as the quality whose apprehension led to feelings of reverence and sublimity. The concepts of height and space are not easily separable, and most of the time (for example, in his discussion of "Sky Gods") Dr. Bevan is describing spatial consciousness. Heaven may be conceived as "up there," high above us, but it is a place, and in most Christian representations (e.g. Dante's *Paradiso*) is an interior space. Nevertheless, Dr. Bevan gives a very convincing description of the feelings inspired by height, and admittedly they enter into man's transcendental imagination. "It is in regard to the sky especially that man has the feeling of the sublime, and that sense we have some warrant for thinking as unanalysable as the sense of beauty. To describe the object which affects us in that way as sublime, of course, tells nothing, since 'sublime' is simply one of the Latin words for high. We are, apparently, just confronted with the fact that great height above him gives man a peculiar feeling which can be known only by having it. Yet it may be possible to discern certain qualities of the sky which give man the feeling in question. "One, I think, is its difference from the terrestrial world. Nature offers the eyes of man, from the outset, two different worlds. There is the earth's surface, in which the two dimensions constituting a plane surface predominate, all a world more or less accessible to man. Even the mountains with some trouble he can climb, and he can cross the water in his canoe. And there is the wholly separate world he sees overhead *in the direction of a third dimension* [My italics.—H.R.]. He can see it there as plainly as he sees the rocks and trees around him; but it is a world utterly inaccessible. In it some of the natural phenomena which have the most terrifying resemblance to the expressions of human anger—the roaring winds, the lightning, the thunder—occur. And, especially on starry nights, it gives, as nothing else can give, *the vision of overarching immensity*. And there are two other characteristics of the world overhead:

(1) It is the world of light, in the daytime all shining with the light of the sun, in the night-time covered with the luminous dust of innumerable stars. . . .

(2) It, that is to say, its higher region above the clouds, is the world of order. While the terrestrial world offered primitive man a region in which regular law seemed to prevail only in particular strands (fire always burnt, and so on) amongst

promiscuous irregularity, the movements of the shining bodies seen in the world overhead repeated themselves with invariable regularity" (pp. 61–62).

[28] "The arch in building was unknown in Europe until the conquests of Alexander, when the Greek architects fastened eagerly on this, to them, novel feature, and they, and later the Romans, introduced to the Western world what was to be the distinguishing element in architecture. Now the arch was a commonplace of Babylonian construction—Nebuchadnezzar employed it freely in the Babylon which he rebuilt in 600 B.C.; at Ur there is still standing an arch in a temple of Kuri-Galzu, king of Babylon about 1400 B.C.; in private houses of the Sumerian citizens of Ur in 2000 B.C. the doorways were arched with bricks set in true voussoir fashion; an arched drain at Nippur must date to about 3000 B.C.; true arches roofing the royal tombs at Ur now carry back the knowledge of the principle another four or five hundred years. Here is a clear line of descent to the modern world from the dawn of Sumerian history. What is true of the arch is true also of the dome and the vault." C. Leonard Woolley, *The Sumerians* (Oxford, 1928), p. 191.

[29] E. Baldwin Smith, *The Dome: A Study in the History of Ideas* (Princeton: Princeton University Press, 1950), p. 5.

[30] Smith, *The Dome*, p. 8. Cf. also Charles Rufus Morey, *Mediæval Art* (New York: Norton, 1942), p. 261: "The architecture of Roman times produced the fundamental change in composition, whereby for the first time a building was composed as an interior. . . . The first great structure that displays the change is the Hadrianic Pantheon in Rome, built at a time when the transcendental element was fast transforming Mediterranean belief—the period of popularity of the mystery cults soon to be supplanted by a nascent Christianity, vehicles of that sense of infinitude which is precisely satisfied by architectural space. [I would say "inspired" rather than "satisfied."—H.R.] . . . In the composition of the Pantheon's space, however, infinitude is recognized but not exploited."

[31] I ignore, for the sake of simplicity, the parallel development of the vault. If a distinction is to be made between consciousness of space and consciousness of height (see note 27 above), then the vault might be taken as the symbol of height and the dome as the symbol of space.

[32] "Katakombenmalerei: die Anfänge der Christlichen Kunst," *Kunstgeschichte als Geistesgeschichte* (Munich, 1924), pp. 31–32, 40.

[33] Bloomington: Indiana University Press, 1951, pp. 54–55.

[34] See Edwyn Bevan again for a discussion of the "incompatible alternatives" of the Hebraic-Christian and Indian-Greek religious symbolism (p. 64). "It would, I think, be a mistake to suppose that the idea which located the seat of the Supreme God upon a mountain-top was more primitive than the idea which placed his seat in the sky. Some wit has said that the ancient Greeks believed that the gods had their dwelling on the top of Mount Olympus till one day someone climbed the mountain and found it untenanted."

[35] Morey, *Mediæval Art*, pp. 10–11. The quotation is from Aristotle's *Nichomachean Ethics*, ed. H. Rackham, Loeb Classical Library, no. 73, II, vi, 14.

[36] *To me on anoeton*; H. Diels, *Die Fragmente der Vorsokratiker* (Berlin, 1903), p. 120.

[37] "See, for example, the 18th Homily of Gregory of Nazianzus, and Procopius's description of the Hagia Sophia in Constantinople" [Demus's footnote].

REFERENCES

38 Demus, Otto, *Byzantine Mosaic Decoration* (London: Kegan Paul, 1947), p. 12.

39 Morey, p. 13.

40 Even such a clamant Thomist as Jacques Maritain recognizes the absurdity of this metaphor. "The cathedral builders had no sort of thesis in mind. They were, in Dulac's fine phrase, 'men unconscious of themselves.' They did not want to demonstrate the propriety of Christian dogma or to suggest by some artifice a *Christian emotion*. They even thought very much less about making a work of beauty than turning out a good work." *Art and Scholasticism*, trans. J. F. Scanlan (London: Sheed & Ward, 1930), p. 67.

41 Panofsky, *Gothic Architecture and Scholasticism*, p. 4.

42 London: Zwemmer; Bollingen Series XXIV, New York: Pantheon, 1949), II, 58–59.

CHAPTER IV

1 Ernst Cassirer, *An Essay on Man: An Introduction to a Philosophy of Culture* (New York: Doubleday, 1953), p. 129.

2 J. D. Beazley, *The Development of Attic Black-Figure* (Berkeley and Los Angeles: University of California Press; London: Cambridge University Press, 1951), pp. 2–3.

3 Beazley, p. 4. Cf. also Karl Kübler, *Altattische Malerei* (Tübingen, 1950).

4 Professor Beazley's phrase for a similar drawing by the same artist.

5 In the Museum für antiker Kleinkunst. Cf. Kübler, p. 92.

6 Beazley, p. 13.

7 Kerameikos, Inv. 1356. Ill. Kübler, p. 6.

8 This is a theme which I have developed in *The Art of Sculpture*, the Mellon Lectures (National Gallery, Washington), 1954, to be published shortly in the Bollingen Series, New York.

9 Ill. by P. de la Coste-Messelière, *Delphes* (Paris, 1943), fig. 10.

10 *Ibid.*, p. 34.

11 Trans. F. P. B. Osmaston, 4 vols. (London, 1920), III, 124.

12 *Ibid.*, pp. 124–125.

13 *Ibid.*, p. 136.

14 Plato, *Phaedrus*, 250–251, trans. J. Wright; first published in 1848; reprinted in *Five Dialogues* (London and New York: Everyman's Library, 1910).

15 The best account of it is the most recent: R. C. Lodge, *Plato's Theory of Art* (London, 1953). R. G. Collingwood, in *The Principles of Art* (Oxford, 1938), was perhaps the first modern philosopher to realize to what extent Plato's theory had been distorted by preconceived notions of aesthetic experience (Renaissance idealism, nineteenth-century naturalism, etc.).

16 Cf. Lodge, p. 252: "The truly artistic life is not (as Plato sees it) a *vita contemplativa*. It is not a life withdrawn from activity and concentrated upon perception or reflexion. It is the life which realizes in practice the ideals which it apprehends. The citizens of the model city are themselves the *personae* of a drama which is, precisely, ideal community living. They live artistically. They project themselves into their rôles. They make, each of them, an individual contribution to the integrated life of the whole. The general citizens, indeed, are living in a kind of dream-*aura*. They are all dreaming parts of one and the same dream. But their

life is not a mere dream, like the life of those who are blindly impelled by the impersonal forces of pleasure (as such), or wealth or power (as such). It is a dream which has a sense of guidance towards a final, ideal vision. This vision they are capable of apprehending (for the most part) only through art. They are helped by the music, the architecture, the marches and rituals which are an ever-present feature of their life."

CHAPTER V

[1] Conrad Fiedler, *On Judging Works of Visual Art*, trans. Henry Schaeffer-Simmern and Fulmer Mood (Berkeley and Los Angeles: University of California Press, 1949), p. 53.

[2] Cf. *Philosophical Investigations* (Oxford: Blackwell, 1953), *passim*.

[3] R. G. Collingwood, *Principles of Art* (Oxford: Clarendon Press, 1938), p. 223.

[4] Collingwood, p. 206.

[5] Collingwood, p. 209. [My italics.]

[6] Croce maintains that there can be no distinction between intuition and expression. "Every true intuition or representation is, also, *expression . . . Intuitive activity possesses intuitions* to the extent that it expresses them.—Should this expression seem at first paradoxical, that is chiefly because, as a general rule, a too restricted meaning is given to the word 'expression.' It is generally thought of as restricted to verbal expression. But there exist also non-verbal expressions, such as those of line, colour, and sound; to all of these must be extended our affirmation. The intuition and expression together of a painter are pictorial; those of a poet are verbal. But be it pictorial or verbal, or musical, or whatever else it be called, to no intuition can expression be wanting, because it is an inseparable part of intuition." *Aesthetic as Science of Expression and General Linguistic*, trans. Douglas Ainslie (London, 1909), pp. 13–14.

[7] Collingwood, p. 216.

[8] Collingwood, p. 217.

[9] Collingwood, pp. 283–284.

[10] *Idealismus und Naturalismus in der gotischen Skulptur und Malerei* (Munich and Berlin, 1918).

[11] There is a suppressed argument here; see, for its complete statement, T. E. Hulme's *Speculations* (London and New York, 1936) and my own *The True Voice of Feeling* (London and New York, 1953).

[12] *A Sienese Painter of the Franciscan Legend* (London, 1909), p. 3.

[13] *Prehistoric Cave Paintings*, Bollingen Series IV (New York: Pantheon, 1945), p. 11.

[14] *Masaccio et les débuts de la Renaissance* (The Hague, 1927), chap. 6.

[15] *Burlington Magazine*, 23:45 (1918). I owe this reference to Mr. John Pope-Hennessy, as cited in the next footnote.

[16] John Pope-Hennessy, *Giovanni di Paolo* (London, 1937), p. 147.

[17] The "Commentaries" of Ghiberti (*Lorenzo Ghibertis Denkwürdigeit*), ed. J. von Schlosser (Berlin, 1912), which are a kind of commonplace book in which we find all the ancient texts and recorded observations that occupied the minds of these fifteenth-century perspectivists, depend a good deal on Arabic sources,

particularly on the Optics of a certain Ibn-al-Haitham, also known as Alhazen, and this Arabian scientist of the tenth century (*c.* 965–1039), like the Arabians in general, had maintained a direct contact with Greek science, particularly with the works of Aristotle. The whole of this tradition is deductive: it assumes the presence of certain ideal laws in nature, and art becomes an illustration of these laws rather than a direct experience of reality. Beauty is conceived solely in terms of harmonic proportion.

[18] *Gothic Art and Scholasticism* (Latrobe: Archabbey Press, 1951), p. 26.

[19] A work on perspective by an English scholar, John of Peckham, was very popular in the thirteenth century and was probably known to the brothers Van Eyck. It was printed in Milan in 1494. Cf. Joseph Kern, *Die Grundzüge der linear-perspektivischen Darstellung in der Kunst der Brüder van Eyck und ihrer Schule* (Leipzig, 1904). For a masterly summary of the whole question of perspective in relation to the art of this period, see Erwin Panofsky, *Early Netherlandish Painting* (Cambridge: Harvard University Press, 1953), especially the introduction, pp. 1–20.

[20] *Early Netherlandish Painting*, pp. 16–17.

[21] Cf. Paul Henri Michel, *La pensée de L. B. Alberti* (Paris, 1930).

[22] "Die Perspektive als symbolische Form," *Vorträge der Bibliothek Warburg* (1924–25), pp. 258 ff.

[23] *The Note-Books of Leonardo da Vinci*, trans. Edward MacCurdy (London and New York, Jonathan Cape, 1908), I, p. 134.

[24] *Note-Books*, I, pp. 167–168.

[25] Cf. R. H. Thouless, "Phenomenal Regression to the Real Object," *British Journal of Psychology*, 21, pt. 4; 22, pts. 1 and 3 (1931–32).

[26] *Note-Books*, II, 266.

[27] Ibid, II, 257–258.

[28] Ibid, II, 364.

[29] Ibid, II, 374.

[30] Ibid, II, 529.

[31] Ibid, II, 528.

[32] For a penetrating analysis of this transition, see M. H. Abrams, *The Mirror and the Lamp* (New York: Oxford University Press, 1953).

CHAPTER VI

[1] H. J. Paton, "The Idea of the Self," in *The Nature of Ideas*, University of California Publications in Philosophy, Vol. 8 (Berkeley, 1926), p. 75.

[2] Paton, p. 78.

[3] Paton, p. 77.

[4] Paton, p. 86.

[5] Paton, p. 86.

[6] *The Principles of Psychology* (London, 1901), p. 251.

[7] "Style," in *Anthropology Today*, ed. A. L. Kroeber (Chicago: University of Chicago Press, 1953), pp. 287–312.

[8] Quoted by Georg Misch, *A History of Autobiography in Antiquity*, trans. E. W. Dickes in collaboration with the author (London, 1950), p. x.

[9] Also quoted in Misch, p. 17.

REFERENCES

[10] Misch, p. 624. Cf. also (*ibid.*, p. 625): "When, in his forties (he was born in 354), he launched his *Confessions* into the world, nearly fifteen years had passed since the summer of 386 in which he had taken the crucial turn in his life that made his autobiography of lasting interest. Whatever may have been the actual circumstances in which his 'conversion' took place, that Augustine then passed through an hour in which he felt himself carried beyond all natural conditions, and endowed with the strength and faith to carry out his highest aspiration—this, however problematic the nature of the spiritual change, remains as the unquestionable reality of a moral and religious experience that might give a man a metaphysical consciousness of his true self. The heightened awareness of the self from which his *Confessions* proceeded grew out of that experience."

[11] Cf. Ludwig Goldscheider, *Five Hundred Self-Portraits* (Vienna and London, 1937), pp. 12–14, Pls. 1–2.

[12] *Psychological Reflections. An Anthology of the Writings of C. G. Jung*, selected and ed. by Jolande Jacobi, Bollingen Series XXXI (New York: Pantheon, 1953), pp. 272-273.

[13] Wilhelm Pinder, *Rembrandts Selbstbildnisse* (Königstein im Taunus, 1950), p. 103.

[14] Letter 631. *Further Letters of Vincent van Gogh to his Brother* (London and Boston, 1929), p. 449.

[15] For a masterly review of "the unconscious in historical perspective," see C. G. Jung, "The Spirit of Psychology," in *Spirit and Nature*, The Eranos Lectures, Bollingen Series XXX, Vol. I (New York: Pantheon, 1954), pp. 371–444.

[16] Quoted by Albert Béguin, *L'âme romantique et le rêve* (Marseilles, 1937), I, 17–18. This is only one of the many illuminating sources of romanticism quoted by Monsieur Béguin.

[17] *Bekenntnisse* (1924), p. 193; quoted by Béguin, p. 230.

[18] "Contemplation suprême," in *Post-scriptum de ma vie* (Paris, 1901), pp. 236–237; quoted by Béguin, p. 139.

[19] Roger Fry, *Last Lectures* (Cambridge: University Press, 1939), chap. 2, *passim*.

[20] Fry, p. 33.

[21] This subject has been discussed by a scientist equally familiar with physics, psychology and the work of art—by Ian Rawlins, *Aesthetics and the Gestalt* (London and Edinburgh, 1953).

[22] *The Psycho-analysis of Artistic Vision and Hearing: An Introduction to a Theory of Unconscious Perception* (London, 1953).

[23] "Unconscious Form-Creation in Art," *British Journal of Medical Psychology*, 21 (1948), 22 (1949).

[24] Correspondences between the handwriting and the drawing of artists have been studied by Max Seeliger in *Handschrift und Zeichnung* (Leipzig, 1920). Cf. also Rudolf Arnheim, "Experimentell-psychologische Untersuchungen zum Ausdrucksproblem," *Psychologische Forschungen*, 11:1–32 (1928). Klara G. Roman, in *Handwriting: A Key to Personality* (New York and London, 1954), reproduces specimens of the handwriting of Claude Monet and of Jacques Lipchitz together with specimens of their work.

[25] *Paul Klee on Modern Art*, trans. Paul Findlay (London, 1948), pp. 49–50.

[26] *Paul Klee*, pp. 49, 51.

REFERENCES

CHAPTER VII

[1] I have dealt with Coleridge's theory of organic form in "Coleridge as a Critic," *Lectures in Criticism*, Bollingen Series XVI (New York: Pantheon, 1949), pp. 73–116 (London: Faber & Faber, 1949); reprinted in *The True Voice of Feeling* (London and New York, 1953), pp. 157–188. Cf. also chap. 1 of this book, "The Notion of Organic Form—Coleridge."

[2] Ernst Cassirer, *An Essay on Man: An Introduction to a Philosophy of Culture* (New York: Doubleday, 1953), pp. 212–213.

[3] Aldous Huxley, *The Doors of Perception* (New York and London, 1953).

[4] *Paul Cézanne: Letters*, ed. John Rewald (London, 1941), p. 271; letter dated 13th October, 1906.

[5] Piet Mondrian, *Plastic Art and Pure Plastic Art* (New York: Wittenborn, Schultz, 1945), p. 10.

[6] Mondrian, p. 19.

[7] Mondrian, p. 31.

[8] Mondrian, pp. 62–63.

[9] Naum Gabo, "On Constructive Realism," in Katherine S. Dreier, James Johnson Sweeney and Naum Gabo, *Three Lectures on Modern Art* (New York: Philosophical Library, 1949), pp. 72–73.

[10] Gabo, pp. 82–83.

[11] This and the following quotations come from *A Week on the Concord and Merrimack Rivers*.

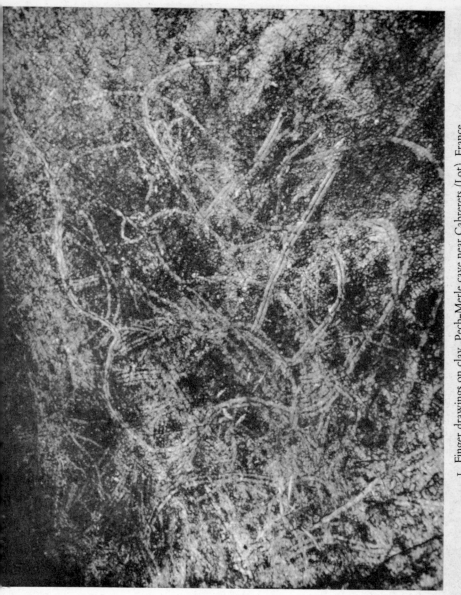

1. Finger drawings on clay. Pech-Merle cave near Cabrerets (Lot), France

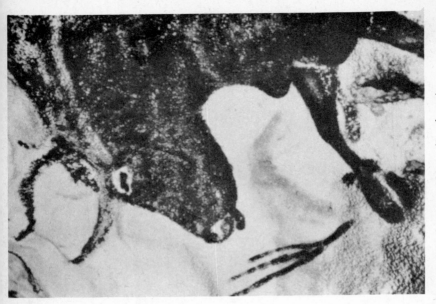

2a and 2b. Heads of oxen from the cave at Lascaux near Montignac-sur-Vézère (Dordogne)

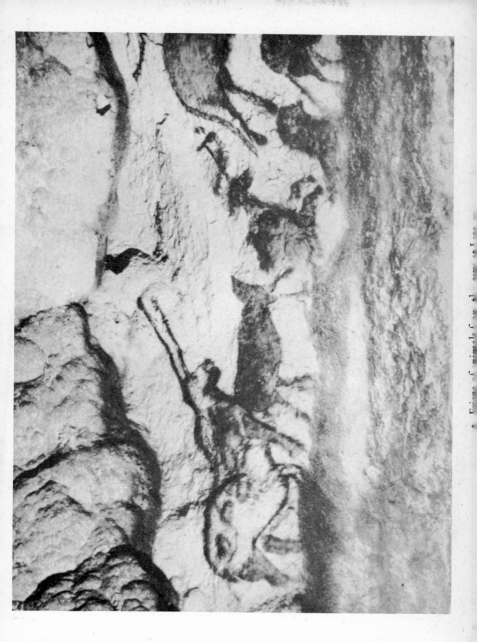

4. Fight of archers. From a cave near Morella la Vella,
province of Castellón, Spain

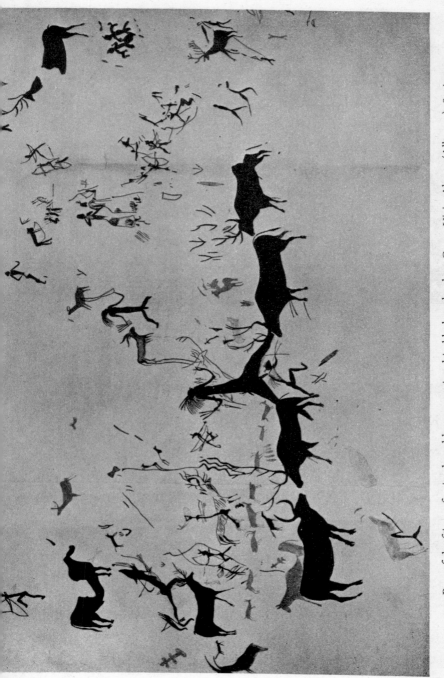

5. Part of the frieze of animals and hunters, painted in black and red, at Cueva Vieja, Alpera (Albacete), Spain

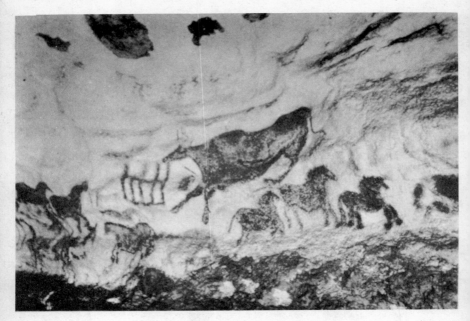

6a. Ox and horses from the cave at Lascaux

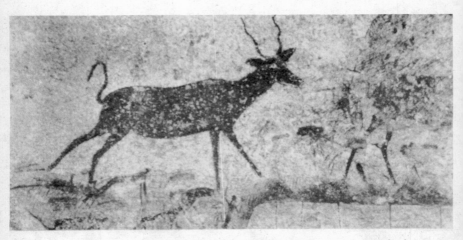

6b. Male koodoo from the Nswatugi cave, Whitewaters, Southern Rhodesia

7. Nine-square checkered design from the cave at Lascaux. Polychrome, 24 × 24 cm. The hoof of an ox breaks into the upper outline

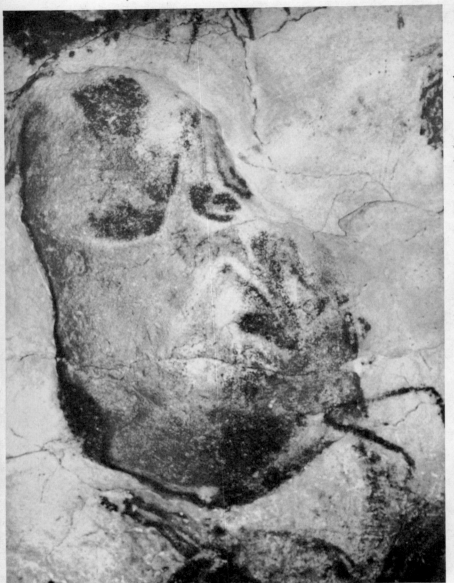

8. Crouched bison from the cave at Altamira, near Santander (Spain). Polychrome, painted

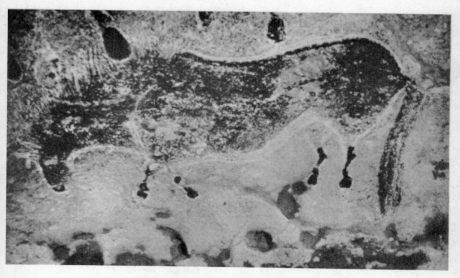

9a. Horse engraved and painted in bistre from the cave at Lascaux

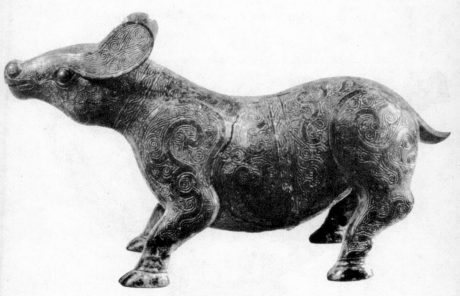

9b. Animal (li-yu) of cast bronze.
Chinese (Chou dynasty: about eleventh to ninth century B.C.)

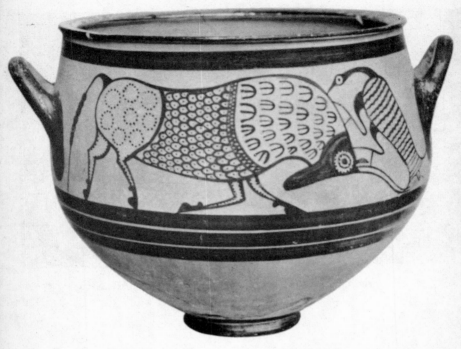

10a. Krater, late Mycenian, found at Enkomi (Cyprus)

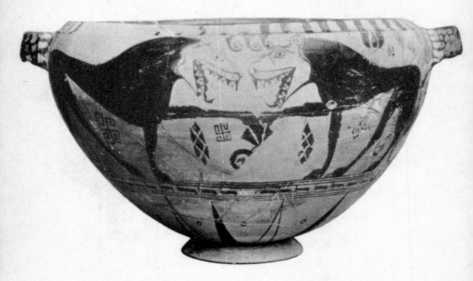

10b. Krater, Athens; seventh century B.C.

11a. The Wolf of the Capitol, cast bronze. Etruscan; sixth century B.C.

11b. Leopards, cast bronze. Benin, Nigeria; sixteenth century

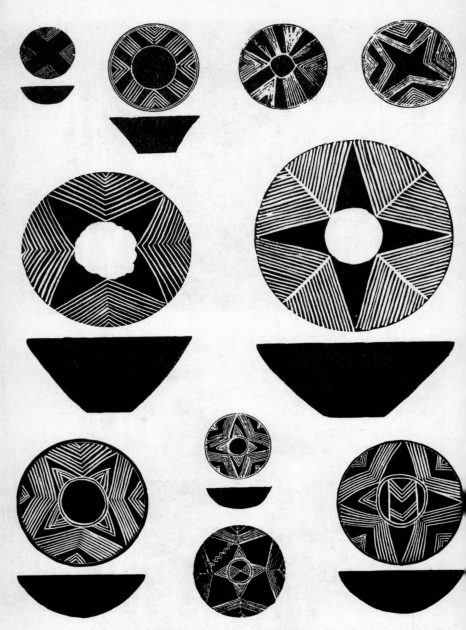

12. Geometric designs on Egyptian pottery of the Stone Age
(Amratian Culture, from Tasa)

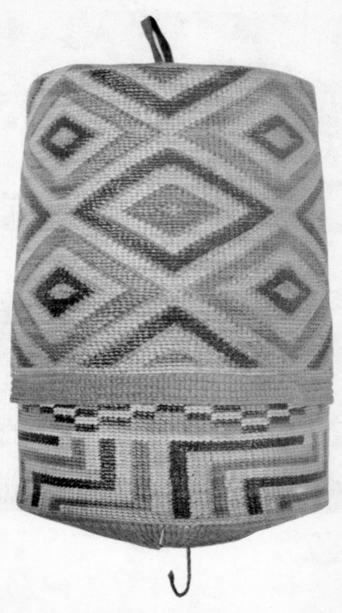

13. Basket. Tlingit Culture, Northwest Coast of America

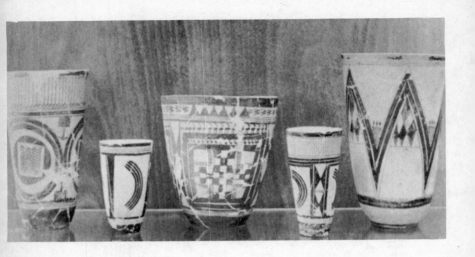

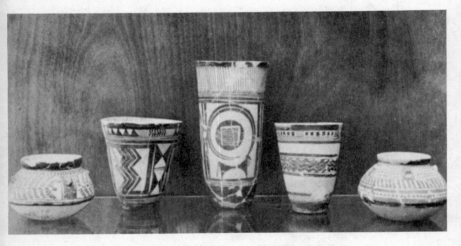

14a and b. Painted vases from Susa. Terra-cotta. Mesopotamian; before 3200 B.C.

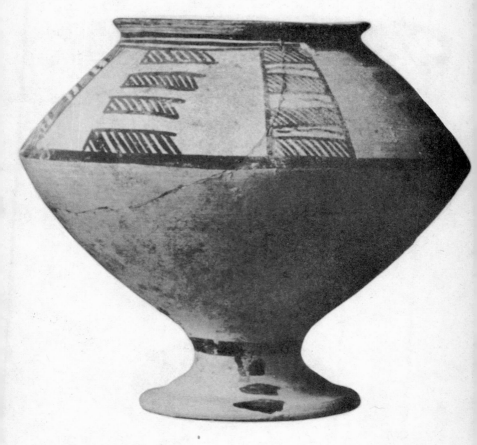

15. Painted chalice from Sialk, near Kashan. Mesopotamian; before 3000 B.C.

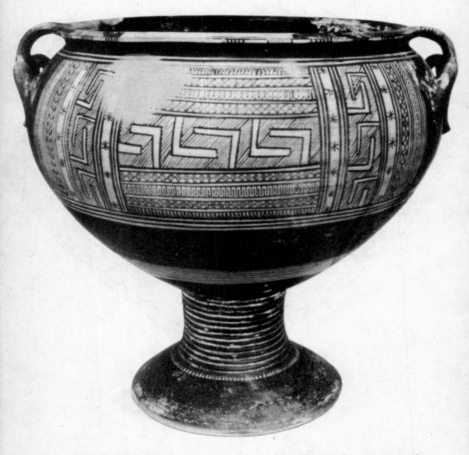

16. Krater, from Rhodes. Geometric period (ninth to eight century B.C.)

17. The Book of Durrow; page facing the opening of St John's Gospel.
Celtic; eighth century

18. Shell inlay from a royal tomb at Ur. Sumerian (Early Dynastic);
beginning of the third millenium B.C.
(This plaque formed a part of the decoration of a harp)

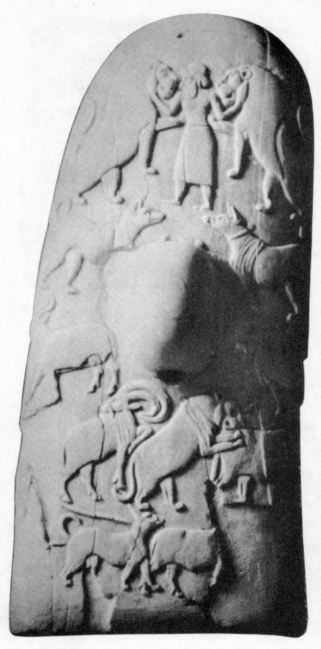

19. Ivory handle of a silex knife, found at Gebel el Arak (Upper Egypt).
Pre-Dynastic period, probably of Mesopotamian origin

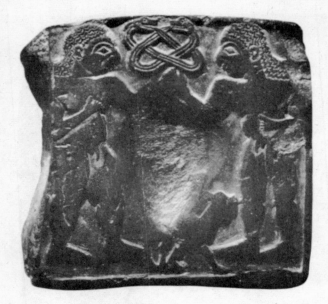

20a. Carved block of bituminous stone, found at Susa.
Sumerian; beginning of the third millenium B.C.

20b. Lamp lid of carved steatite, found at Tello.
Neo-Sumerian period, twenty-fourth century B.C.

21. Carved limestone plaque, representing the king of Lagash, Ur-Nina, as a builder. He carries on his head a basket containing the cornerstone of the temple he is about to dedicate. He reappears below, holding a goblet. The smaller figures represent his wife and sons. Found at Tello. Sumerian; about 2900 B.C.

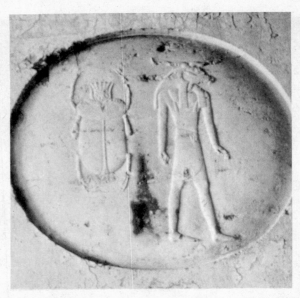

22a. Relief from the Memnonium of Seti I, 1313–1292 B.C. from Abydos

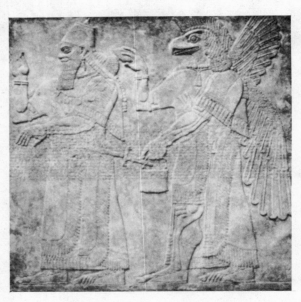

22b. Relief showing Ashur-nasir-pal II, king of Assyria, being anointed by a magical figure with head and wings of an eagle. 883–859 B.C.

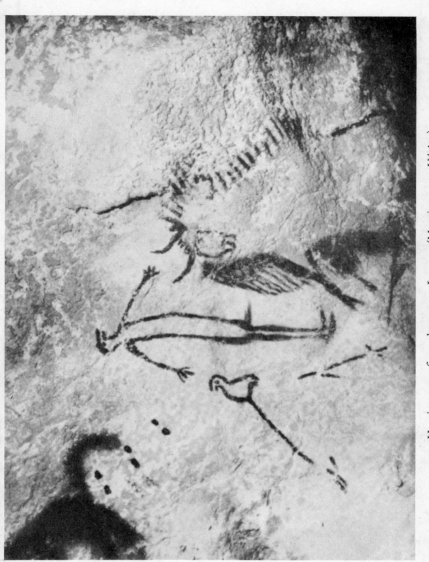

23. Hunting scene from the cave at Lascaux (Montignac-sur-Vézere). Upper Paleolithic period

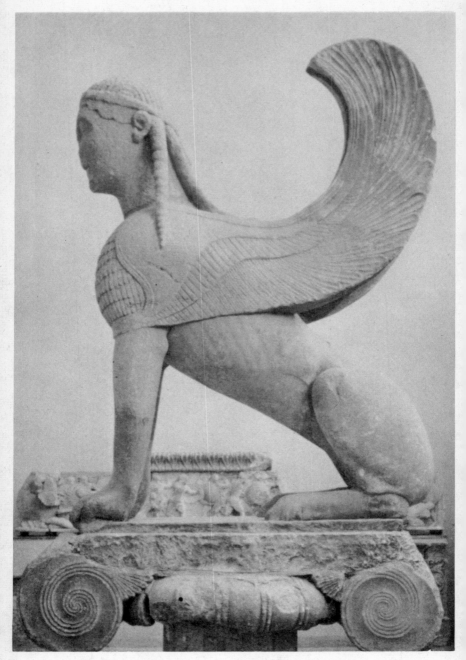

24. The Sphinx of Naxos. From Delphi. Greek; about 550–540 B.C.

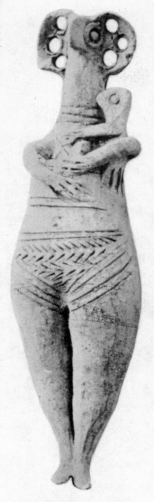

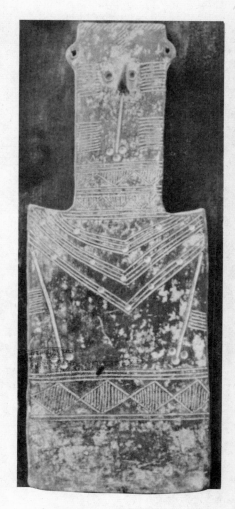

25a. Mother and child.
Terra-cotta figurine from Cyprus

25b. Terra-cotta idol from Cyprus

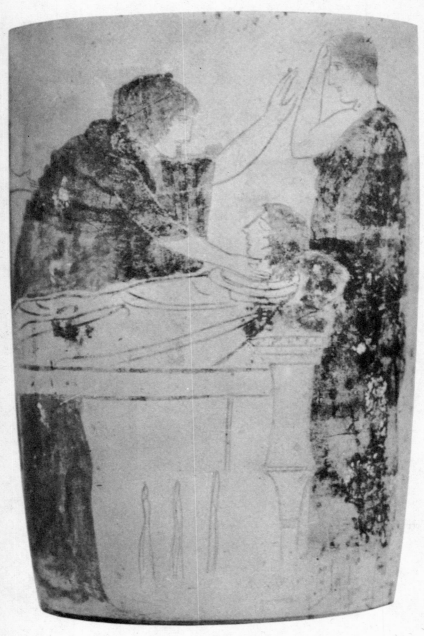

26. Mourning over a dead child. Painting from a lekythos, found at Eretria.
Second half of fifth century B.C.

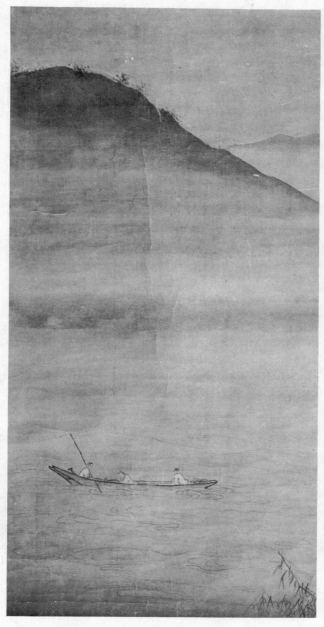

27. Boating by moonlight. Attributed to Ma Yüan (c. 1190–1224).
Chinese; Sung dynasty (A.D. 960–1279)

28. Church of S. Maria Maggiore, Rome. A pagan basilica restored and redecorated by Pope Sixtus III (432–440)

29. The Ascension, by Niccolo di Pietro Gerini (matriculated 1368, died 1415)
Pisa, S. Francesco

30. Dome of the church at Chèves (Charente), France

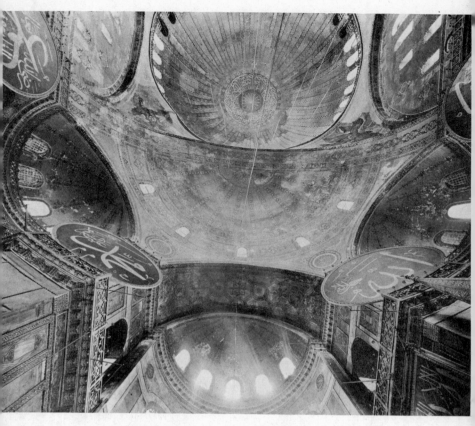

31. The church of Hagia Sophia, Constantinople (Istanbul)

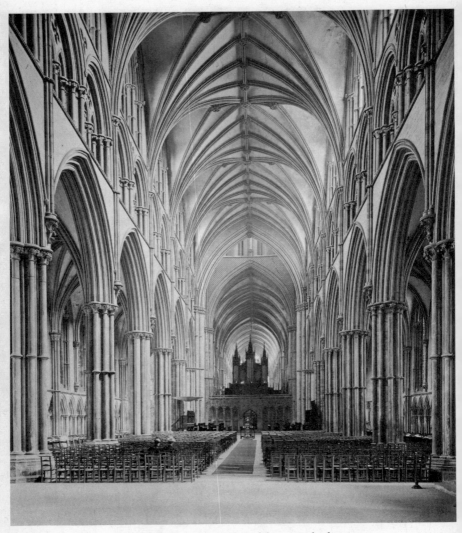

32. Lincoln Cathedral: interior of the nave, looking east

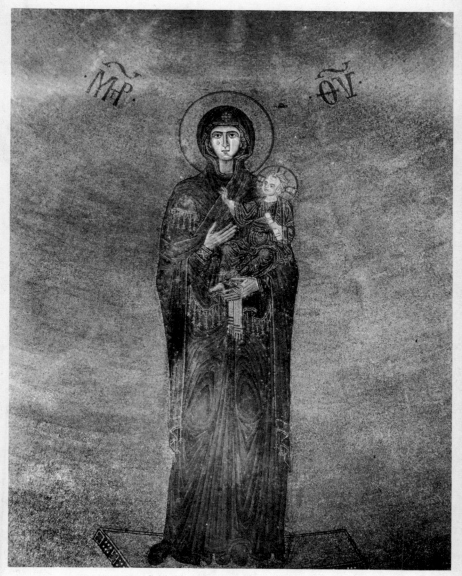

33. Virgin and Child with the Apostles. Mosaic in the main
apse of the cathedral, Torcello; about 1100 (detail)

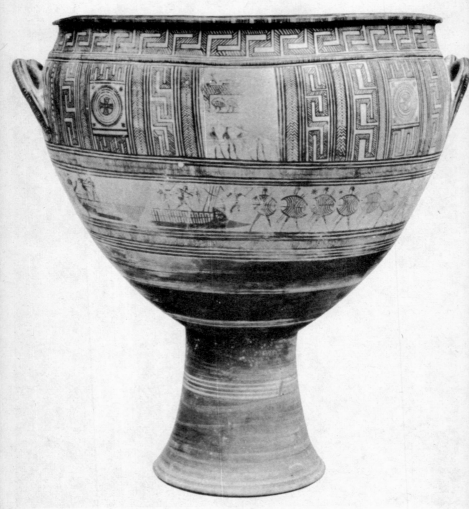

34. Krater, dipylon ware. Greek; eighth century B.C.

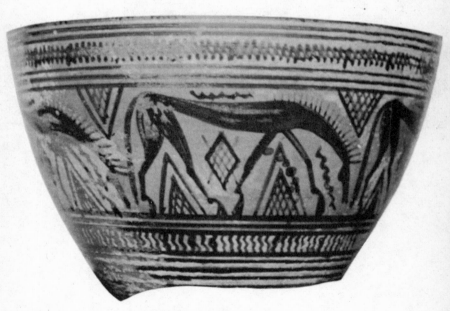

35a and b. The Broomhall krater.
Attic; seventh century B.C.

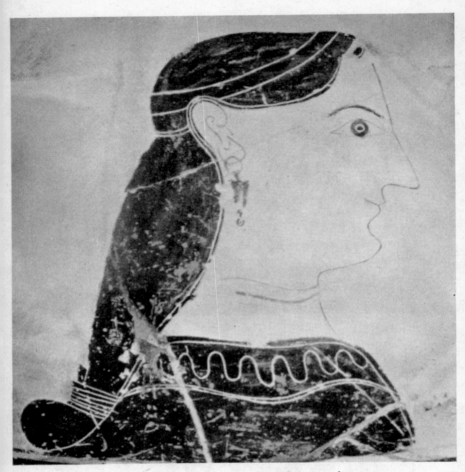

36. Head of a woman. From an amphora; late seventh century B.C.

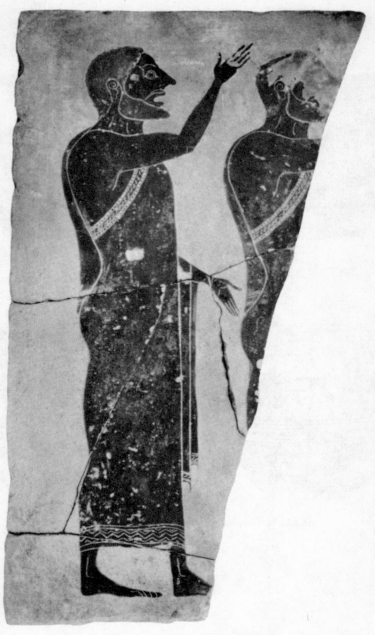

37. A valediction scene by the painter Lydos.
Attic; middle of the sixth century B.C.

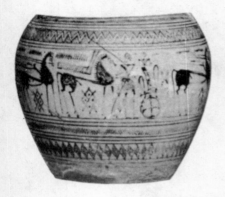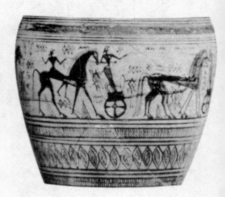

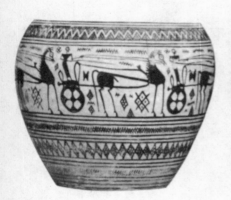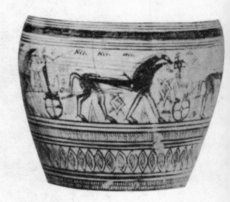

38a and b. Amphorae, decorated with chariot races.
Attic; sixth century B.C.

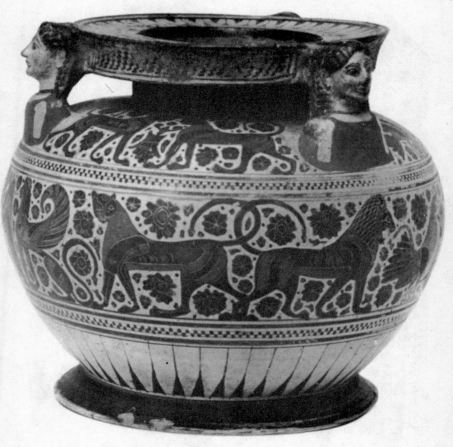

39. Pyxis, middle Corinthian period (600–575 B.C.)

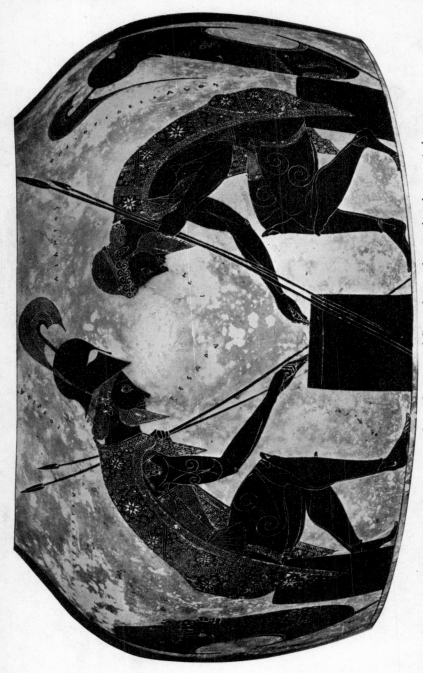

40. Painting by Exekias on an amphora, showing Achilles and Ajax playing a board game; sixth century B.C.

41. Pinax (plate) signed by Epiktetos; about 500 B.C.

42. Stylized female figures, carved marble. Cycladic; second millenium B.C.

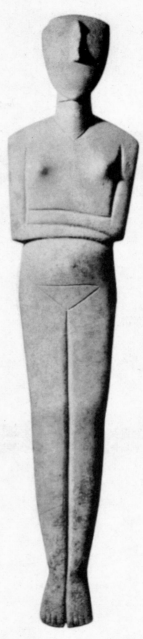

43. Idol of carved marble. Cycladic; Bronze age,
end of third millenium B.C.

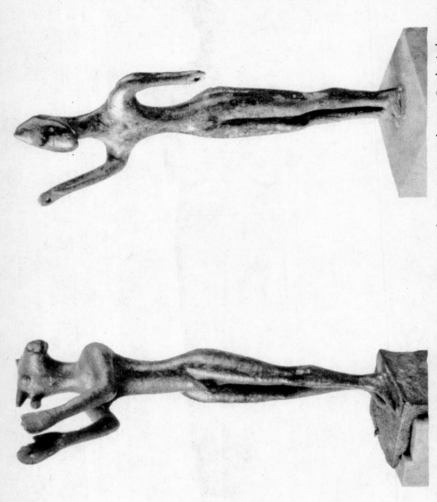

44a. Minotaur in cast bronze. Greek; sixth century B.C.

44b. Warrior in cast bronze. Greek; sixth century B.C.

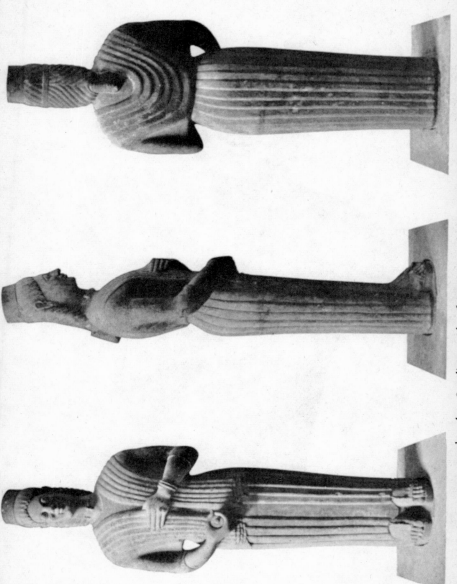

45a, b and c. Standing maiden from Attica: about 580–560 B.C.

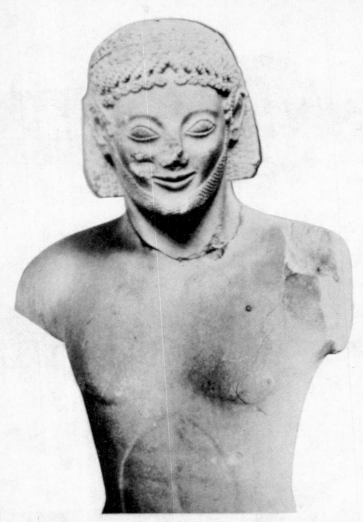

46. The Rampin horseman: the head from the Louvre Museum, Paris, completed by fragment of the torso from the National Museum, Athens; about 600–575 B.C.

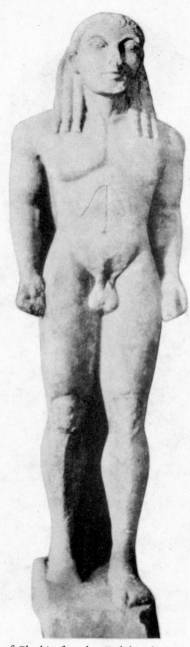

47. Figure of Cleobis, found at Delphi; about 600–575 B.C.

48. Figure from the Parthenon frieze; 442–438 B.C.

49. Fragment found on the Acropolis, Athens

50. Bronze statuette found at Delphi. Possibly Cretan; about 640–630 B.C.

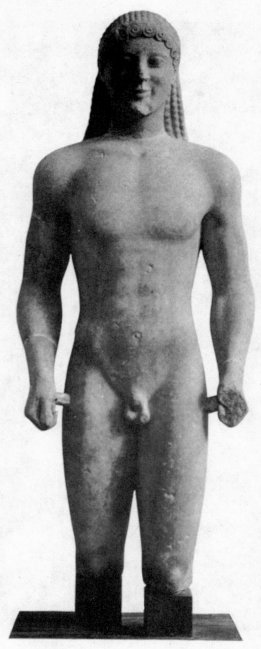

51. Apollo from Boeotia; about 540–510 B.C.

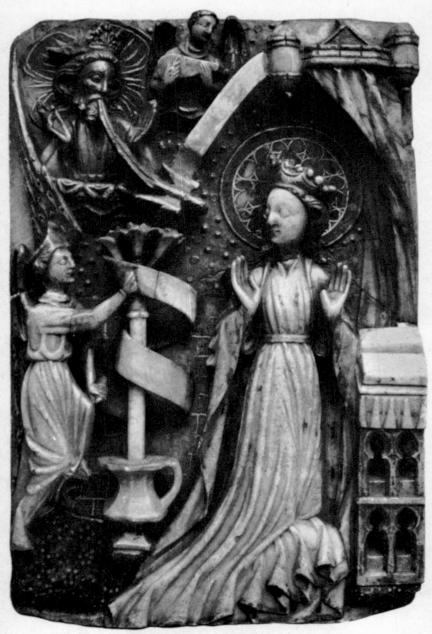

52. The Annunciation. Carving in alabaster.
English (Nottingham); fifteenth century

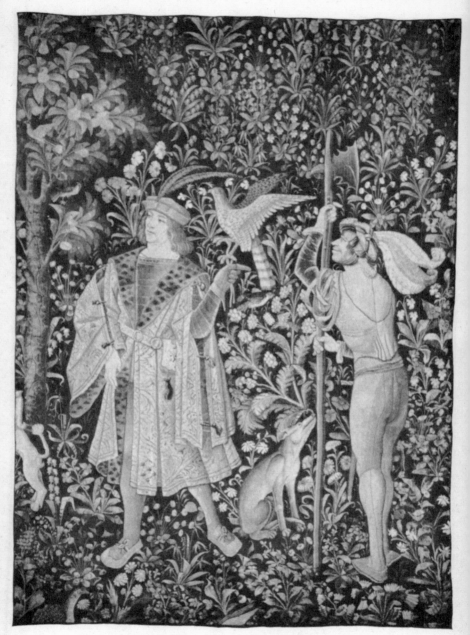

53. Tapestry. French; end of the fifteenth century

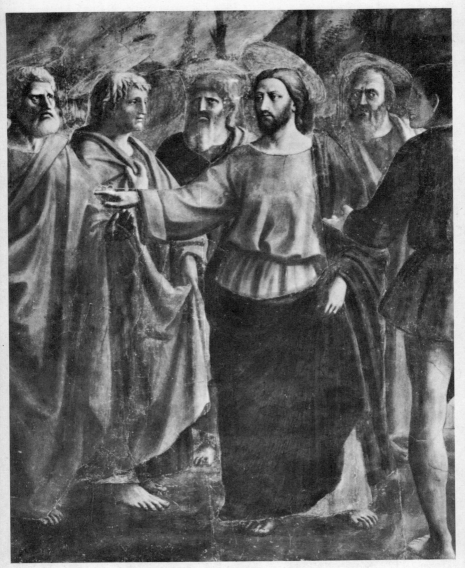

54. Masaccio: Detail from the 'Tribute Money'.
Santa Maria del Carmine, Florence

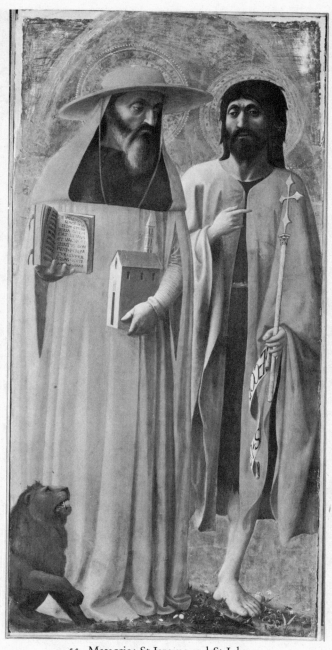

55. Masaccio: St Jerome and St John

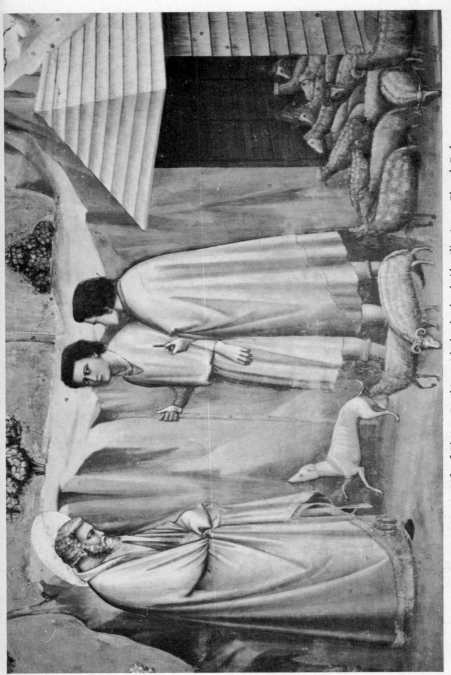

56. Giotto: Life of Christ – Joachim with the shepherds (detail). Arena Chapel, Padua

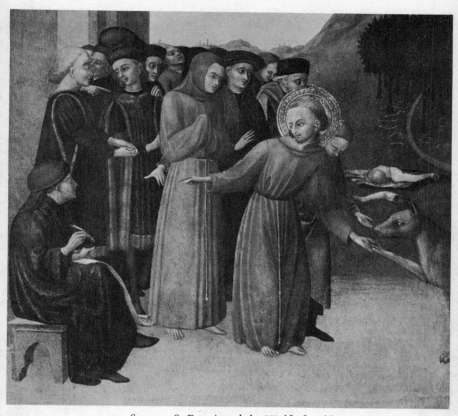

57. Sassetta: St Francis and the Wolf of Gubbio

58. Giovanni di Paolo: Christ Suffering and Christ Triumphant

59. Jacopo Bellini: A well. Drawing

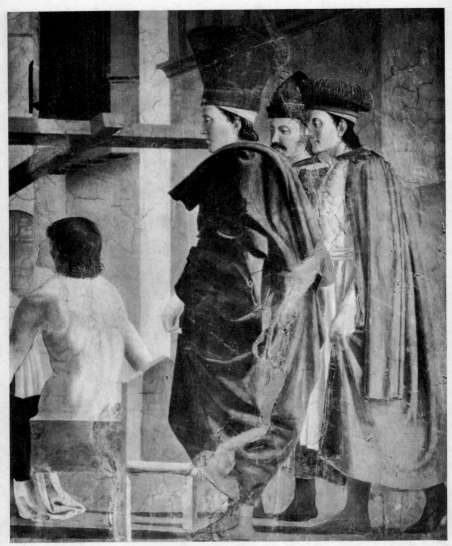

60. Piero della Francesco: Discovery of the True Cross (detail).
San Francesco, Arezzo

61. Leonardo da Vinci: The Virgin of the Annunciation (detail). Uffizi, Florence

62. Leonardo da Vinci: Battle of Cavalry. Drawing

63. Leonardo da Vinci: Landscape with Deluge

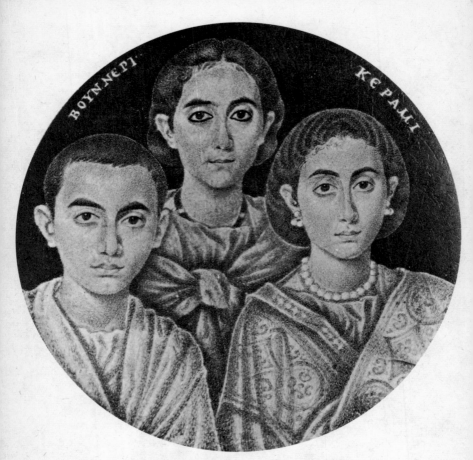

64. Portraits of Galla Placidia, Honoria and Valentinian.
Byzantine School; fifth century

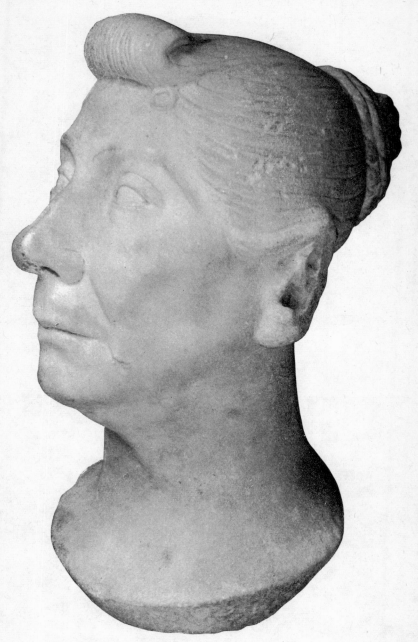

65. Head of an elderly woman (from Palombara). Marble.
Roman; first century B.C. (toward the end of the Republic)

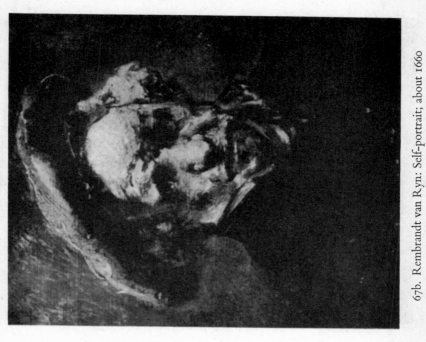

67b. Rembrandt van Ryn: Self-portrait; about 1660

67a. Rembrandt van Ryn: Self-portrait; about 1660

68b. Vincent van Gogh: Self-portrait; January, 1889

68a. Caspar David Friedrich: Self-portrait; about 1835

69b. Paul Klee: Self-portrait; 1919

69a. Oskar Kokoschka: Self-portrait; 1917

71a. Paul Klee: Black Boats. Oil; 1927

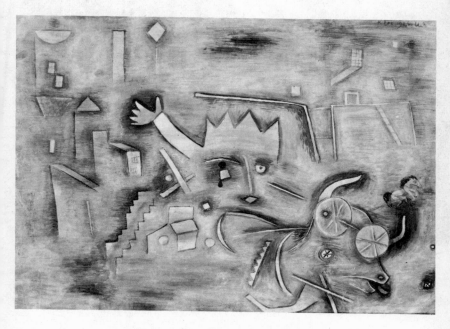

71b. Paul Klee: Animal Terror. Oil; 1926

72. Detail showing the brushwork of a painting, probably by Titian: The Tribute Money

73. Georges Mathieu: Painting. Oil; 1952
The artist's signature appears below.

74. Sam Francis: Green Oil; 1953

75. Mark Tobey: Edge of August. Tempera; 1953

76. Raoul Ubac: Forest. Oil; 1953. The artist's signature appears below

77. Jean Fautrier: Corps d'Otage. Oil; 1944

78. Paul Cézanne: Environs de Gardanne. Oil; 1885–6

79. Pablo Picasso: The Factory at Horta de Ebro. Oil; 1909

80. Juan Gris: Composition No 2, blue; 1922

81a. Piet Mondrian: Still-life. Oil; 1910

81b. Piet Mondrian: Still-life. Oil; 1910

82a. Piet Mondrian: Still-life. Oil; 1911

82b. Piet Mondrian: Painting. Oil; 1920

83. Mies van der Rohe: Apartment houses at
860 Lake Shore Drive, Chicago; 1951

84. Antoine Pevsner: Twinned column. Bronze; 1947. Height, 40½ in.

85. Naum Gabo: Construction in space – Continuity; 1941–2.
Plastic. Height, 17¼ in.

86. Jean Arp: Aquatic. Marble; 1953. Height, 13 in.

87. Lebanese Club, Diamantino, Brazil. Architect: Oskar Niemeyer

88. The Boston Center; 1953. Projected by 'Boston Center Architects'

INDEX

The numbers in italic type refer to illustrations

INDEX